PARIS by DESIGN

An Inspired Guide to the
City's Creative Side

By Eva Jorgensen
of Sycamore Co.

Photography by Chaunté Vaughn

Food and Drink Editor:
Rebekah Peppler

Design by Linnea Paulsson Neppelberg

Abrams, New York

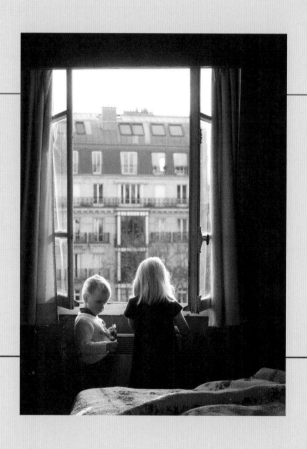

To Ingrid, Lars, and Kirk

And to my mom, granny, and papa
for teaching me to love Paris since
before I can remember

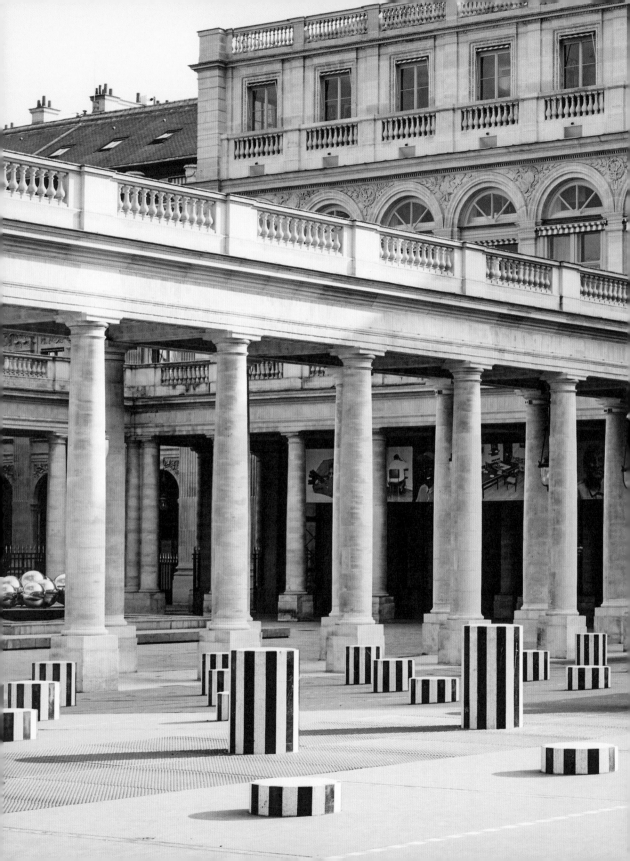

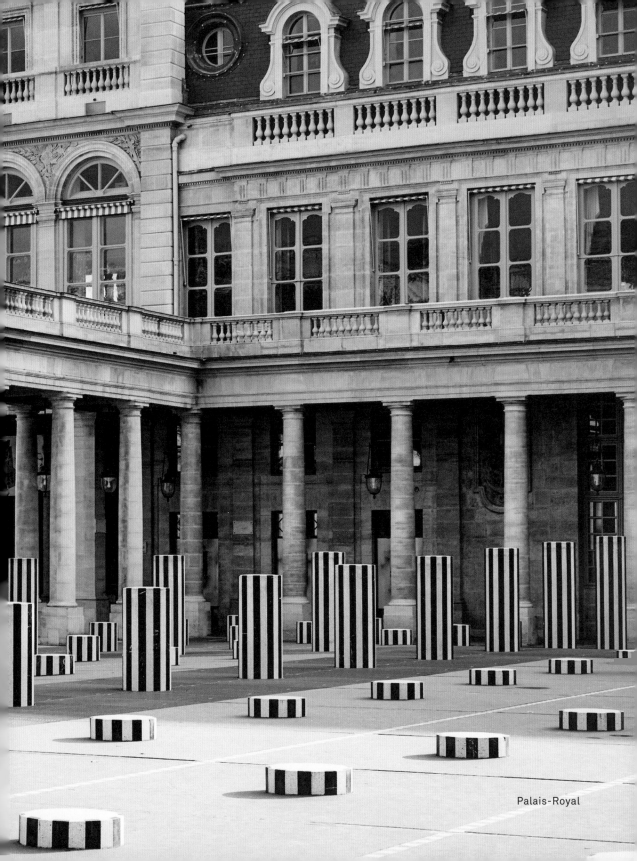

Palais-Royal

Contents

Oni Masta of Atelier Beaurepaire

Musée Nissim de Camondo
Photo: Meta Coleman

Souvenirs from Paris

In the home of Cécile Molinié

The garden of Kali Vermes

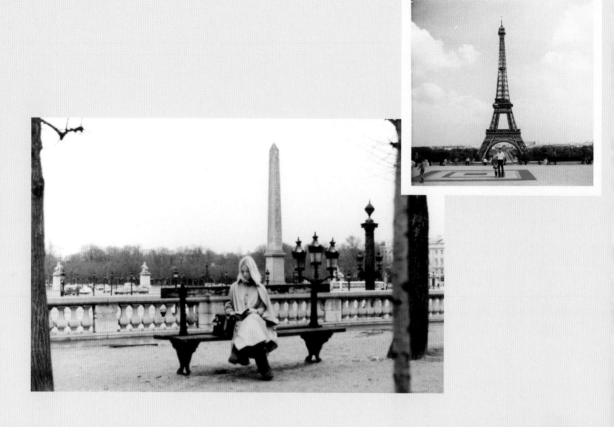

Photography by Carl Warren,
Laura Warren, and Christine Warren Pollock

PREFACE

It's 1969. My mom is twelve. Her dad works for IBM and accepts a transfer from Seattle to Paris, so the entire family packs their bags, including boxes of Kool-Aid, Jell-O, Skippy, and other convenient American foods you can't get overseas. They arrive in the French capital and find a house in neighboring Versailles. My mom and her younger brother and sister enroll at the International School of Paris where the administrators say a twelve-year-old is probably too old to study in French; she won't pick up the language fast enough. They say she'll flunk out, so they have her skip a level, thinking that when she fails and has to repeat a year, she'll end up back in her proper grade.

But she doesn't flunk out. And she learns not only how to read, write, and speak like a Parisian, but how to dress like one, too. She notices that the stylish locals don't have a lot of clothes—they wear the same outfit for a week straight. Each season they freshen up their look with one or two key pieces. One winter, it's all about knee-high boots with wool midi skirts. Come summer, it's a white V-neck T-shirt worn with white jeans and a red belt. And so forth.

While her kids are in school, my granny scours the countryside for antiques. The French are all about the mod midcentury look, so she scoops up incredible pieces for a song. Her favorite shop is in a small town called Pontchartrain. There's a café nearby called Chez Sam with a bald, smoking chicken at the front.

Together, the family discovers Camembert, *steak frites*, pâtisseries, and baguettes, not to mention real butter and lettuce varieties that aren't iceberg. My grandparents' favorite restaurant for a big night out is Le Soufflé, not far from where my grandfather works on Place de la Madeleine. But they still head to McDonald's when they're feeling a little homesick for burgers, fries, and milkshakes.

On Saturdays, my mom goes to the city with her friends. They play guitar and sing in the park, catch concerts by touring bands, and pop into boutiques to try on the newest trends. Pushing their luck, they wait until the very last train before heading home.

When I was a kid, there was a process to bedtime. Showers and books and prayers and back-scratching and, finally, lights out. If I was lucky, while my mom was scratching my back, she'd tell me a story from her childhood. And if I was really lucky, it would be from her time in Paris. As I got older and had several chances to spend extended periods of time in and around that city—while studying abroad, for an internship, as a volunteer, and on sabbatical—I realized that so much of my mom's sophisticated aesthetic was influenced by her former life there. As Hemingway predicted, the City of Light stayed with her—just as it has for countless other creatives before and since, myself and all the contributors to this book included.

INTRODUCTION

Simone de Beauvoir, Auguste Rodin, Charles Baudelaire, Colette, Claude Debussy, Berthe Morisot, Marc Chagall, Josephine Baker, Christian Dior, Isadora Duncan, James Baldwin, Le Corbusier, Gertrude Stein, Coco Chanel, Pablo Picasso—the list could go on and on. Paris has been a dream destination and muse from the Age of Enlightenment to the Belle Epoque, from the Lost Generation to the Beat Generation. Among the people drawn to this city, artists and aesthetes have always played a major part.

In the Tuileries Garden

No question, the richness of art and design history around every corner is a huge part of the French capital's allure.

Every time I've been there, including while working on this book, I sometimes find myself wishing I could step back in time, like a character from *Midnight in Paris*, and explore the City of Light of past generations. It still feels like a bit of the magic from those days remains in the nooks and crannies of the city.

But that's not the whole picture. Today Paris is reemerging as a leading force on the front line of art, fashion, food, and design. Alongside **the Louvre** and the **Musée d'Orsay,** the **Centre Pompidou** and the **Palais de Tokyo** offer world-class modern and contemporary art collections, and you can find many prestigious galleries, theaters, and design shops, not to mention a large community of creatives making new and exciting work.

It's this wonderful mash-up of old and new that makes the creative side of Paris so fascinating.

Several years ago, I was planning a trip to Paris and was looking for a book that dove deep into the art and design of that city—from new to ancient to everywhere in between—as long as it fit my aesthetic sensibility. As a creative director with a background in fine art and stationery design, I wanted a book that would give an intimate look into the creative life of the city—a book that would transport me and help me feel like I, too, could be a part of that creative life. I wanted it to include a practical guide full of beautiful places to visit. From a classic art museum to an avant-garde clothing boutique to a cozy secondhand bookshop—an eclectic collection of places someone with an artful aesthetic would appreciate.

I ended up buying a lot of books about the French capital, but not the one I was looking for. It didn't exist—even in a sea of Paris publications. I knew I couldn't be the only one looking for that book, so I decided to create it myself.

But I love collaboration and knew that a work of combined passion and expertise would surpass the quality of what an individual author could deliver. With that in mind, I enlisted the help of more than three dozen contributors I'd either teamed up with before or had admired from afar for their work in places like the *New York Times*, *Vogue*, and Refinery29. Parisians and Francophiles, writers, illustrators, stylists, models, and photographers, each of them brought an inside knowledge of Paris and an immense affection for that city to their work.

The book's primary photographer—Chaunté Vaughn—and I were determined to capture an intimate and eclectic portrait of this renowned city, so we relocated to Paris for five weeks and lived like locals, hanging out with artistic Parisians while we interviewed and photographed them in their homes, their workspaces, and their favorite haunts. In a truly collaborative undertaking, I combined my own extensive research with our Parisian contributors' expert recommendations and added some good old-fashioned exploration to unearth the most fascinating people and places in Paris. Food and drink editor Rebekah Peppler mined her own experience as a Paris local and accomplished food writer to compile our list of where to eat and drink in style.

The book we made is exactly the book I'd hoped to find. Whether you read it from beginning to end or hop and skip around according to your needs and interests, *Paris by Design* is the perfect companion to your Parisian adventures. The five chapters—"The Arts," "Design," "Style," "Interiors + Exteriors," and "Creative Food + Drink"—show you a behind-the-scenes look at the creative side of the city—a side that is often hard to find or off-limits for visitors. And The Guide is full of recommendations of the places you'll actually want to go—places with beauty and atmosphere that will leave you feeling inspired. I think this might be the book you've been looking for, too.

"If you are lucky enough to have lived in Paris . . .

then wherever you go for the rest of your life, it stays with you,

for Paris
is a moveable
feast."

ERNEST HEMINGWAY

The
Arts

Art in Paris did not die with World War II, as some have said. Yes, the center of the art world moved to New York in the postwar years and remained there for decades, but today the idea of a monolithic art center is crumbling as cities all over the world, Paris included, house their own thriving art scenes. A trip to the city today reflects this resurgence of contemporary art and artists who exist side by side with the riches of art history that have made Paris famous.

In this chapter, writer, actor, and PBS host Kira Cook recommends both new and old titles to watch, read, and listen to for Parisian inspiration. We'll learn how local writer Anne Berest's grandmother invented modern art; take a look at the Paris-inspired drawings of contemporary illustrators; get a peek into the lives and work of sculptor Samir Mougas, creative director Cécile Molinié, and painter Bruno Albizzati; and find out what inspires photographer Juan Jerez about his adopted hometown. We've also included an itinerary for an artful day in the buzzy Saint-Georges neighborhood and a list of must-follow Instagram accounts for art-loving Franco-philes, so that you can soak up a little of this inspiring atmosphere whether you're visiting or not.

IN THE MOOD

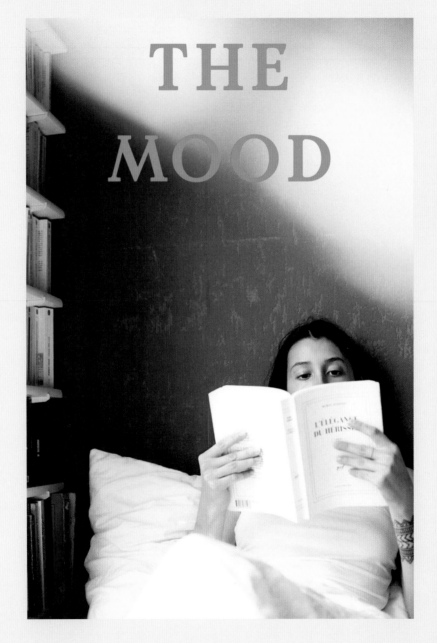

By Kira Cook
Model: Angèle Fougeirol

A PARISIAN COLLECTION OF BOOKS,
FILMS, MUSIC, AND MORE

There's no shortage of inspiration for dreaming up a voyage to Paris for this writer/actor/PBS host. Where to even begin? *Zut alors*, with a list of essential books, music, and films, of course! Let this Parisian cultural bounty be your muse as you edify and entertain yourself. Paris is referred to as the City of Light because it was a center of education and ideas during the eighteenth-century Age of Enlightenment, so it's no wonder that the following erupted out of such a vibrant civic wellspring.

Sophie Calle: Did You See Me? by Sophie Calle

A forever favorite artist of mine, French artist Sophie Calle is a master of using her city, her body, and her personhood for her art. One of my favorite pieces of hers is *Room with a View*, which illustrates, via photography and text, the night in 2002 when she set up a bed at the top of the Eiffel Tower and received a succession of strangers at her bedside to tell her stories so she wouldn't fall asleep.

Impressions of Paris by Cat Seto

A sketchbook to serve as inspiration for the ultimate Paris lover, this tome presents a painter's version of Paris with delightful stories, rich illustrations, and notes that meditate on the connections between color, pattern, perspective, and rhythm.

"La Mer," Charles Trenet

My high school French teacher had us memorize the lyrics to this song, and I'm still able to bowl over my fellow diners whenever I'm in a traditional French restaurant (where the song is sure to play at least once during the night). Listen to this epic French tune from the 1940s and pretend you're in a straw hat, perched on the banks of the Seine, and romantically rendered in pointillism.

Radio France

Practice your French skills in surround sound by playing Radio France in the mornings as you get ready. Your makeup routine will take on a whole new sexy gravitas.

The Alice B. Toklas Cook Book by Alice B. Toklas

This is one of the bestselling cookbooks of all time, which is curious because most of the recipes within it seem so ancient, they aren't all that appetizing. The draw here is the intimate look the book gives at Toklas and her life partner, Gertrude Stein, through their mutual adoration of food and French culture.

Islands Without Cars, "Porquerolles"

I host a travel series for PBS called *Islands Without Cars*, and last year we visited Paris and the tiny French island of Porquerolles, which prohibits modern transport. The locals mostly go barefoot across the island's lavender-scented terrain. You can

check it out on PBS or at www.islandswith-outcars.com! (What's French for "shameless plug"?)

A Moveable Feast
by Ernest Hemingway

Hemingway's memoir of life in Paris in the 1920s is requisite reading for any insistent Francophile. This book proves how enduringly Paris engages you, whether you're broke, broken-hearted, both, or neither.

The New Paris by Lindsey Tramuta

Subtitled *The People, Places & Ideas Fueling a Movement*, Tramuta's book highlights the new trends and quickly evolving ideas that have moved Paris from its historic (read: stagnant) status to a forward-thinking city chock-full of a new, vibrant spirit.

Michael Haneke's film
Code Unknown

Several characters intersect in Paris in this racially tinged masterpiece, which explores how challenging it is for a city to successfully host a diverse group of people from wildly different backgrounds, religions, and attitudes.

Richard Linklater's film
Before Sunset

The endlessly romantic sequel to *Before Sunrise*, starring the endlessly charismatic Julie Delpy and Ethan Hawke. Get inspired to fall in love in Paris, maybe just like this.

Alice in Paris

This online food and travel series from Tastemade, composed of two-minute vignettes, allows us to follow actress/director Alysse Hallali around her hometown of Paris. She explains what local food destinations she loves best in what is certifiably the most adorable accent ever.

Françoise Hardy,
Tous Les Garcons et les Filles

Released when Hardy was just eighteen years old, this album was the start of a whirlwind career. She became the most famous figurehead of the yé-yé (literally, "yeah yeah") movement, which was France's answer to Britain's beat music, featuring teenage girls singing with melancholic fervor about adolescence. Favorite line, sung with a smile? "But do not ask me to go home with you."

How to Be Anne Berest Wherever You Are

THE WRITER WHO FIRST TAUGHT US HOW TO BE
PARISIAN IS NOW TEACHING US A FEW THINGS
ABOUT MODERN ART. STARTING WITH THE FACT
THAT IT WAS CREATED BY A WOMAN WHO JUST SO
HAPPENS TO BE HER GREAT-GRANDMOTHER.

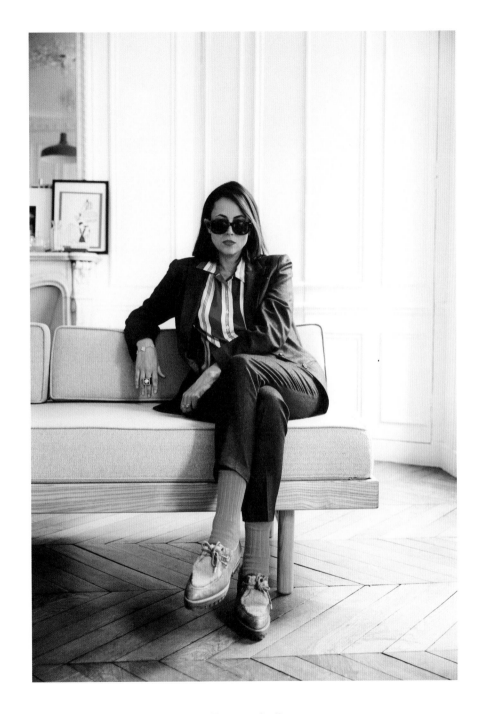

By Shannon Carlin

Anne Berest is rarely seen without her red lipstick. Her brand of choice is Dior Addict, and she recommends it to any woman looking to channel her inner Parisian in *How to Be Parisian Wherever You Are: Love, Style, and Bad Habits*. Despite its title, the 2014 guidebook, which Berest cowrote with three of her friends, is not an Emily Post–inspired how-to. It's a tongue-in-cheek takedown of society's misconceptions about Parisian women. Berest is a writer in every sense of the word—a novelist, a journalist, a playwright, and a TV writer—but she's also a cultural anthropologist who honors her city with everything she publishes. She longs to understand Paris and its people, handling with care even the most trivial of things—like the correct lipstick to buy.

Perhaps Berest's attitude that no detail is too small comes from growing up with parents who were researchers. She understands that the most interesting stories linger deep below the surface. You need to be willing to dig to find them, often within yourself. "I have a thousand subjects in my head," Berest said of deciding what to write next. "I go with what seems to take up the most space in my brain.

"After writing three novels, including *Recherche femme parfaite*, which looks at the modern woman's endless search for perfection, and a biography of French novelist Françoise Sagan, Berest told a story that was not only stuck in her head, but is close to her heart, in the book *Gabriële*, which she coauthored with her sister, Claire. It's the story of her great-grandmother Gabriële Buffet, who Berest says, was one of the founders of the modern art movement. Haven't heard of her? Berest isn't surprised, but she is ready to share Gabriële's life with the world. Not to mention her own life, which includes nights filled with oysters and art deco swimming pools. Luckily, now yours can, too.

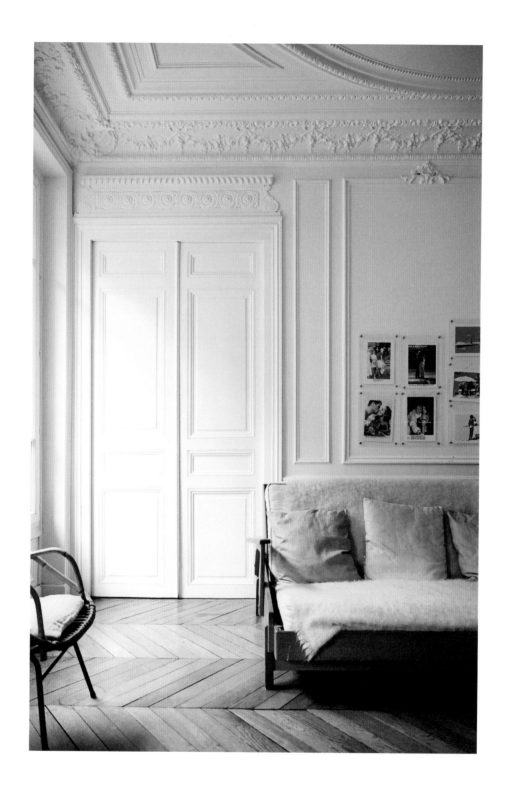

Like many people who grew up in the suburbs, you said you were bored as a child and always dreamed of moving to Paris. Did you always dream of becoming a writer?

I always wanted to be a writer, well before I actually was a writer. It was a profession I wanted to pursue for the costume in the same way a little boy wants to be a fireman. It seemed to me that writers led extraordinary lives. I thought all writers really lived the lives they wrote about in their books. That's what attracted me.

How has living in Paris influenced your work?

Paris is a city where the past is very present. The streets, the buildings, the paving stones—it all breathes the city's history. The city is so beautiful that almost every day, on a bridge or the corner of a street, I'll be amazed by the beauty and grace of the place.

Paris is a city that revels in its cultural past, but some are wondering about its future. Since the attacks on Paris, both Charlie Hebdo and the Bataclan, what has been the biggest change you've seen in the city? How do you think it will affect the art and literature community?

A lot has changed; fear has taken hold. I would say that in literature, I'm not sure, but I think the books to come will be about things that are more serious or more political.

After reading your work, it's clear you have a knack for writing about strong, creative women. What is it about these women that makes you want to put pen to paper?

Women are my favorite subject. Why? Undoubtedly it's a way to talk about myself. Writers speak only about themselves, even when they describe the construction of a bridge.

You cowrote a book about your great-grandmother Gabriële Buffet with your sister. Why did you want to write about her?

I wanted to write a book with my sister. That was the starting-off point, to find a subject that would allow us to work together.

I know Gabriële passed away in 1985 when you were young, but did you know about her amazing life?

No, my mother never spoke to us about her because she was upset with her. Gabriële was a great teacher and an incredible friend. However, she was not always there for her children and grandchildren, so we did not have a relationship with her, unfortunately. We did not know anything about her history and only learned about it from writing the book.

Let's start from the beginning, then. Where did Gabriële grow up?

Gabriële lived in the mountains, and she liked the solitude of long walks. She had a gift for music from very early on in her life, but she was not from a musical family.

I read that Gabriële was the first woman to be accepted into a composition class at the Schola Cantorum, the private music conservatory founded in 1894, and that in her 104 years she was not only an experimental musician, but also a writer and art critic. Often, though,

she is simply described as the first wife of painter Francis Picabia. How did that change her life?

She stopped experimenting with music when she met her first husband. With him, she invented modern art. It was an extraordinary adventure—intellectually and in love.

You've said that a big part of this book is in exploring Gabriële's role in founding the modern art movement. It's something I hadn't heard before. How did you come to this conclusion?

It's difficult to summarize it in one sentence, but she invented it through the influence she had on her husband, Francis Picabia, and her lover Marcel Duchamp. She was an integral part of the Dada movement.

You've described Gabriële as the "mistress of Marcel Duchamp." Why is that important to her story?

It's not only important to hers, but his, too! She inspired much of his work.

Why is it that we haven't heard more about her in art history books?

Because men write the history of art, and we've discovered that they often, very often, forget to acknowledge what women have done in the field. In the last twenty years, things have started to change, and we're discovering, little by little, these forgotten personalities.

Being that Gabriële's life is one that hasn't really been examined, is there something you'd like people to know about her before they read your book?

She was a woman who had men worshiping at her feet. Not because of her beauty or her wealth, but because of her intelligence. Not bad, no?

Certainly not. Your book How to Be Parisian Wherever You Are is a guide to Paris for those who don't live there, but as someone who does, what would your perfect day in Paris look like?

I prefer the night. I love Paris at night, the celebration. My friends like to dress up, hang out, and talk late into the night around a plate of oysters.

For those who come to Paris looking to discover something new they wouldn't necessarily find in the guidebooks, is there a hidden gem you'd suggest checking out?

La piscine de Pontoise. The swimming pool is a historical landmark, thanks to its art deco décor. It's open every day, even Sunday, until midnight, for those who want to go for a night swim.

What is the one piece of advice you'd give to any tourist visiting Paris for the first time?

Parisians are not very nice at first, unfortunately.

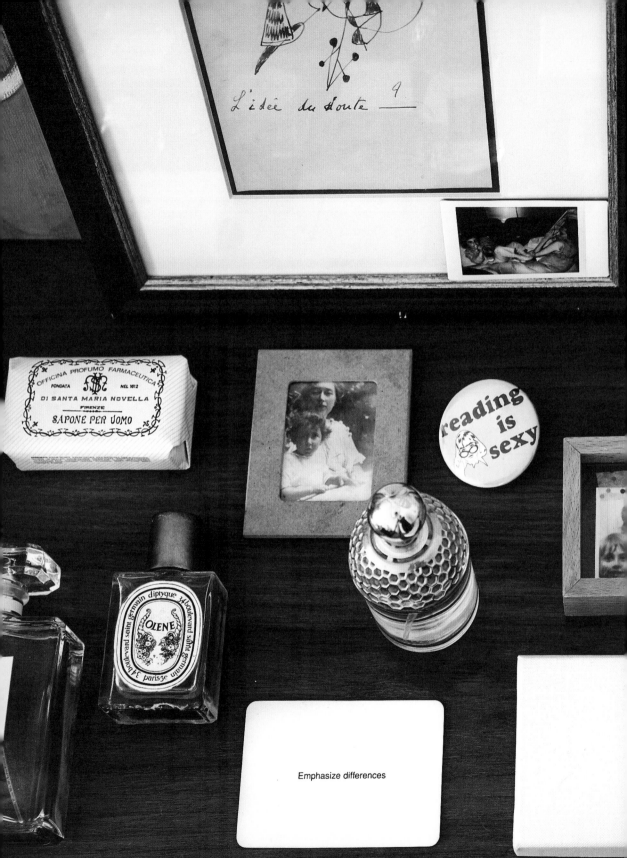

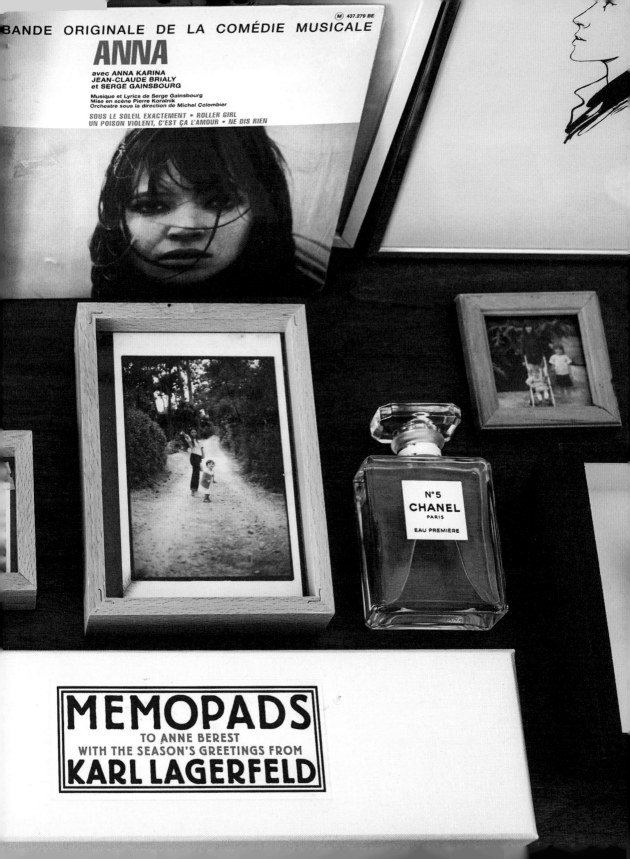

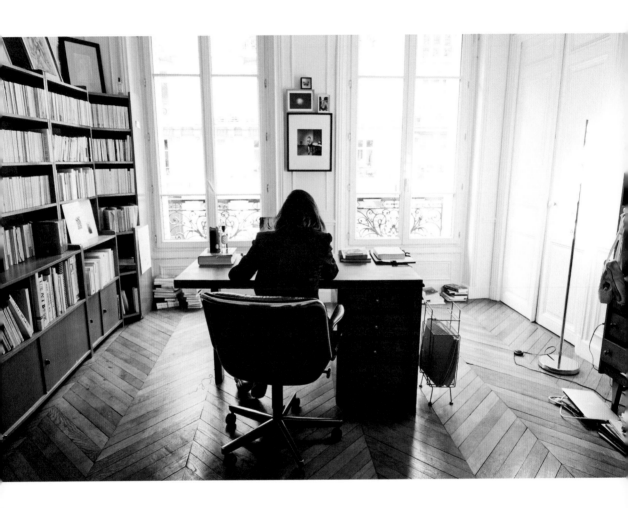

Anne's Favorite Places to Celebrate the Launch of a New Book in Paris

"**Chez Castel**, for drinking cocktails. If you manage to get in, because the place is very select, you can sip a cocktail prepared in this mythical place where all the writers used to drink in the old days."

"**La Mano**. It's the best place to go dancing in Paris. The music is excellent, and the clientele are there to drink as much as they are to dance. It's a joyful way to spend an evening, but getting in can be difficult."

"**Roger la Grenouille**. It was a Paris institution where the artists would go to taste frog legs. Today, the menu has been updated and the food is very good—not just the frog. The drinks are also delicious."

"**Hôtel Amour** for brunch. For over ten years, this place has been considered trendy. Cozy and chic, it's a place where you can find a mixture of artists, neighborhood families, and models, especially during fashion week, when they stay in the hotel. The brunch is very enjoyable."

"**L'Alcazar**. In the seventies, it was a very famous cabaret. It's since been redone, including the menu, which has vegetarian options. Delicious. The place is large, so it can accommodate big groups."

@anneberest

Drawing Inspiration

Paris has long been a magnet for artists of all kinds. It's not hard to see why, when you stroll down the Grands Boulevards, take a break in a lush public park, or visit one of the many museums. To follow in their footsteps, stock up on supplies at one of the historic shops along the banks of the Seine—**Sennelier**, **Charvin**, and **Charbonnel**—then try your hand at capturing the light from the willow-lined banks of the Île de la Cité or in a live figure-drawing class at **Académie de la Grande Chaumière**.

CAT SETO

The **Jardin des Plantes**, or Botanical Gardens, inspire me to my core. This illustration comes from a day of wandering bookshops and pâtisseries, filling my mind and belly, and ultimately landing in the gardens to sketch within the beautiful hothouses. It is an artist's oasis in the city.

catseto.com
@paristosf

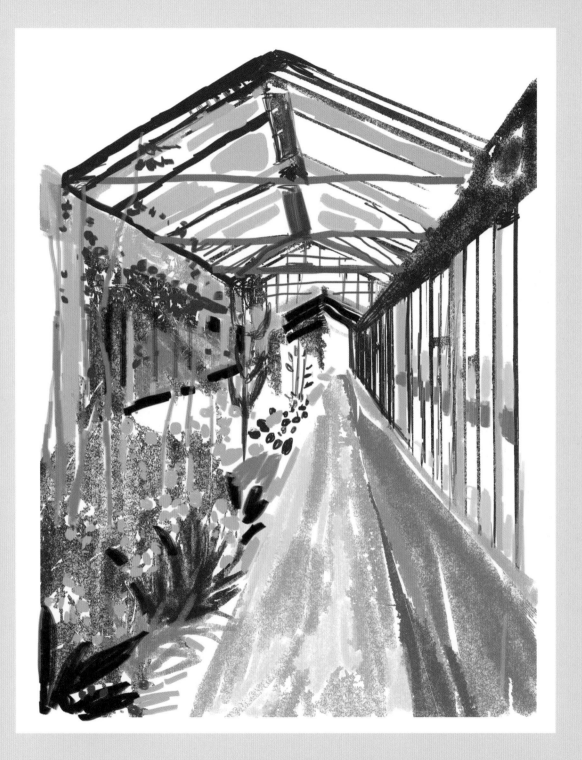

Illustration from *Impressions of Paris: An Artist's Sketchbook*

33

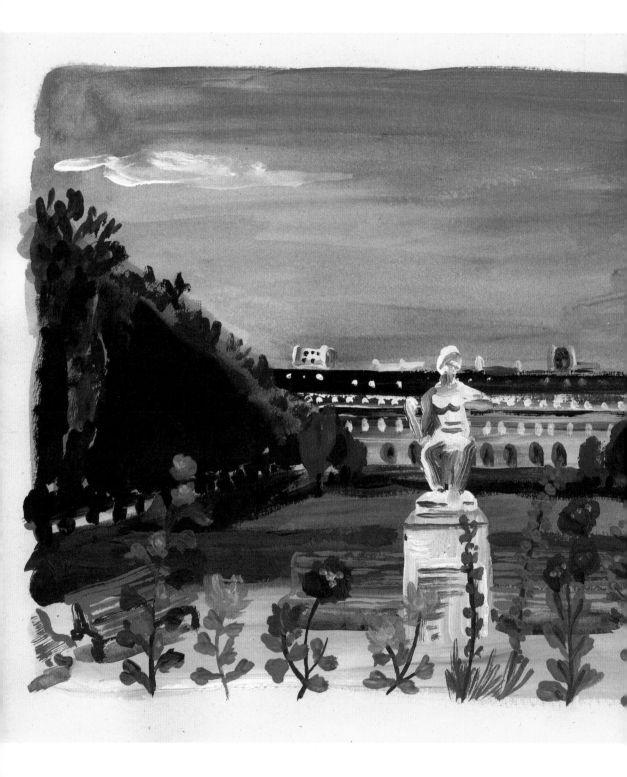

NATHALIE LÉTÉ

I always try to find areas in Paris where I can feel less stressed by the people and where I can enjoy the feeling of an "old Paris" atmosphere. **The Palais-Royal** garden is one of these places where time seems to have stopped.

nathalie-lete.com
@nathalie_lete

ANJA RIEBENSAHM

When I moved to Paris by myself right after high school, I was often very lonely. But it was the kind of loneliness that could be soothed by a *tarte au citron*. I ate one every day until my French improved and I had made some friends. By then, I was hooked and kept eating them. All the weight I gained that magical year was from lemon cream and butter crusts, and the landmarks I remember most fondly are the ones that I visited with my trusted pastry in hand: strolls through **the Orangerie**, sitting by the pond in the **Jardin du Luxembourg**, or pausing for a private picnic on the **Pont Neuf**."

anjariebensahm.com
@dasbrooklyn

MARIE DOAZAN

Everything inspires me in the Parisian streets. When I hang out on the terrace, I love to observe colors: the powerful red of a chair, a bike's dark blue, or even the pale pink of a peony.

@mariedoz

STEFFIE BROCOLI

Paris is known worldwide for its monuments, but they are always full of tourists. When I pass by on my bike they make me feel like a tourist, too. But these places also remind me that I live in the most beautiful city in the world, and how lucky I am to live here. So, with these six tiny paintings, I wanted to pay tribute to Paris—this city that I love as much as I hate.

steffiebrocoli.com
@steffiebrocoli

SCULPTING

A LANGUAGE

A STATE OF INTERPRETATION
VIA ARTIST SAMIR MOUGAS

By Nic Annette Miller

Just as science fiction novelist William Gibson would draft one of his novels—conceptualizing an environment with shapes, colors, and habits for his characters before composing the narrative—Samir Mougas first sketches 3-D digital models that later become large-scale, abstract sculptures with a thoughtful, atmospheric quality. Mougas takes a break from his work and offers an explanation of his esoteric point of view.

How do you communicate through sculpture?

I really believe that art is a language of its own—a language with no grammar, no rules, no structure. It is a language invented as a reaction to everyday experiences in the world. Art is a language because people need to decipher it to get something out of it. But we cannot control what people get out of artwork, of course. We are just making it. If my work can make you feel something, that's a reaction without verbal language.

Talk more about your science fiction inspiration. How is it conveyed in your artwork?

Science fiction novels, music, computer graphics, and archaeology are a few of my inspirations. I think it's important to create work that conveys an almost otherworldly encounter, something that can't be fully understood. This approach relies heavily on technology.

Do you always render your work as a sketch before starting a sculpture?

Using a 3-D computer program is absolute freedom. With the computer, you can create anything at any time. But as soon as you go back to the studio and deal with actual materials and actual tools, you start to narrow down your choices. Everything you do can only build on the previous choices you made. Trying to connect the overwhelming possibilities in terms of textures and shape manipulation available on the computer to the rigorous approach to sculpture in my studio is a compelling exercise. One of my pieces was produced with an aluminum cast and painted chrome so that it mirrors everything. It is a concrete example of what is possible to achieve with sculpture modeling today.

Your solo show, .TECHNO at Galerie Eric Mouchet, received a lot of praise. It seemed so meticulously conceived, even down to the title itself. What's your concept to execution process?

I've exhibited in Paris before, but always in group shows. This solo exhibition was a very big thing for me, and I created new work based on an idea I've had for a while. The show was called **.TECHNO**, written in caps, bold, italic, and underlined. The title refers to my fascination with electronic music and the notion of creating with a computer. The edits made on the word techno shows that it's all about adding layers, whether they are edits via software or marks made with tools on real materials.

43

Photo: Samir Mougas

There were two human-size aluminum casts in the exhibition space, and a group of sculptures displayed on the gallery walls. The show had a technological atmosphere, though there were no glimpses of software anywhere.

<u>Tell us more about your life as an artist in Paris.</u>

I was a resident in La Cité Internationale des Arts for a year. It's a place made for artists to spend some time in the city, both to work and to develop a network by meeting curators, gallerists, art critics, or other artists. It's hard to get in, due to the high number of applications coming from France and abroad. There are no guidelines for this residency; artists are free to use it as they see fit. I used it to invite people for studio visits. This allowed me to introduce my work with the hope of getting into a couple of shows. That's how I managed to meet a gallerist who was interested in my work and invited me to do a solo show.

Like Marcel Duchamp, Louise Bourgeois, and other avant-garde artists before him, Samir Mougas has found Paris to be fertile ground for the development of his art and ideas.

samir-mougas.net
@samir_mougas

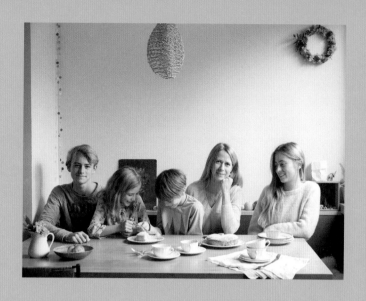

Cécile Molinié Is Living Her Best Life & Not Just on Instagram

Everyday life in the 5th arrondissement looks as pretty
as a picture for this mother and photographer

By Shannon Carlin

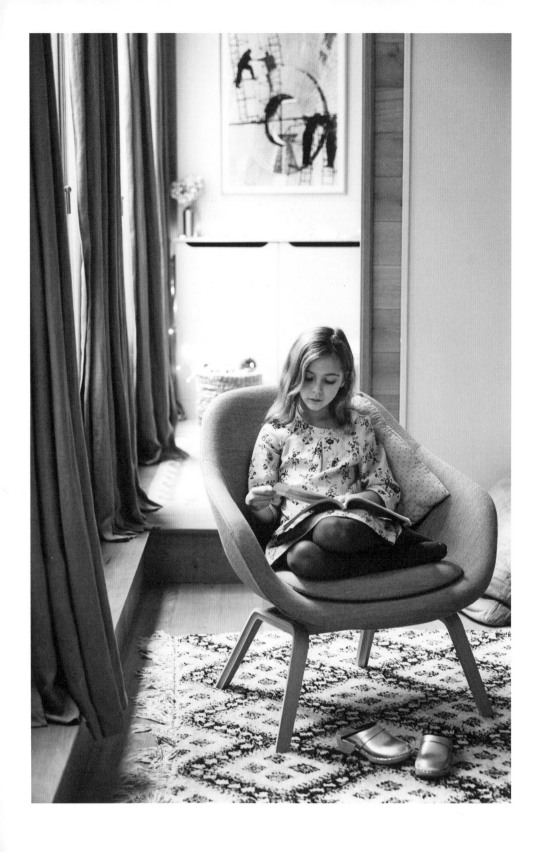

Cécile Molinié, a former lawyer who now works as an artistic director and photographer for brands like the jeweler Chaumet, lets you discover an intimate, homey side of Paris through the images she makes. Follow her at @cecilemoli on Instagram and you'll see her daughter's ballet class, oranges from the local market, and the too-pretty-to-actually-eat crème caramel she's just made.

Since 2014, Molinié, whose four children range from ten to twenty years old, has used her photography skills to show us glimpses of a life in Paris. Having grown up in a small French village, Molinié still enjoys life's simple pleasures. It's the little things that make her work stand out—her love of flowers, old buildings, and time spent with her kids. Molinié sincerely loves the life she lives, and she allows us to love it, too.

You were a lawyer, and after having kids you decided to go in a more artistic direction. In what ways has being a mom influenced your creativity?

I've always had this creative side. I like colors, fabrics, and patterns—and children. From how you dress them to how you design their bedroom, raising children is a gold mine for creativity. Twenty years ago, there was not as much choice as there is now for children's fashion or interior design, so I went to flea markets. I bought fabrics near Montmartre and started to create my own children's clothes with the colors and shapes I loved. Same thing for their bedrooms: I made the sheets, dyed old linen. It is in this way that you can say that my children made me creative again. Then food, too. How could I make greens attractive enough for kids to eat, or bake a nice cake with my children? And, of course, photography. Who can resist taking pictures of children?

Your Instagram shows an artistic side of motherhood that doesn't get a whole lot of attention. Was that a conscious decision?

Maybe it wasn't conscious, but yes, some of the daily and unavoidable tasks like meal prep or washing the dishes are part of everyone's life, and somehow you can find beauty in them. It's also true that I wouldn't like to impress people with a perfect life, because it simply doesn't exist! But nothing pleases me more than when people tell me a photo made their day, reminded them of their childhood. As much as I like perfectly styled photographs, I always prefer to let in a little bit of natural chaos, like a bandage on a knee. It feels more genuine.

When people talk about life in Paris, the topic of children rarely comes up. What is it like raising kids here?

At first, I found that raising children in Paris was challenging because of the noise everywhere, the cars, no private space in the

public gardens. But, on the other side, you have nursery school, high school, even college, public libraries, and grocery stores within walking distance. In a city, you can be lonely, for sure, but when you have young children, you meet lots of people in the park, at school. I must say that my best friends are all these Parisian moms that I've met in the past twenty years. It was totally new to me to meet so many educated, creative women, all supporting one another. In the countryside, when I was a child, my mother was the only one with a degree, and sometimes felt lonely. But I think that has changed, too.

You said your mom was intellectual, not creative. What was it like growing up with her?

My mother is a psychologist who stopped working when my dad got his PhD in medicine, so she was taking care of us and helping him with his work. I loved the way she was always here for us, supporting us, never upset. My children have only heard her get angry once! She would manage to be obeyed without shouting. We had to help at home, but she always thanked us for what we were doing. She was very encouraging and gave us self-confidence. She is a real intellectual and shared with us a love of books and the importance of thinking for yourself. In a way, my mother gave me a freedom to create that has never left me.

What is the importance of food and family in your home?

Food and family are often linked, as you need to feed your children and feed them well. Meals are also a happy moment when we share our day, impressions, ideas. I think the link between food and family is not that obvious in Paris, at least with very little children, but it happens in the markets where local producers give little bits of bread, cheese, vegetables, or fruits to the children. Markets are so colorful and tempting that I think it is a very good idea to take your children there. When they grow up and are patient enough to wait for their food and curious enough to try new flavors, Paris is full of restaurants. Maybe I'm old-fashioned, but I think there is a moment for everything in life and that you can't enjoy the same things with toddlers as you do with grown-up children.

Where are the best places in Paris to take children?

You must try the **Eiffel Tower** or **Montparnasse tower,** a boat ride on the river Seine, a stop in a public garden for the kids to breathe and play. I am really fond of all the artist's studios or houses you can visit in Paris.

There are a lot of stereotypes about Paris and its people being rude or abrupt. Is that true, and if so, why?

As a former *provinciale*, meaning everybody from France except Paris, I was at first shocked by the abruptness of people in Paris. Everyone is rushing in his or her own way, not paying attention to the others. It was so different from my life in a quiet village. Lots of French people don't understand why the Parisians are so stressed, but a working life in Paris is very exhausting. Most of those who work in the city, especially in the tourist sector, can't afford to live within the city of Paris and have a very long commute. And most tourists don't even try to understand

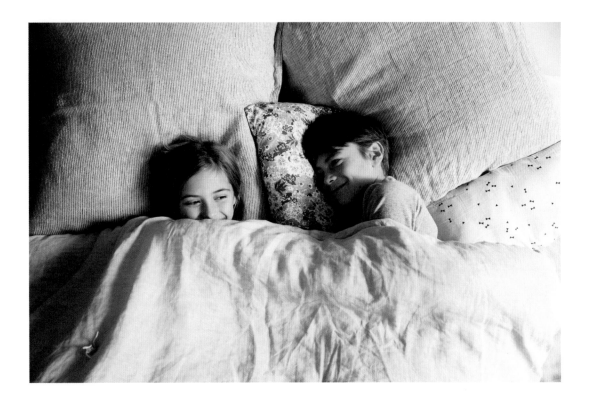

the culture behind the city, the people's lives. Parisians are not as enthusiastic as people in the United States, nor as welcoming as those everywhere else in France. You can feel judged in a trendy café, but you mustn't pay any attention. You should read *Parisian Sketches* by Henry James or any novel by Balzac set in Paris. I recently read *Lost Illusions*, and found that people have not changed.

CÉCILE'S FAVORITE PARISIAN MUSEUMS TO VISIT WITH CHILDREN

Musée Bourdelle
Musée de Montmartre
Musée Grévin
Musée Gustave Moreau
Musée National Eugène-Delacroix
Musée Victor Hugo

vsco.co/cecilemolinie
@seemyparis
@cecilemoli

Bruno Albizzati, Painter

By Tania Strauss

If you thought the tradition of artists in light-filled attics overlooking the city's rooftops was a thing of the past, think again. Bruno Albizzati works on his abstract paintings and drawings in one such studio just a stone's throw from the trendy Rue des Martyrs in the 9th arrondissement. As a matter of fact, when the building was designed in the 1800s, the architect expressly designed the top floor as an atelier, with double-height, north-facing windows. Apparently, this was a common practice at the time—architects of today, take note.

Bruno invites us for a visit to his airy workspace and shares a few of his favorite artistic spots in the city.

FIVE QUESTIONS

What was it like to grow up in Paris?
It's a beautiful place to discover the arts. I was always going to galleries and museums, which eventually led to me becoming an artist.

Where do you go for art supplies?
I go to **Adam Montmartre, Boesner,** or **Sennelier** for their large selection of papers, since much of my work is on paper. They also have paints, pencils, and all kinds of art supplies.

How does Paris inspire you?
I'm inspired by its history, and by the way one can physically and visually experience the city, and by its diversity and theatricality.

What do you love about your neighborhood?
I live in the 9th arrondissement, between Pigalle and Saint-Georges. I like the lively ambiance, the beautiful facades of the buildings, and the unusual perspectives that you find—such as the sight of **Sacré-Coeur** behind l'Eglise Notre-Dame de Lorette as you're walking up Rue Laffitte.

Where in your neighborhood would you recommend to eat and drink?
Ito is great Japanese restaurant, though it doesn't serve sushi. For French food, I like **Richer** and **Le Caillebotte**. **Artisan** is a good cocktail bar.

brunoalbizzati.com
@brunoalbizzati

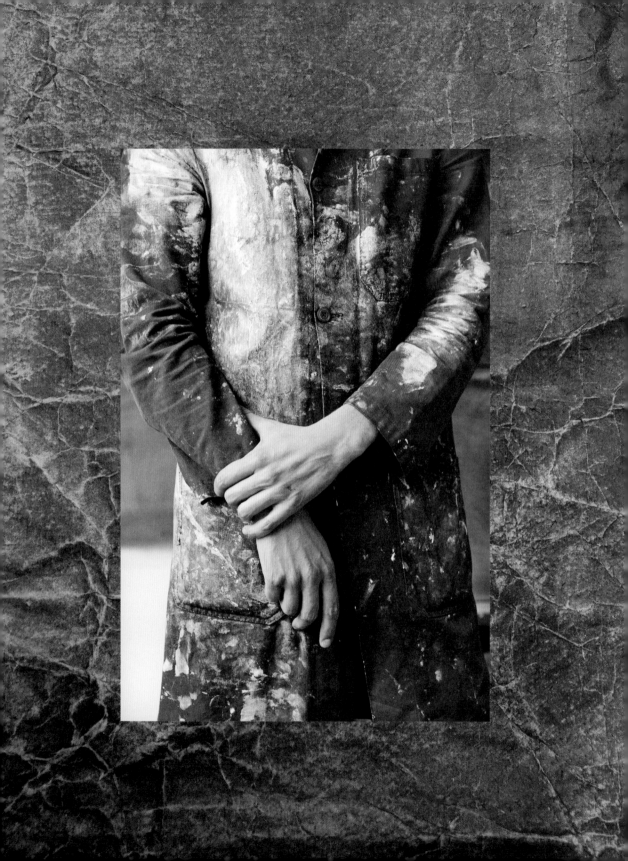

BRUNO'S FAVORITE ART GALLERIES AND MUSEUMS IN PARIS

Galleries
Galerie Escougnou-Cetraro
Galerie Jérôme Pauchant
Galerie Karsten Greve
Galerie La Forest Divonne,
 which represents Bruno's work
Galerie Laurent Godin
Galerie Thaddaeus Ropac
Galerie Untilthen

Museums
Centre Pompidou
Galerie Nationale du Jeu de Paume
La Maison Rouge
Le Louvre
Musée d'Art Moderne de la Ville de Paris
Musée de l'Orangerie
Musée de la Vie Romantique
Musée d'Orsay
Musée National Eugène-Delacroix
Musée National Picasso-Paris
Musée Rodin
Palais de Tokyo

INTERLUDE:
JUAN JEREZ,
PHOTOGRAPHER

Photo: Juan Jerez

Born in Spain, photographer Juan Jerez moved to Paris by way of Rome seven years ago and hasn't looked back. He feels that between the city's long cultural history and the dynamic rhythm of contemporary cafés, concert halls, and cultural centers, there's always something new to capture with his camera. His light-filled images of the Paris streets have caught the interest of clients like Condé Nast, Apple, and Nikon.

Juan lives in the 11th arrondissement, which, with its narrow streets, ancient courtyards, and artists ateliers, can seem like a village. "Sometimes I feel I live in a little town where everybody knows each other. After the terrorist attacks in 2015 (which took place here in the 11th), I thought things would change, but I was wrong. I have to say that I'm really proud of peoples' reactions. Everybody seems more united, and the solidarity with the victims was exemplary."

Back on the streets not long after the attacks, Juan has continued to stand by his adopted hometown, camera always at the ready.

I usually listen to records while I'm editing my photographs, but it's mostly while I'm taking them that music inspires me. I often listen to the same song over and over again while I'm walking along the streets of an unknown city or waiting for the decisive moment in a fixed location.

Music helps me to mix abstraction and concentration and to enter into a sort of *état second* in which I forget myself and concentrate on what is outside. I didn't know how to describe it until I ran across a text by the Spanish writer Esther García Llovet about the work of the American photographer Louis Faurer: *Durante unas horas no hemos sido reales, solo ha sido real lo que hay fuera y no hay nada en el mundo mejor que eso* ("For a few hours we haven't been real, only what is outside has been real, and there is nothing better in the world than that").

Most of the songs on my list are related to important moments in my life, such as my departure from Italy ("This Must Be the Place," Talking Heads), my arrival in Paris ("La valse à mille temps," Jacques Brel), experiencing love in the city of Light ("Ultimo amore," Vinicio Capossela), or my infinite nostalgia for my homeland ("La Leyenda del Tiempo," Camarón de la Isla).

—Juan

Juan's studio playlist

"La Leyenda del Tiempo," Camarón de la Isla, *Integral (Remastered)*
"Le vent nous portera," Sophie Hunger, *1983*
"La valse à mille temps," Jacques Brel, *La Valse à Mille Temps*
"Reckoner," Radiohead, *In Rainbows*
"One Sunday Morning (Song for Jane Smiley's Boyfriend)," Wilco,
 The Whole Love
"Ultimo amore," Vinicio Capossela, *Modì*
"Samba en Preludo," Maria Creuza, Toquinho, and Vinícius de
 Moraes, *Chants du Brésil*
"La Javanaise," Serge Gainsbourg, *Bonny and Clyde*
"This Must Be the Place," Talking Heads, *Speaking in Tongues*
"L'amour est un oiseau rebelle," sung by Maria Callas, Bizet, *Carmen*

You can listen to Juan's playlist on Spotify at
 https://spoti.fi/2DZwdEL

juanjerezphotos.com
@juanjerez

ITINERARY:

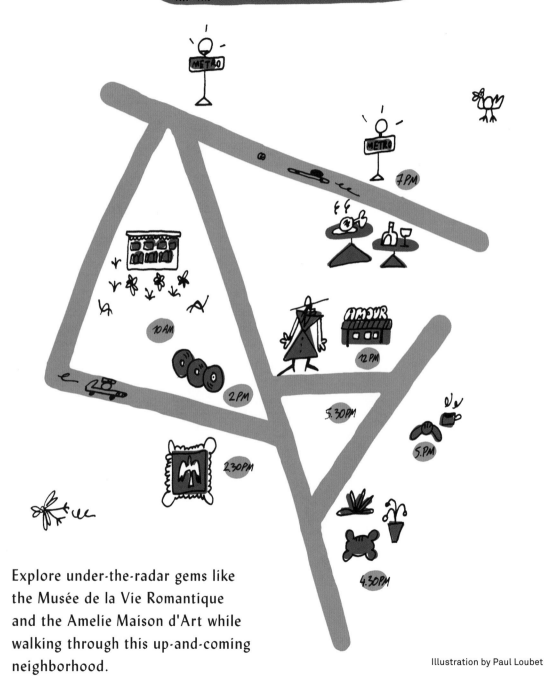

AN ARTFUL DAY IN SAINT-GEORGES

METRO

METRO

7 PM

AMOUR

10 AM

12 PM

5.30 PM

2 PM

5. PM

2.30 PM

4.30 PM

Explore under-the-radar gems like the Musée de la Vie Romantique and the Amelie Maison d'Art while walking through this up-and-coming neighborhood.

Illustration by Paul Loubet

Saint-Georges, or SoPi (South Pigalle), is a small neighborhood tucked between its more strident neighbors of Pigalle to the north and Opéra/Les Grand Magasins to the south. But don't let its understated facade fool you—on a recent trip, I found this *quartier* to be a gold mine of small museums, delicious food, and stylish shops. The hordes of tourists you'll encounter in the Marais or Saint-Germain haven't discovered this little corner of Paris yet—but that will probably change soon.

Tip: Don't follow this itinerary on Monday or Tuesday, when one or both of the museums are closed.

10:00 A.M.

Begin your day at la **Musée de la Vie Romantique**. Visit this beguiling museum in the warmer months, when you can better enjoy the garden courtyard. But even in winter, the exhibits in the "Museum of Romantic Life" charm visitors—I was fascinated by the elaborate wall treatments.
16 rue Chaptal, 75009
+33 1 55 31 95 67

12:00 P.M.

Lucky for you, **the Rose Bakery** recently opened an outpost at la Musée de la Vie Romantique, so you don't have to go far for a delicious lunch. Known for their earthy salads, roasted vegetables, and English-inspired cakes, the only issue will be narrowing down your order.
16 rue Chaptal, 75009
+33 1 42 82 12 80

Alternatively, on the weekend you could hit up **Hôtel Amour**. As writer Anne Berest tells us on page 31, this is a perennial favorite among the fashion crowd for brunch among red velvet chairs, checkerboard tiles, and lush greenery.
8 rue de Navarin, 75009
+33 1 48 78 31 80

2:00 P.M.

With a wide selection and affordable prices, you're sure to find a gem digging through the racks at **Plus de Bruit**, a popular local record shop.
35 rue de la Rochefoucauld, 75009
+33 1 49 70 08 70

2:30 P.M.

Occupying the mansion and studio where Symbolist painter Gustave Moreau lived, the **Musée Gustave Moreau** holds a dizzying number of his paintings and drawings. After touring the first-floor apartment where he lived with his family, ascend to the spectacular two-floor studio with its coral walls and ornate spiral stair-case. Twelve hundred paintings line the walls, and five thousand drawings fill the cabinets and cupboards.
14 rue de la Rochefoucauld, 75009
+33 1 48 74 38 50

4:30 P.M.

Designed in Paris and made in India using eco-friendly techniques, **Jamini's** textiles prove that sustainability and artistry can coexist.
10 rue Notre Dame de Lorette, 75009
+33 9 83 88 91 06

5:00 P.M.

Time for a tasty little snack at **Sébastien Gaudard**— food and drink editor Rebekah Peppler recommends the croissants. But you'll also love taking in the tumbling block-patterned tile, pale blue cabinets, and crisp black-and-white packaging. *Classique.*
22 rue des Martyrs, 75009
+33 1 71 18 24 70

5:30 P.M.

Amélie du Chalard's goal with Amelie Maison d'Art, her gallery (or "house of art," as she prefers to call it), is to make the experience of buying art less intimidating. Instead of a traditional white box, Amelie Maison d'Art is outfitted like an apartment, complete with gorgeous art that's all for sale.
8-10 rue Clauzel, 75009
+33 7 87 02 00 89
By appointment only.

7:00 P.M.

Le Pigalle is a beautiful restaurant and bar located in the renovated Hotel Pigalle. It serves a dozen different wines by the glass and a refreshingly bright menu from Camille Fourmont (of La Buvette in the 11th).
9 rue Frochot, 75009
+33 1 48 78 37 14

MORE PARISIAN BOOKS, SONGS, FILMS, ETC. THAT WE LOVE

BOOKS

Americans in Paris: A Literary Anthology by Adam Gopnik

Bonjour Paris and *Bonsoir Paris* by Marin Montagut

The Elegance of the Hedgehog by Muriel Barbery

How to Be Parisian Wherever You Are: Love, Style, and Bad Habits by Anne Berest, Audrey Diwan, Caroline de Maigret, and Sophie Mas

The Invention of Hugo Cabret by Brian Selznick

Les Misérables by Victor Hugo

Les Parisiennes: How the Women of Paris Lived, Loved, and Died under Nazi Occupation by Anne Sebba

Linnea in Monet's Garden by Christina Björk

Madeline by Ludwig Bemelmans

Me Talk Pretty One Day by David Sedaris

My Life in France by Alex Prud'homme and Julia Child

My Paris Dream: An Education in Style, Slang, and Seduction in the Great City on the Seine by Kate Betts

Paris, I Love You But You're Bringing Me Down by Rosecrans Baldwin

Paris in Winter by David Coggins

Paris to the Moon by Adam Gopnik

The Paris Wife by Paula McLain

A Short History of Cahiers du Cinema by Emilie Bickerton

A Tale of Two Cities by Charles Dickens

Tender Is the Night by F. Scott Fitzgerald

MAGAZINES

Architectural Digest France
Crash
ELLE Décoration
Holiday
Marie Claire Maison
Milk Decoration
Milk Magazine
L'Officiel
Rika

FILMS

Amélie
An American in Paris
Avenue Montaigne
Breathless
Charade
Cléo from 5 to 7
Funny Face
Hugo
Marie Antoinette
Midnight in Paris
Ratatouille
The Red Balloon
Sabrina
The Triplets of Belleville
La Vie en Rose

SONGS

"Sous le soleil exactement," Serge Gainsbourg, *Serge Gainsbourg & Jane Birkin*
"Voilà," Françoise Hardy, *Ma jeunesse est fou le camp*
"Fences," Phoenix, *Wolfgang Amadeus Phoenix*
"Kelly Watch the Stars," Air, *Moon Safari*
"Rest," Charlotte Gainsbourg, *Rest*
"La Madrague," Brigitte Bardot, *Brigitte Bardot*
"Verlaine," Charles Trenet, *Y'a d'la Joie: Best of*
"Baby C'est Vous," Sylvie Vartan, *Sylvie Vartan, Vol.1*
"Une fraction de seconde," Holden, *Pedrolira*
"La Vie en Rose," Louis Armstrong, *The Best of the Decca Years Volume 1: The Singer*
"I Love Paris," Ella Fitzgerald, *Ella Fitzgerald Sings the Cole Porter Songbook*
"Je fais le mort," Juniore, *Juniore*
"Non, je ne regrette rien," Edith Piaf, *The Best of Edith Piaf*

You can listen to this Paris-inspired playlist on Spotify at https://spoti.fi/2p1qd4j.

Anne Berest's office

Twenty-Four Instagram Accounts to Follow for Art in Paris

ARTISTS

@brunoalbizzati
@frenchisbeautiful
@hebdomania
@ineslongevial
@jesuisclaraluciani
@liarochasparis
@mariedoz
@michelgondry
@paradisfm
@paulloubet
@saskiadebrauw
@sophieguillouart
@vincentdesailly

CLASSES

@studiomrg
@yannicksuznjev

GALLERIES

@alminerechgallery
@florenceloewy
@galeriederouillon

MUSEUMS

@centrepompidou
@museelouvre
@museepicassoparis
@palaisdetokyo

VENUES

@lamano.paris
@lecomptoirgeneral

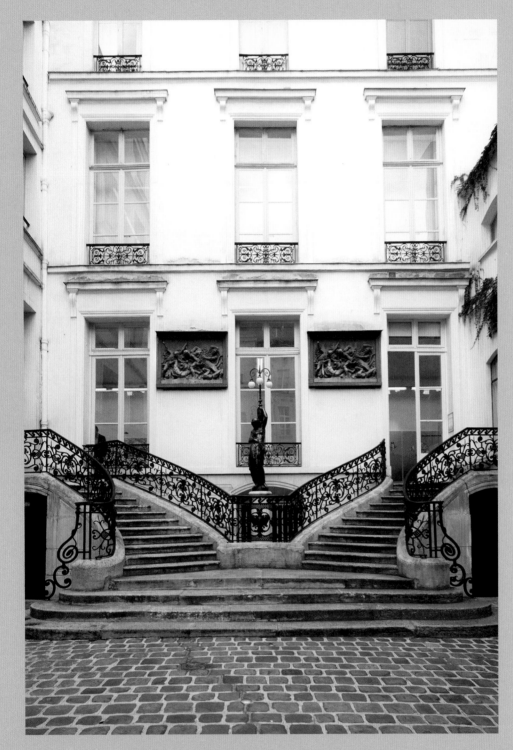

Galerie Karsten Greve

Design

There's no shortage of design inspiration in Paris—everything from contemporary paper goods in high-end boutiques to antique furniture at the flea market. Keep reading to find recommendations for well-designed souvenirs from the City of Light, an interview with Papier Tigre cofounder Maxime Brenon, and a trip to scout antiques at the **Paris flea market** with artist and author of the *Bonjour/Bonsoir Paris* series Marin Montagut. Studio Plastac recommends their favorites in the local design scene, and Fulbright scholar Jaimie Stettin tells us about the history and meaning behind a series of graphic *buvards*. The fast-expanding Parisian design brand OMY shares their story and a music playlist with writer (and former roadie) Erin Austen Abbott, along with a map of Paris they designed that the kid in your life will love to color (if you don't beat them to it). Then I'm letting you in on my favorite itinerary for classic design in the elegant Saint-Germain district and giving you another Instagram list—this time for our top Paris-based design feeds.

"It seemed
that in Paris
you could discuss
classic literature
or architecture

or great music
with everyone
from the garbage
collector to the
mayor."

JULIA CHILD

Souvenirs from Paris

THE BEST MEMENTOS FROM FRANCE'S SOPHISTICATED CAPITAL—ALL SMALL ENOUGH TO FIT IN YOUR CARRY-ON

Clockwise from top left: Caran d'Ache 849 metal ballpoint pen (fahrneyspens.com; $25). Le Chocolat des Français dark 70% chocolate bar (lechocolatdesfrancais.fr; $6). Buly 1803 scented matches (buly1803.com; $16). Vintage ribbon brooch (Porte de Vanves Flea Market; $8). Cousu de Fil Blanc artisanal soap (cousudefilblanc.com; $13). Buly 1803 Pomade Concrète (buly1803.com; $38). Macon et Lesquoy handembroidered Palm brooch (maconetlesquoy.com; $43). Vintage box of clips (Porte de Vanves Flea Market; $5). Le Labo Vanille 44 eau de parfum (lelabofragrances.com; $78).

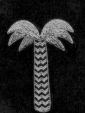
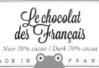

Le chocolat des Français
Noir 70% cacao / Dark 70% cocoa

MADE IN FRANCE

PARIS

PARIS

PARIS

PARIS

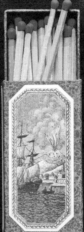

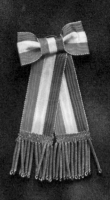

POUR VOS DOSSIERS...
La Pince "ACLÉ"
Breveté S.G.D.G.
BOITE Nº 2
10 pinces — 1 paire de clés

VANILLE 44

eau de parfum / vaporisateur
natural spray

Compounded in Paris by
2G/10/16
Chaunté

LE LABO Paris

100 g - 3.5 oz
cousu de fil blanc
SAVON ARTISANAL
À l'huile d'argan
vegan oil soap
MADE IN FRANCE

Eye of the Tiger

Maxime Brenon and his stationery
brand Papier Tigre are on the rise

With brick-and-mortar shops in Paris and Tokyo, along with hundreds of stockists worldwide, Papier Tigre is growing fast. Their smart, colorful paper goods are playful yet sophisticated and range from greeting cards to notebooks to wallpaper. As someone who worked in the paper goods industry for a decade, I can tell you it's rare for a brand to come along with such fresh, original designs as Papier Tigre. The first time I laid eyes on their work, I knew it was something special. But when Maxime Brenon and his partners, Julien Crespel and Agathe Demoulin, created their first products in 2012, they had no idea if they'd sell a single thing.

Maxime explains how they found success from the start, the unexpected (yet highly inspiring) job he had before Papier Tigre, and lets us in on where they're going next.

You and your partners started Papier Tigre when you were asked to join a retail show in Paris, and were soon picked up by prestigious stockists like Le Bon Marché and Colette. Were you surprised at how quickly Papier Tigre took off?

Of course! There was no guarantee at all that this would be a hit! We've been lucky, or maybe knew how to create good luck. We did show samples to some very important buyers, and they trusted us. With their first order, we had enough money to pay our suppliers and start our first mass productions.

What sorts of challenges have you had to overcome in growing your business?

Having a growing business is not easy, and we knew very quickly that we could not manage our brand by ourselves anymore. Finding the right people is definitely the biggest challenge.

Your flagship shop is in Paris, but you have a second in Tokyo. Why did you decide to open a location there? How similar and/or different is it running a shop in Tokyo vs. Paris?

Ha, things are so different in Paris and Tokyo! The building we have in Japan is amazing—big and beautiful. Service is also very nice, and there is a tea salon. The Japanese market has been very interested in our brand since the beginning—they love our interpretation of stationery. And when they love something, it means they really love it. A Japanese investor helped us a lot with the retail—having a shop is a good start to expanding the brand.

The local team is also Japanese, which make things easier for the local buyers.

The most challenging part is the business strategy between the two countries—with a different culture, different currency, different language, different traditions—it can be difficult. But we have a common taste for graphic design and stationery!

Any plans to open more locations? (We'd love one here in the United States!)

We will concentrate our efforts on online business instead of brick-and-mortar this coming year. We already won an award last year for the best online business in France. We create paper but we sell and market online, how funny and encouraging is that?

The United States is a developing market for us, and we will expand slowly but surely. We are already in the best stationery shops in New York and LA!

Were you always this creative and business-savvy? What was your childhood like?

I grew up on the west coast of France, near the Atlantic Ocean, in a very peaceful town. It was a dreamy life for a kid. We traveled a lot with my parents, and that gave me a great taste for adventure and discoveries. I guess this helps me now as an entrepreneur not to be afraid of challenges. My two business partners, Agathe and Julien, were born in Paris and grew up in creative districts of the city with artistic

parents (graphic designer, architect, trend analyst). I think it gave them this unique sense of aesthetics for their everyday work.

What kind of work did you do before Papier Tigre, and how do you think it prepared you for what you're doing now?

I was working as a product manager for an old French luxury house of silverware—**Christofle.** It was my very first serious job, and it was really challenging. I was young and inexperienced, but they needed someone fresh to make sure this very old and traditional brand could look a bit younger. I worked with very important designers (e.g., Andrée Putman, Ora-ïto), and it was the best school ever! It taught me how long the process could be for launching products, and how technical simple design could be.

What advice would you give someone looking to start a creative business in Paris?

Go! Yes, go! Starting a business is not very complicated. We are lucky to live in one of the most creative and busy cities in the world, and a lot is happening. There are a lot of opportunities.

Do you feel that there is a supportive creative community in Paris? How so?

Of course there is! We, as entrepreneurs, always need advice and always give advice. There is a strong community between brand owners of businesses of the same size. We go for lunches or dinners from time to time and share our experiences.

What's in store for Papier Tigre in the future?

Sooooo many things! We will soon move our office into a larger space, change the existing

shop with a lot of construction to install on-demand printing presses, and develop our online business. And, of course, we are still working on new products, new collaborations—it's all so exciting!

MAXIME'S FAVORITE PLACES FOR DESIGN AND INSPIRATION IN PARIS

Galleries, Museums, and Inspiring Places

Arts Factory
Le galerie Vivienne
Jardin des Plantes
Musée de la Chasse et de la Nature
La Phonogalerie
Sainte-Chapelle

Boutiques

Deyrolle
Ground Zero
Kerzon
Macon & Lesquoy
Steel

Restaurants and Bars

Le Bar à Bulles
Bateau El Alamein
Comptoir Général

papiertigre.fr/en
@papiertigram

HUNTING FOR TREASURE WITH MARIN MONTAGUT

The artist reveals his approach to his career
and his favorite places for flea market finds
during a trip to Saint-Ouen

BY L. SASHA GORA

Marin Montagut looks like he's stepped out of one of his drawings. Dressed in a sturdy sweater, white jeans, and a classic pea coat, he has a notebook tucked under his arm. Neat and minimal, his drawings have enough detail to recognize them instantly, but enough whimsy so they can easily assume the form of protagonists in scenes and stories. They're not too perfect—there is room for a little mess, for lines that are not too straight, which gives them their charm.

But drawings are just one of many things Marin makes. To name a few others, he makes videos, founded and pens the *Bonjour City Map-Guides* (published by Flammarion), runs an online shop (a sort of digital cabinet of curiosities), and manages a production company that collaborates with the grandes dames of French brands. For instance, he created a collection for **Pierre Frey**, the celebrated fabric and wallpaper company, and for **Saint James**, the classic maker of *marinières* (striped Breton shirts), he made a *Bonjour* guide for Normandy, a video, a collection of shirts, as well as scarves and bags based on his drawings. **The Grand Palais** has invited him as a designer to showcase his work.

We met Marin in his adopted hometown, where he shared his love for treasure hunting at the city's most iconic flea markets: **Marché aux Puces de Saint-Ouen**. He fills his apartment in Paris (and country home in Normandy) with the furniture and design objects he sources here—and finds inspiration for his nostalgic product designs while he's at it.

Your work dabbles in so many different mediums that it is hard to use just one word to explain what you do. How do you describe your work?

When an old friend asked me back when I was eighteen what I wanted to do, I replied that I wanted to travel around the world, draw, create, and buy beautiful objects. She looked at me and said, "But that's not a profession." About six months ago, she said to me, "Marin, it is funny, because, in effect, you invented your own profession. Today you are doing exactly what you said you wanted to do when you were eighteen."

I never wanted to choose one single medium ... And it was really when I was around thirty

years old that I was able to consolidate all my different mediums into one craft. So today, when someone asks me what I do, I laugh and joke that I don't like answering this question. I say that I work with beautiful things, and I like creating beautiful things. It could be with design or illustration or anything. But what is most important is transcribing my universe.

What brought you to Paris?

I arrived in Paris when I was nineteen. It was obvious for me to come to Paris to look for art, crafts, and the trades I wanted to do. When I arrived in Paris, I didn't have an adjustment period—it was like Paris was my hometown, like I was born here. I felt so at ease in this city.

So I started opening doors—the doors of artisan workshops and flea markets. I really discovered the city through encounters with Parisians. It is wonderful to get to know a city like Paris through its inhabitants who share their creations in their shops.

What keeps you here?

Today I travel more and more, but every time I arrive at Charles de Gaulle Airport, I am happy to rediscover Paris. I continually encounter new neighborhoods and places. I think Paris is a good size. It isn't too big like London, and it isn't too small. After twelve years, I am still enchanted.

How do you decide which places to share in your Bonjour City Map-Guides?

It really is a feeling. I walk around with a sense of adventure when I arrive in a city like New York or London, or in Provence. I walk around like someone who doesn't know the city and wants to discover it, strolling down smaller streets and wandering into places that pop out. And then it's a feeling. I don't look at the window displays; I just go inside and it is about atmosphere. I call this the "Bonjour" atmosphere. I can eat at a restaurant and the food can be excellent, but if the atmosphere isn't cozy or warm, then I don't want to put it in the guide. What I need is for what is on the plate to be good, but at the same time to feel good. When I step into an artisan workshop, I want the place to feel alive, that things are scattered about. I like to feel the real atmosphere. A place has to be welcoming because *bonjour* is "hello". And so to say hello to someone is to smile and to initiate a discussion. It is the first word they say, so it is about the feeling with which they say it.

Bonjour City Map-Guides are about exploring a city without being a tourist—how do you do this?

What really interests me are the artisans of a city. In big cities, there are fewer artisans. Small workshops are closing because of the arrival of bigger and bigger chains. And artisans really touch me. I find their designs beautiful because they take time and do not use machines. The people are their own instruments. I seek out artisans because I admire that they work with old crafts from the past that take time, and that they take the time to create.

The Bonjour City Map-Guides also take time. They are about taking time to travel, to get to know the people of a city. They are about

taking time to wander, eat, and stroll. So when I meet an artisan whom I would like to feature, I always ask about friends who might have similar boutiques or workshops. They tell me to go to a different city quarter and I wander over to see. The guides resemble treasure maps because I designed them with that in mind. When I was a kid, I was obsessed with treasure maps and was constantly drawing them. Then I would hide them in my neighbor's garden. It's fun that the guides are like treasure maps. One opens the map, puts down one's finger, and voilà! You could land on a museum or a hat shop or a café or a bakery—it's a different way to discover a city.

What do you do, or where do you go, when you need to take a break from work?

It's not easy because when you are an artist, you are never on vacation. When I travel to Normandy, or anywhere, I am always looking and reading and observing details and colors. It never stops, unless I am at a beach and am doing nothing else. But it's difficult to take a vacation. It's true that sometimes I want to disconnect for a week and rest, but it's by looking and exploring that I nourish myself and gather ideas for future projects. It's difficult to stop creating.

As an illustrator whose work is very influenced by past design traditions, you're a regular at flea markets and going to them is very much a part of your job. Which day do you visit the Saint-Ouen flea market?

I go on Friday mornings. Friday is the day antique dealers and decorators storm the market before the tourists arrive in order to get first pick and the best prices. Friday is also the first day that the market opens, so it's the day that one can find treasures and discover the new items that the dealers have acquired during the week.

What is your most recent favorite find?

I found a small marble table with only three legs. I am obsessed with collecting tables with three legs and not four. And I found another one—a larger one with green legs.

MARCHÉ AUX
PUCES DE SAINT-OUEN

The Marché aux Puces de Saint-Ouen near the Porte de Clignancourt station is the largest flea market in Paris (and some say the world). From small to large treasures—ceramics decorated with distant land-scapes and history lessons, families of chairs in bright colors and sultry shapes, ritzy chandeliers—it is a serious hunting ground.

The market's history dates back more than two centuries. *Pêcheurs de lune* (literally, "fisher-men of the moon") once hunted through the city's trash at night looking for odds and ends valuable enough to sell. They set up stalls within the city walls, but were pushed farther out to places like Clignancourt. Here they formed clusters of stands and began to attract antique dealers and bargain-hunters. The town of Saint-Ouen cleaned up the area in 1885, which marks when les Puces de Saint-Ouen officially became a market.

Today, the Marché aux Puces boasts a few thousand traders and feels like a small city. The market is actually a web of different, smaller markets, with more than five million visitors each year.

It can be tricky getting there and then tough to find the good stuff, so here's my advice, based on a tip from Marin and my own experience: To avoid stalls selling new, cheap bric-a-brac, exit the Métro at the Garibaldi stop, walk toward the church, and then through the park on the right side of the church. When you come out the other side of the park, turn right on Rue des Rosiers and right again on Impasse

Simon at which point you'll see a sign for "Marché Paul Bert," which is Marin's favorite section of the market. To navigate on your device upon leaving the Métro at Garibaldi, use this address: Ma Cocotte, 106 rue des Rosiers, 93400.

In Marin's favorite market at Saint-Ouen, Paul Bert, one walks through a constellation of time periods and worlds—a stand filled with objects from the seventeenth century and another from the 1990s and then through stands that are a mix of every-thing. This is where he found his two tables, each with only three legs. His favorite booth is Phero-mones, with its highly edited selection of antique furniture and charcoal walls, but there are many more with wonderful collections that you'll see as you walk the alleyways.

For a break between treasure hunting and bargain-ing, Marin recommends stopping at **Le Café Paul Bert** for lunch.

Like any good market, haggling is part of the expe-rience. Marin says not only can you haggle, but also that you should, because the prices are too high. However, it is better to speak French, so make sure to brush up on what you learned in high school or convince your Parisian friends to tag along.

Friday morning is the best time to visit this weekend market. Marin is a regular on Friday mornings, which he swears is the best day for discovering new things before the tourists and for getting the best deals.

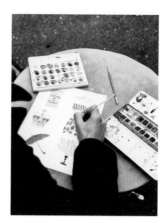

THREE MORE OF MARIN'S
FAVORITE FLEA MARKETS IN PARIS

Marché aux Puces de Vanves

Brocante de la rue de Bretagne (in the Marais)

Marché d'Aligre (there is a little flea market
 here that's part of the larger food market)

Buvard
Bavard

j'écris m et o... mo
j'écris c et o... co
je bois ...

moco

SODAS ORANGE ET CITRON DE QUALITÉ *motte cordonnier*

BUVARD A CONSERVER

Graphic artifacts from French advertising
history, vintage blotting papers, sell all

BY JAIMIE STETTIN

In the first chapter of Flaubert's *Madame Bovary*, the iconic antiheroine of French literature buys herself "a blotter, a writing case, a pen, and some envelopes, although she had no one to write to." In her restless boredom, Emma Bovary longs to travel and to write. Like many others, ultimately, "she wanted both to die and to live in Paris."

A blotter, or *buvard*, a now long-forgotten stationery essential, was used to soak up extra ink on a page. There are various types of blotters, but a *papier buvard,* or a blotting paper, is made specifically from thin, absorbent paper. Over the years, companies have used blotters as a way to advertise various products, and these *papiers buvards* surface often in Parisian flea markets, generally in mint condition. They make for a distinctively French souvenir, at once a relic of French literary history and popular culture.

Buvard comes from the same French root word as *boire*, meaning "to drink." A blotter drinks, absorbs, or soaks up extra ink or moisture. *Buvard* is also close to the French word for "chatty," *bavard*, and as notably paired in *Les Misérables, buvard bavard* makes a handsome, poetic couple. In the book's section titled "Buvard Bavard," Jean Valjean discovers that a copy of a love letter written by Cosette, the daughter he is careful to protect, is imprinted on her blotter. After all, a blotting paper is a chatty artifact—always reading, absorbing, listening, recording, and helping to spread a message.

This is an advertisement for Corset de France, a local corsetiere, or corsetmaker, who also specializes in bandages, brassieres, and other medical wraps. The *papier buvard* notes that the shop is recognized by the French healthcare system.

Back-to-school shopping at a boutique at the Place de la République in Paris is the subject of this *buvard*. The shop highlights the relaunch of its "ravishing" girls' line.

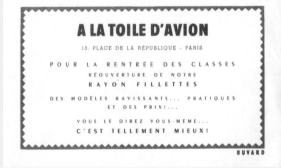

Morvan, a rubber company, encourages people to have their shoes heeled and soled with their rubber.

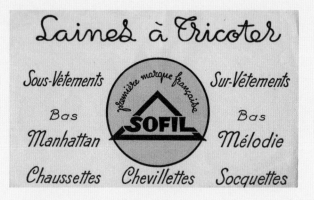

This *buvard* advertises Sofil, a French undergarment company. They specialize in knitted wool, with a product range including socks, anklets, sockettes, and styles of underwear called "the Manhattan" and "the Melodie".

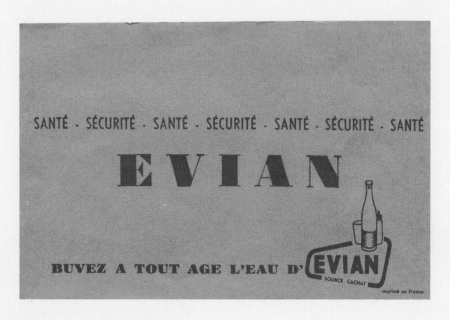

Cleanly and simply, this advertisement promotes Evian water, with a focus on health and trust. Their slogan: "It's good to drink at any age."

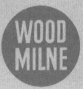

**PORTEZ
DES SEMELLES ET DES TALONS
WOOD MILNE**

- **VOTRE SANTÉ SERA MEILLEURE**
- **VOTRE MARCHE PLUS AGRÉABLE**
- **VOUS RÉALISEREZ DES ÉCONOMIES**

WOOD MILNE

This blotter reads: "Wear Woodmilne heels and soles for better health, a comfortable step, and to save money."

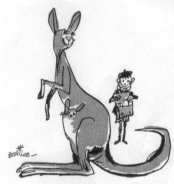

La Vache Qui Rit (The Laughing Cow), a ubiquitous French cheese brand, printed this animal-themed series of advertisements, likely aimed at children, on blotting papers. This illustration features a kangaroo and reads: "Mrs. Kangaroo, a good mom, has in her pocket what she likes: her little one. To each his own! Me, what do I have in my pocket or my bag? My Vache Qui Rit snack!" Snack time, or *le goûter*, is an institution in France.

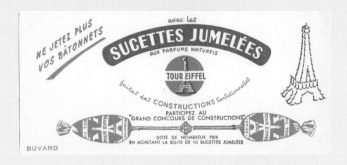

In classic French *bleu, blanc, et rouge*, this *buvard* sells twinned lollipops and encourages customers not to throw away their sticks, but rather to use them to build sensational things and to participate in the company's contest.

MENTHE · PASTILLE

Liqueur Digestive et Rafraîchissante

de E. GIFFARD, Distillateur, ANGERS

Spécialités renommées :

Menthe Pastille blanche et verte, **Cherry-Giffard, Parfait Triple-Sec**

ORANGEADE

A distiller in Angers advertises his refreshing, digestive liqueurs, with three well-known specialties: a mint version (white or green), a cherry one, and a perfect triple sec.

ADRIEN CUINGNET OF STUDIO PLASTAC, A GRAPHIC DESIGN STUDIO

Known for their unique take on the colorful, forward-thinking aesthetic that's taking hold across Europe, Adrien Cuingnet, Fanny Mary, and Romain Riousse of Studio Plastac design visual identities, publications, environments, and more from their airy attic studio not far from Sacré-Coeur. Adrien tells us about their process, sources of inspiration, and why their neighborhood is so great.

FIVE QUESTIONS

There are three of you who work together at Studio Plastac as equal partners. How do you divide up your workload?

Each of us has his or her own speciality: motion design, photography, scenography, packaging, web design . . . At the beginning of a project, we decide who will be the project manager, the unique intermediary with the client. We have meetings about each project as often as possible; this helps us to make decisions and move forward quickly.

Where do you look for inspiration?

Strangely, we think that searching for inspiration in the past separates us from what everybody is doing today. We have a well-stocked library with books from everywhere and every decade. We also watch movies and go to museums.

Which neighborhood is your studio in? What do you like (or not like) about it?

Our studio is in the 18th arrondissement of Paris, one of the last working-class neighborhoods in the city, and that's what we like about it. The rents and the food are relatively cheap, but you can also find fancy restaurants and shops. We love this in-between-ness. We all live less than a fifteen minutes' walk from our workplace—we are very lucky. It's like living in a small village, which can also be a problem—we sometimes spend weeks without leaving the 18th . . .

There are several other studios and artists working in the same building as you. How does that affect your work?

Our workspace is in perpetual motion—a lot of different people have worked or currently work in the house—musicians, stylists, journalists, mixologists, startups, artists of all kinds. It provides us with good energy and permits us to meet new people, connect, and sometimes work together.

What is it like to be a designer in Paris?

We're not sure that nowadays there's a big difference between a designer from Paris or one from New York or Hong Kong, since we all share trends and production via the internet. Except for the fact that in Paris, in the evening we can all meet together around a good baguette, cheese, and wine.

STUDIO PLASTAC'S FAVORITE PARISIAN DESIGNERS AND STUDIOS

A is for Apple (type foundry)
Brichet Ziegler (design studio)
Clemence Seilles (object designer)
Colonel (design studio/shop)
deValence (graphic design studio)
Donatien Mary (illustrator)
Fanette Melier (design studio/shop)
Julie Rothhahn (food designer)
Studio vaste (space/light design
 and scenography)
WA75 (graphic designer)

studioplastac.fr
@studioplastac

INTERLUDE:
OMY

By Erin Austen Abbott
Photography by OMY

Design doesn't get more fun than the graphic arts brand OMY. From giant coloring books to wallpaper to coloring poster maps of cities around the globe to embroidered bracelets, this team, started by Elvire Laurent and Marie-Cerise Lichtlé, has created an all-encompassing coloring brand unlike any other in the world.

Before starting OMY, Elvire and Marie-Cerise were running their own freelance graphic design business together in Paris. Around that same time, they also both became new mothers and felt a pull to change how they approached design. In 2012, OMY launched. "We wanted to develop our own products that would take us out of our day-to-day work, graphic products that we wanted for our own homes but that also allowed us to be more creative personally and not just for commissioned work for a client."

When asked what tips they would give to creative entrepreneurs just starting out, Elvire and Marie-Cerise emphasize how important it is "to share your vision and to be able to communicate your ideas and direction distinctly to others. It's also important to be surrounded by good people who understand the business and where we are coming from and where we want to go."

We love music, we constantly have music on at the office and at home. There are so many different styles, it all depends on the moment or the feeling at the time . . . We love to discover new styles of music and new artists that we have never heard of before.

On the following spread, you'll find Omy's coloring map of Paris, which they generously offered to share with us. You could let your kid/niece/neighbor go to town, or do it yourself and etch the city's geography further into your mind. Plus, there's something so therapeutic about filling in the all the little lines and shapes with color.

Elvire and Marie-Cerise's studio playlist

"Canopée," Polo & Pan, *Caravelle*
"Over & Over," Hot Chip, *The Warning*
"All This Love That I'm Giving," Gwen McCrae,
 Miami Funk Vol. 4
"White Tiger," Izzy Bizu, *White Tiger*
"This Girl," Kungs & Cookin' On 3 Burners, *Layers*
"Lose Yourself to Dance," Daft Punk (feat. Pharrell
 Williams), *Random Access Memories*
"Sunset Lover," Petit Biscuit, *Sunset Lover*
"To Let Myself Go," The Avener (feat. Ane Brun),
 The Wanderings of Avener
"I Follow Rivers," Lykke Li, *Wounded Rhymes*
"Make it Clap," Busta Rhymes (feat. Spliff Star),
 It Ain't Safe No More

You can listen to Elvire and Marie-Cerise's
playlist on Spotify at https://spoti.fi/2MUn4kd.

omy-maison.com/en
@omy_maison

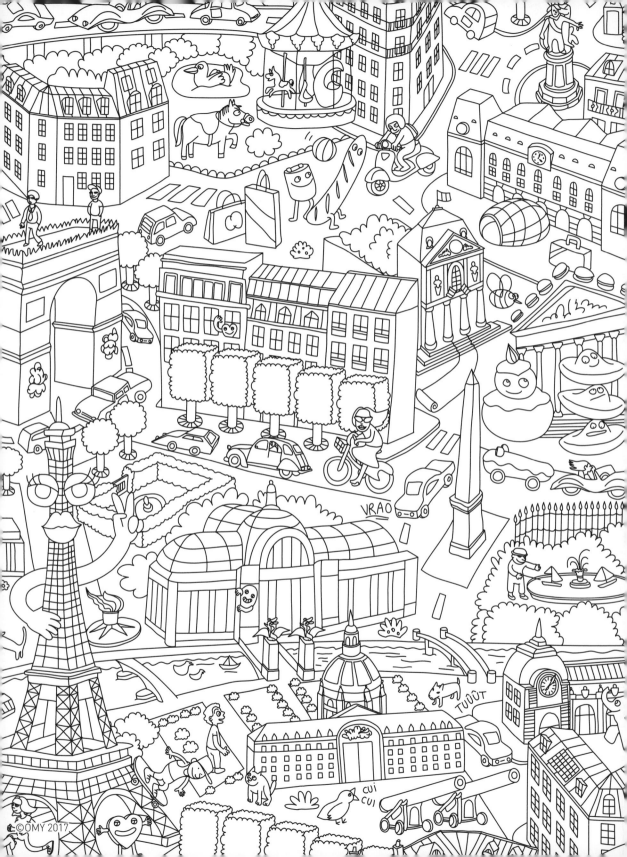

VRAO

TUÛÛT

CUI
CUI

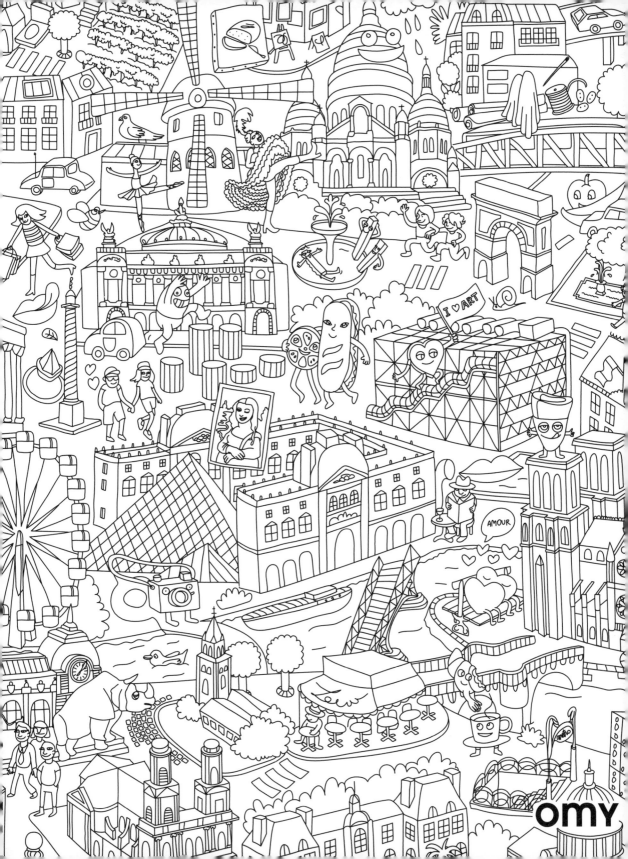

ITINERARY:

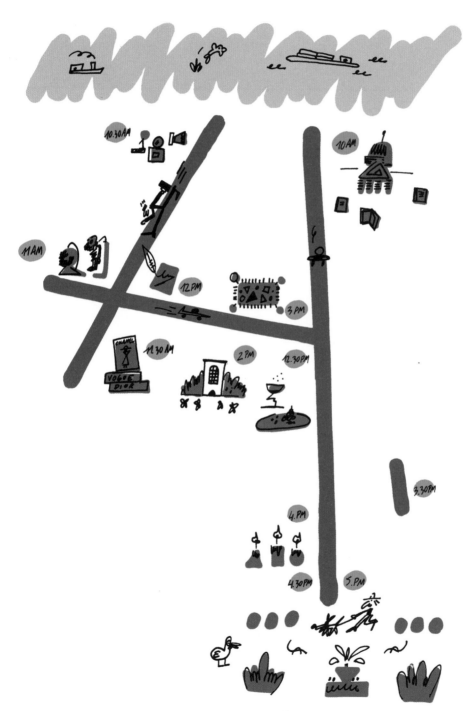

Illustration by Paul Loubet

A day of ancient bookshops, traditionally inspired boutiques, and Romantic paintings in this most elegant of quartiers

You'd be hard pressed to find a more elegant quartier in Paris than Saint-Germain-des-Prés. Strolling down the lanes of this section of the Left Bank, it's easy to imagine yourself there in the days of Eugène Delacroix, Oscar Wilde, Simone de Beauvoir, and other artistic "Germanopratins," as residents of the area are known.

10:00 A.M.

The carved wooden columns, brass chandeliers, and emerald green lampshades of **Bibliotheque Mazarine's** main hall will enchant those who love classic architecture and design. This library is the oldest in France, built by Cardinal Mazarin in the seventeenth century as his personal library. Today, anyone can come and have a peek or even sign up to study and use the facilities—just bring your picture ID.
23 quai de Conti, 75006
+33 1 44 41 44 06
Closed Saturday and Sunday.

10:30 A.M.

Next up, **Buly 1803**. With careful attention to detail, Victoire de Taillac-Touhami and Ramdane Touhami resurrected the spirit of Europe's favorite nineteenth-century apothecary, which Jean-Vincent Bully founded in 1803. Today the shop looks much like it could have back then—with carved wooden shelves, a worn tile floor, and picturesque potions packaged in tin tubes and glass jars.
6 rue Bonaparte, 75006
+33 1 43 29 02 50
Closed Sunday.

11:00 A.M.

Librairie Alain Brieux specializes in antique scientific books, engravings, and instruments. A carved wooden magnifying glass circa 1840, a portrait in oils of French naturalist Louis-Jean-Marie Daubenton from 1791, an exquisite leatherbound volume filled with engraved illustrations of the plants and animals making up the ingredients of eighteenth-century medicines . . . all stunning examples of art and design from years past.
48 rue Jacob, 75006
+33 1 42 60 21 98
Closed Sunday.

11:30 A.M.

There's something so intimately beautiful about a signature and a handwritten letter. Like his father before him, **Frédéric Castaing** knows this and has dedicated his career to the expert curation of historic autographs, letters, and documents. Housed in a handsome interior complete with arched doorways and robin's-egg-blue walls, his eponymous gallery is definitely worth a look. Who knows, you may even walk out with an autograph by Colette or Baudelaire, tastefully encased in a golden frame.
30 rue Jacob, 75006
+33 1 43 54 91 71
Closed Sunday and Monday.

12:00 P.M.

Founded in 1995 to publish visually driven books in the areas of luxury, fashion, and design, **Assouline** continues to create sumptuous volumes every season. Behind the narrow entrance at 35 rue Bonaparte hides an expansive collection of design titles and other well-designed objets.
35 rue Bonaparte, 75006
+33 1 43 29 23 20
Opens late on Sunday.

12:30 P.M.

Make reservations at neo-bistro **Semilla** for a casual atmosphere with a daily-changing menu of modern interpretations of classic French dishes. Or walk right into **Freddy's** for excellent small plates, a curated wine list, and a way less fussy atmosphere. Plus, Freddy's is open continuously from daytime into evening, making it the perfect place to stop for a quick snack or glass of wine while everyone else is closed to change over to dinner service.
Semilla: 54 rue de Seine, 75006
+33 1 43 54 34 50
Freddy's: 54 rue de Seine, 75006
+33 1 43 54 34 50
Reservations suggested.

2:00 P.M.

There are many jewels among the smaller museums of Paris, and **Musée National Eugène-Delacroix** is one of them. Housed in the Romantic artist's former studio off the Place de Furstenberg and complete with a lush backyard garden, the museum is home to thousands of works by Delacroix and the artists he inspired.
6 rue de Furstenberg, 75006
+33 1 44 41 86 50
Closed Tuesday.

3:00 P.M.

As local textile designer Usha Bora says on page 171, **Pierre Frey** is "a must-visit for textile lovers." Founded in 1935, this luxury house specializes in upholstery fabric and in recent years has branched out into wallpaper, rugs, and other items for the home.
2 rue de Furstenberg, 75006
+33 1 46 33 73 00
Closed Sunday and Monday.

3:30 P.M.

Cour du Commerce Saint-André is a wonderful example of the city's hidden passageways and courtyards (see page 175 for more info). It follows a section of the perimeter wall King Philippe-Auguste built in the late twelfth century, and you can still see remnants of this rampart if you look closely. Shops and restaurants line the walkway, paved with original cobblestones, including Café

Procope, the oldest café in Paris.
Cour du Commerce Saint-André, 75006

4:00 P.M.

Next, stroll a couple of blocks down to **Cire Trudon**. Sought after by royalty and commoners alike since 1643, their luxurious candles are still made by hand in Normandy. The shop décor walks the line between traditional and contemporary—to delightful effect.
78 rue de Seine, 75006
+33 1 43 26 46 50
Closed Sunday.

4:30 P.M

Working in an atelier that once housed Napoleon's own silversmith, a team of twenty artisans create **Astier de Villatte's** signature ceramics out of black terra-cotta coated with a milky glaze. In this beautifully designed boutique, you'll find their collection along with other antique-inspired trinkets—pencils, candles, incense, notebooks, etc.
16 rue de Tournon, 75006
+33 1 42 03 43 90
Closed Sunday.

5:00 P.M.

Originally created for Maria de' Medici based on memories of her childhood home in Florence, the **Jardin du Luxembourg** is a crowd favorite. On sunny days, join the locals basking in the sun around the central basin. Kids can rent toy sailboats, play on the playground, ride the carousel, go for a pony ride, watch a marionette show, and more. Be aware that many of these activities will set you back a pretty penny, but strolling through the evocative lanes where Marius and Cosette first meet in *Les Misérables* is gloriously free.
Jardin du Luxembourg, 75006
+33 1 42 34 20 00

Studio Plastac

Fourteen Instagram Accounts to Follow for Design in Paris

BRANDS

@antoinettepoisson
@emoi_emoi
@kerzon_maison
@klindoeil
@lechocolatdesfrancais
@omy_maison
@papiertigram

MAGAZINES

@etapes
@holidaymagazine

STUDIOS

@atelierfranckdurand
@lesgraphiquants

@lesliedavidstudio
@mvmtparis
@playground.paris

"Whoever does not visit Paris regularly will never really be elegant." Snobbish maybe, but these words by nineteenth-century French writer Honoré de Balzac still hit home. The City of Light was and is paramount in the world of fashion, and Parisiennes are adored as ever for their intimidatingly nonchalant style. Inside the following pages, we'll find out how Youssouf Fofana's West African roots figure in his work at **Maison Château Rouge**, get the inside scoop from *New York Times* contributor Alexis Cheung on where to people-watch in style, and learn about the work and Parisian lives of jewelry designer Ayça Özbank Taskan of Mara Paris, stylist Alison Reid, and Bonne Maison creative director Béatrice de Crécy. A dreamy fashion editorial shot in the Le Corbusier masterpiece **Maison La Roche** rounds out the chapter, along with a playlist from designer Elise Tsikis, a whirlwind Right Bank shopping itinerary, and a list of my favorite style-focused Instagram accounts from Paris.

"Fashions fade,

style is eternal."

YVES SAINT LAURENT

FASHION DESIGNER YOUSSOUF FOFANA OF MAISON CHÂTEAU ROUGE TAKES INSPIRATION FROM HIS WEST AFRICAN HERITAGE, THEN FINDS A WAY TO GIVE BACK

By Kari Jorgensen

Youssouf Fofana is the owner and designer of **Maison Château Rouge**, a Parisian fashion line that transforms traditional West African textiles into contemporary clothing and accessories. The result is a visionary take on aesthetics that exudes coolness.

The label is named for the Château Rouge neighborhood of Paris, a place Fofana describes as "the 'Little Africa' of Paris. People come here from all over Africa, so if you're looking for certain African products or food that you grew up with, you can find them here." Fofana lived in a northern suburb of Paris as a child but frequented Château Rouge regularly with his mother on shopping errands. Both of his parents immigrated to France from Senegal and continued to infuse their French home with West African culture. Fofana's mother, in particular, is his primary inspiration, and her personal style has shaped his creative work: "My mother always wore clothes made from African wax textiles, which are printed in bright colors. And, in fact, those textiles have always been a big source of inspiration for me."

That inspiration is more than just a peripheral influence. Fofana exclusively uses West African wax print fabrics in his clothing line, part of an initiative led by Les Oiseaux Migrateurs ("Migrating Birds"), an organization that works collaboratively with African businesses to help fine-tune products, increase brand visibility, and otherwise generate growth. Fofana is a partner with Les Oiseaux Migrateurs and has consequently lent a hand to businesses like Bana Bana, a Senegalese hibiscus juice company: "We work with a cooperative—there are about eight hundred women who work there to harvest the flowers, sort them, transform them into juice, and put it into bottles. So we helped them enhance their branding and

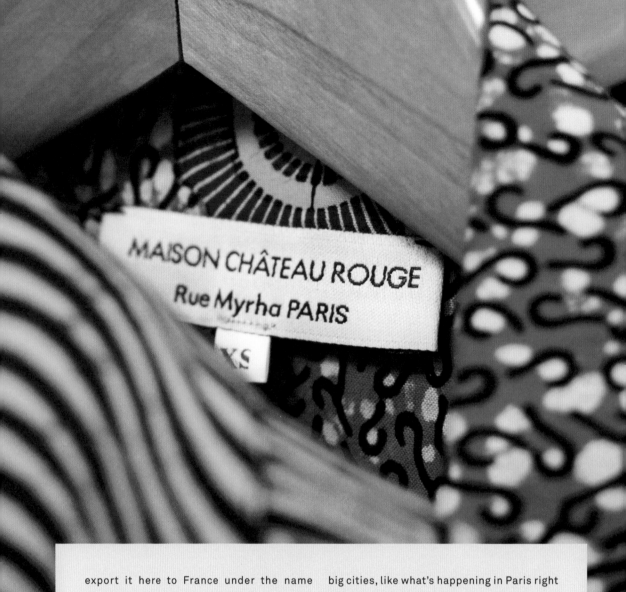

export it here to France under the name Bana Bana. And we were able to finance this project thanks to the sales of Maison Château Rouge."

The textiles used by Maison Château Rouge showcase gorgeous textures and colors arranged in sophisticated patterns, which Fofana marries with his fresh, sportswear-inspired designs. On one hand, his roots are his passion and an impetus for his work, but, "On the other hand, there's all this energy in big cities, like what's happening in Paris right now, as well as New York, Scandinavia, and Japan . . . I combine these with my culture, because my culture is very, very traditional, so I try to find the sweet spot in the mix of the two. Today we have to think globally. So it's central in our approach to try and make African culture accessible to everyone." Maison Château Rouge's forward-thinking sensibilities and irresistible style are swiftly leading us to that sweet spot, along with the depth of character to help others find success, too.

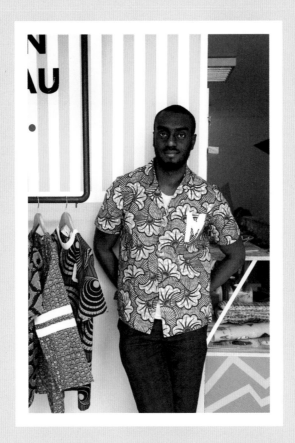

maison-chateaurouge.com
@maisonchateaurouge

The Best People-watching in Paris

Why do we love Paris? Could it be the croissants? The historic monuments? The permissible, even encouraged, wine with lunch? Perhaps it's the people. Should that statement make you scratch your head—ever so delicately, as if wearing a beret—I don't blame you. Parisians, our impressions of them, are universally unappealing. ("How do you think God tempered the city's beauty?" my French waiter joked. "By filling it with Parisians!")

Still, I love them. Unlike Americans, Parisians inhabit themselves unapologetically. It's why they wear only red lipstick, possess an unchanging uniform of white shirts and black pants, continue to smoke incessantly. Their stubbornness is a point of pride. And because there's no replacement for witnessing an impossibly chic woman wearing an impeccable coat, her hair nonchalantly coiffed, momentarily flash before your eyes, then disappear back into the crowd, I scoured Paris (enduring the good, the bad, and the American) for the city's best places to people-watch. After all, we ultimately love Paris for showing us who we could become—perhaps if we only studied its people for long enough.

JARDIN DU LUXEMBOURG

Constructed at the behest of Marie de' Medici, Henri IV's consort, this 6th arrondissement garden is expectantly beautiful. On the brisk afternoon I visited, an older woman dressed in olive green with burnt umber hair speedily walked about while three girls with flicks of eyeliner, dressed in simple, streamlined coats, sauntered through. One man, resplendent in eighties athletic attire, jogged around the perimeter, wearing headphones that looped behind his skull, while two amorous teenagers, their skin still unblemished, clung to each other nearby. Open to flâneurs of all sorts, it's ideal for multifaceted people-watching when you'd like an easy escape from the city.

CAFÉ CHARLOT

Located across from the **Marché des Enfants Rouges**, Paris's oldest covered market, this trendy café spills over on the weekends. Both patrons and pedestrians stare at one another, making the space feel like an aquarium or a zoo, one where it's difficult to discern whether you're the observed or the observer. The staff skews younger, dressed in suspenders and black ties, and many fashionable families stop in. While eating my *tarte aux pommes*, at least two dogs (including one particularly drooly, sedentary bulldog) splayed themselves on the floor. Here the patrons are individually cosmopolitan, but not eccentric, per se. It's a good venue to contemplate the art of subtly standing out while simultaneously blending in with your surroundings.

HUÎTERIE RÉGIS

Admittedly, the oysters are the attraction. But sometimes the world conspires to bring you the best people-watching unexpectedly. After I ordered an obscene amount of shellfish, an American man walked in and boomed, "I brought my wife!" She trailed behind him and said "Bonjour," and immediately I confided to my friend, "She looks just like Helen Mirren." "That is Helen Mirren," he retorted. And then we Googled her husband, confirming our speculations. In person, as in photos, she's stunning, with pewter hair, regal features, and immediately discernible poise. But after our revelation, I largely forgot about her presence. To be fair, she sat behind me, destroying any ogling opportunities, but honestly, the women beside me intrigued me more. They were two friends, over fifty, in immaculately tailored clothing. One had short, curling hair, and neither wore makeup. I admired their gold rings and their fashion sense, and wondered about their friendship, what they were saying. If they recognized the movie star in our midst, they certainly never let on. And when it comes to ideal people-watching, when Helen Mirren isn't the most interesting woman in the room—well, what more could you ask for?

LES DEUX MAGOTS

Frequented by the literary illuminati, this is perhaps the most famous (or notorious) café in Paris. The bar smells faintly of cigarettes, and the waiters wear bow ties and dinner jackets, resembling dilettante husbands who snuck out of the opera for a smoke break and neglected to return. They serve you olives and pretzels immediately. Perhaps it's the institution conveying its own illustriousness upon patrons, but everyone here has an old-worldliness about them. An older American gentleman sat alone drinking wine, and a couple, one woman wearing a headscarf, spoke quietly. Two American women arrived and sat before us. One said "like" so many times that I lost count, ruining the spell and sadly reminding me I was just a visitor in this elegant city.

CAFÉ DE FLOR

As one of the city's oldest cafés, this Saint-Germain-des-Prés spot is frequented by both locals and visitors in equal measure. With seating organized in three rings reminiscent of Dante's *Inferno*, it's ideal for admiring people ambling down Boulevard Saint-Germain. I witnessed one woman wearing a camel coat that matched her silky dog; then another canine, dressed in a sweater, tottered by. Within the café, two men smoked cigars and three women wore furs of varying authenticity. Classic French status signifiers like a Louis Vuitton monogrammed scarf, Chanel 2.55 quilted bags, and an Hermès crossbody bag abounded. At nine P.M., it was hardly full, and by ten, mostly quiet. The scene is classic, if staid, and espouses the archetypal people-watching that's necessary for any first-time visitor. Miraculously, one woman even wore a beret.

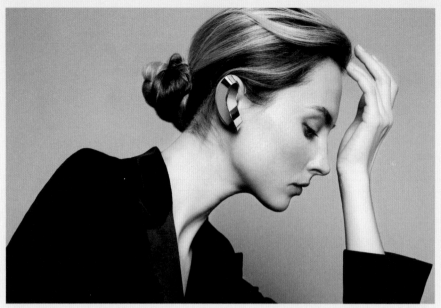

Photography by Mara Paris

Architectural Shapes

The artful jewelry of Mara Paris owes
its success to architect-turned-designer
Ayça Özbank Taşkan

Ayça Özbank Taşkan is settling down. A multi-faceted and multitalented artist, she's been a student, architect, magazine writer, and in various design roles while relocating from Istanbul to Venice, Padua, Milan, Berlin, and Helsinki. But in 2016, right as she was moving from Helsinki to Paris, the excitement around her line of jewelry, Mara Paris, took off. Inspired by a wide range of sources—from David Bowie to the Walt Disney Concert Hall to the line drawings of Picasso—Ayça still maintains variety in her creative work even though she's now focused on one medium.

Where did you grow up? What were those years like, and how did they influence who you've become and the work you do today?

I was born in Istanbul to a family of artists. I had a colorful and happy childhood. I spent a lot of time surrounded by artist friends of my parents. The idea of working in a creative field gradually grew on me, and I decided to study architecture, a field in which I believed I could combine art and design.

After high school, I left Istanbul to move to Italy. I lived for four years between Venice and Padua, studying architecture at Università Iuav di Venezia [IUAV], surrounded by Palladian architecture and the cultural richness of one of the most surreally beautiful cities in the world. Then I spent four years in Milan, studying at Politecnico di Milano within a slightly more modern and fast-paced environment.

Different cultures have always inspired me. The places I have lived and visited have offered me a lot with their culture, art, and design history. I'm always amazed at how our surroundings affect our approaches.

I've also had the chance to live in Helsinki and Berlin. I believe experiencing Scandinavian culture firsthand is a must for everyone who is working in design. For the past several years, I've been living in Paris. I've established Mara Paris here, and I'm quite happy to be here.

How did you become a jewelry designer?

I am a big fan of the multidisciplinary approach. Before starting jewelry design, I tried to do various things: I worked as an architect, I wrote regularly about architecture in magazines, I got into photography, and worked on some design projects within other disciplines.

I started Mara Paris as a project alongside my architecture career in 2015. The core idea was to create wearable pieces inspired by architecture and modern art for people who love to wear and collect exceptional objects. A precise definition helped a lot during the initial decision-making process. The rest came naturally. Over time, I focused solely on Mara Paris due to its energy and its potential.

My husband is also a designer. We've been thinking about and building the brand together since the beginning. He and my mother have been my biggest supporters since the first prototypes.

So Mara Paris is a family affair? What's it like to work with your husband and mother?

Gökçe, my husband, works as a design director for a video-sharing platform. My mother is a photographer and worked in the film industry for years. When my mother saw the first drawings, she immediately said, "Let's produce them." When Gökçe saw the first prototypes,

his immediate reaction was, "We need to create a brand for these."

There are many steps that we go through for each collection: initial design process, prototypes, campaigns, photo shoots, production, operations, and marketing. During some of these, I am alone, and in others they support me.

What is your favorite part of your work?

Jewelry is closely related to identity. I design jewelry as an expression of the creative energy from various inspirations of mine. I come from an architecture background, and architectural projects tend to be quite complicated, involving big teams with many different specialties. Seeing the end result usually takes years. Designing jewelry can be done with a small team at an amazingly fast pace. It is possible to prepare two collections within a year, hold them in my hands, and witness them being worn. I find this very exciting and more suitable to the rhythm of life we live today.

What do you find most difficult?

The production phase is the most challenging part. Each piece of Mara Paris jewelry is handcrafted by expert artisans. There's always a new challenge with each model. Sometimes we have to produce a design using a whole new set of techniques; this complicates the initial prototyping phase. Usually, each jewelry piece goes through three or four specialized artisans to reach the final result. As the designer, I supervise this process carefully.

What inspires your designs?

I try to design each collection with a unique state of mind, moving from one inspiration to another.

"Curves & Personas" is inspired by modern art and architecture. "Curves" is inspired by deconstructionist architects like Frank Gehry and Zaha Hadid. Jewelry pieces are shaped similar to the way they work with surfaces and curves in their designs. Gehry's Walt Disney Concert Hall, especially its facade, was one of the most important inspirations. Gehry designed a public building that enriches the city with the light reflecting from its curves. I tried to design ear cuffs and earrings that adorn people with light reflections in a similar manner. "Personas" is inspired by simple line drawings by Picasso and Matisse.

"TWO" was inspired by Italian architect Carlo Scarpa. Scarpa worked as the president of the university where I studied in Venice, IUAV. He has left modernist traces in Venice with his designs like the Olivetti Showroom and the Brion Cemetery. This always fascinated me, and I tried to turn some of the details he used into jewelry.

How does Paris inspire you?

First and foremost, I believe it is crucial to love our surroundings and the culture we live inside. We can only achieve peace and creativity this way. Paris is the seventh city that I've lived in. Since the first day, the city has treated me well. French people know well *l'art de vivre*. The fabric of the city is built on top of this. Paris is not exhausting; it doesn't drain your energy

like many other big cities do. I benefit from its cultural richness. Exhibitions, performances, concerts, museums are almost endless. I can always keep a very active to-do list, which *never* gets boring. All of these influences keep me inspired. It's not a coincidence that Mara Paris was born here.

<u>What should we expect from Mara Paris and you in the future?</u>

Mara Paris will continue to evolve, full of energy and surprises. When I look back, I see that we have achieved quite a lot. It makes me excited about the future. We currently have clients from all over the world. My jewelry has reached locations that I have never visited myself. There are even some people who have tattooed my figures on their bodies. It's fascinating. I would love to come across people wearing Mara Paris while casually walking down the street.

mara.paris
@mara.paris

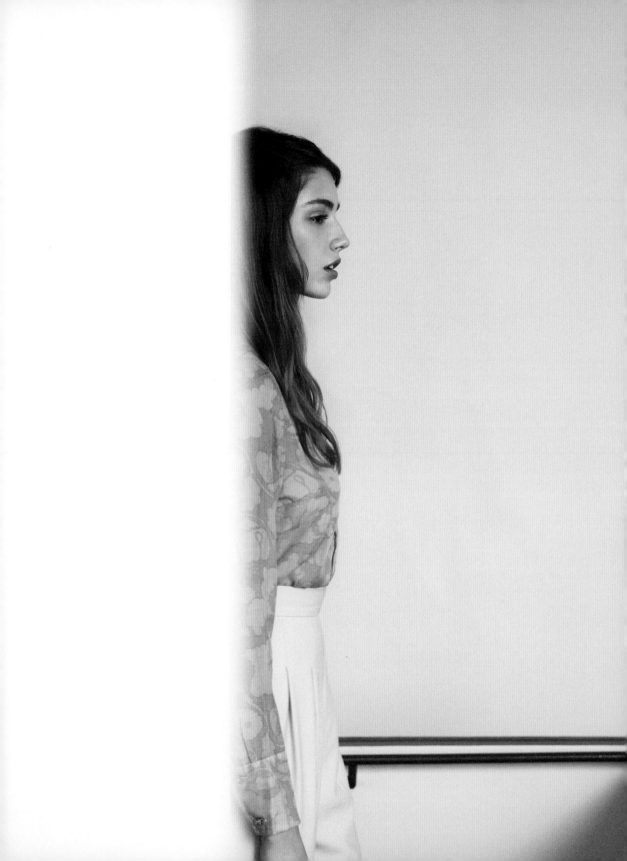

House of Style

Clothing by Parisian designers is showcased against the backdrop of iconic French architect Le Corbusier's midcentury masterpiece, Maison La Roche — a modern marvel of sharp angles, sweeping curves, and bursts of natural light, in this fashion story by photographer Chaunté Vaughn and stylist Alison Reid. Gentle feminine silhouettes, ruffled accents, and whispering color play against the building's strong modern architecture.

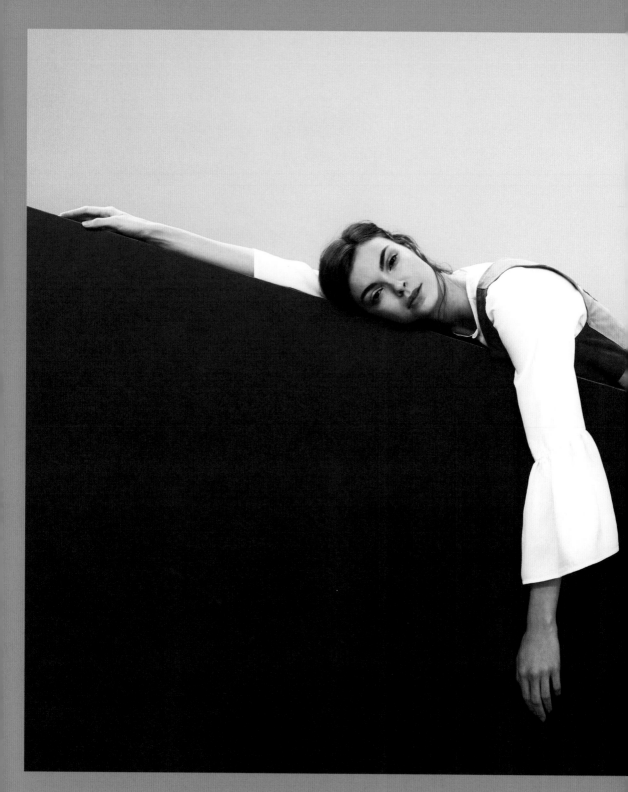

EARTHY SUEDE POPS WITH A TOUCH OF CRISP WHITE. BELL SLEEVE TOP STYLIST'S OWN, PATCHWORK VINTAGE DRESS FROM KILIWATCH PARIS.

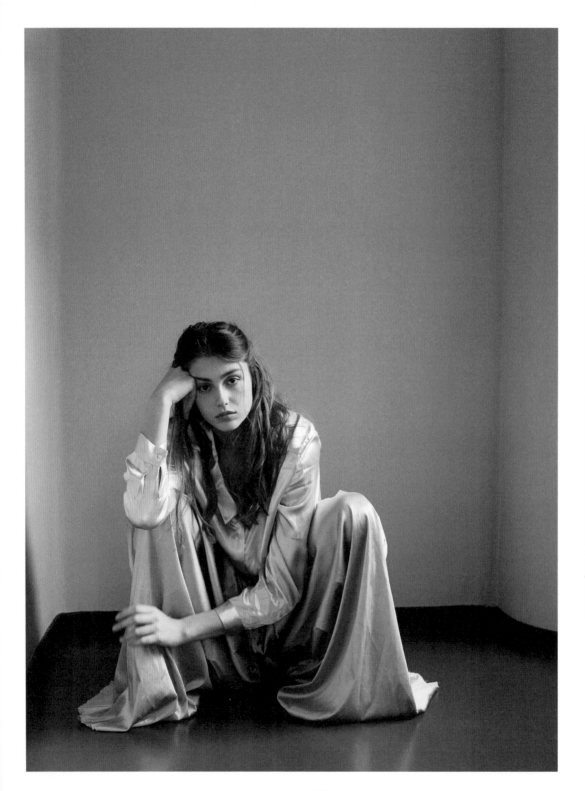

THE SOFTEST SATIN SHINES IN DUSTY PINK. BLOUSE
STYLIST'S OWN, TROUSERS BY LE STUDIO PIERRE.

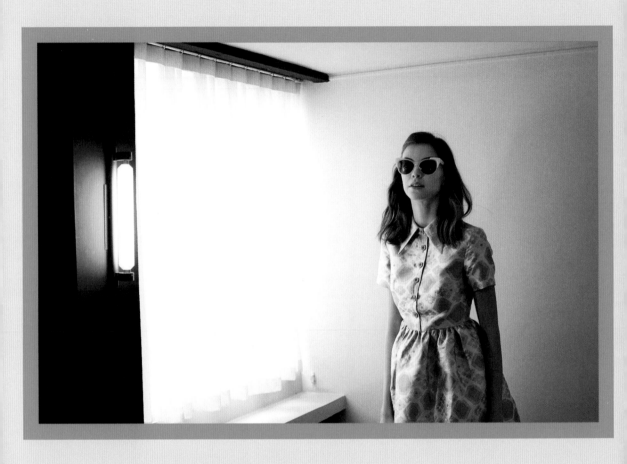

YELLOW SPECS ADD A DASH OF ATTITUDE TO AN OTHERWISE BUTTONED-UP ENSEMBLE.
SUNGLASSES BY ANDY WOLF, DRESS BY MANOUSH.

PARIS CALLS FOR PILES OF LACE, RUFFLES, AND ALL THE PRINTS. VINTAGE PRINTED TURTLENECK
FROM KILIWATCH PARIS, DRESS STYLIST'S OWN, FLARED SUEDE TROUSERS BY DROME.

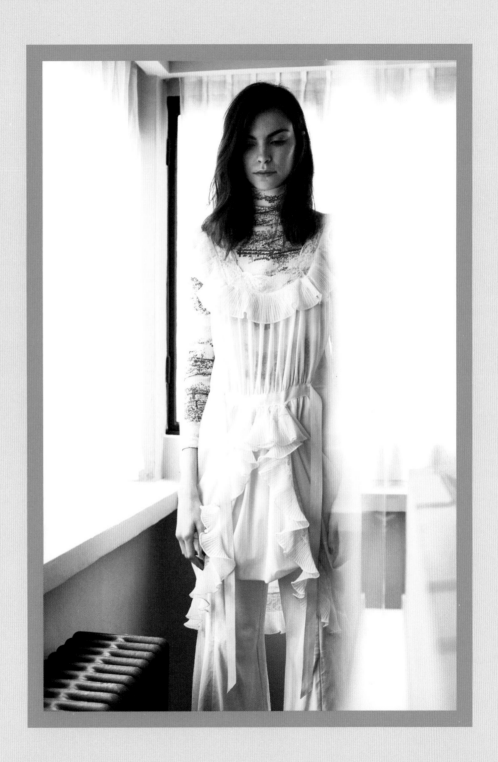

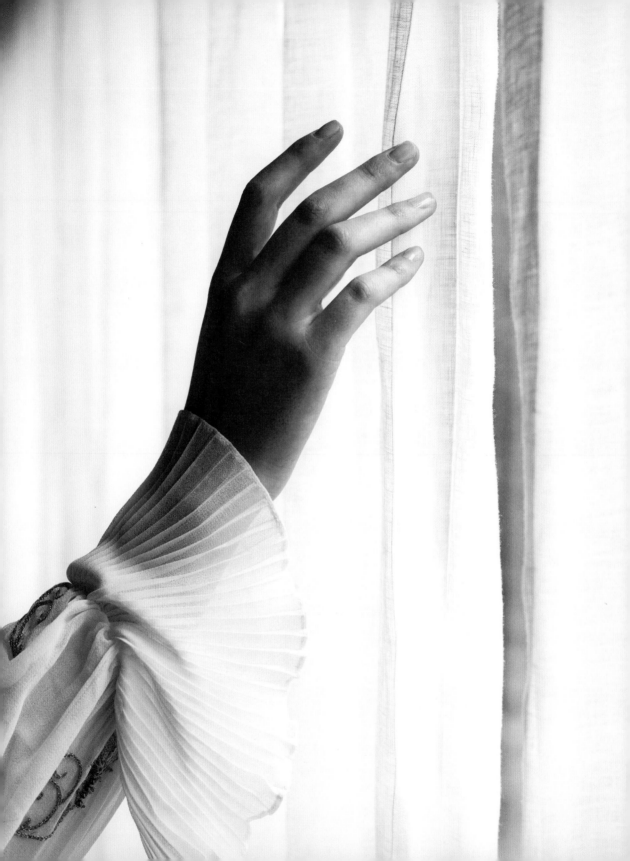

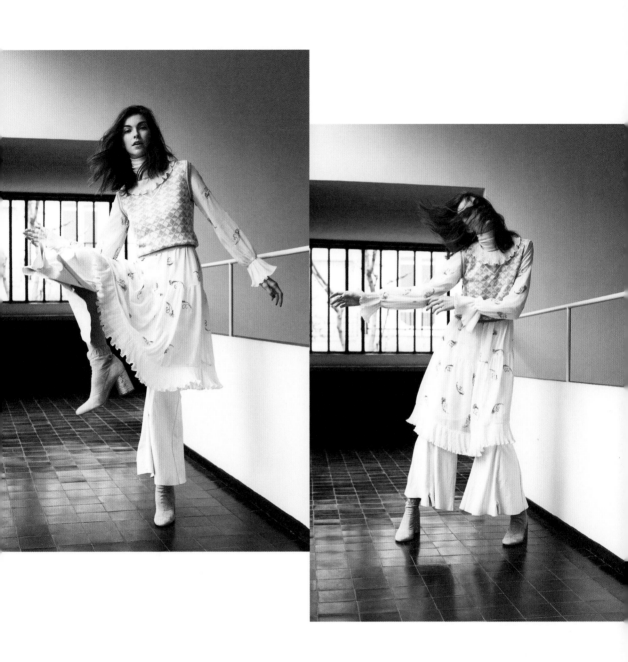

ANCHOR A MIX OF WHISPER-LIGHT LAYERS WITH A CROPPED KNIT. TURTLENECK STYLIST'S OWN, VINTAGE KNITTED TANK TOP FROM KILIWATCH PARIS, PRINT DRESS BY MANOUSH, FLARED SUEDE TROUSERS BY DROME, SUEDE BOOTS WITH GOLD HEEL BY DROME.

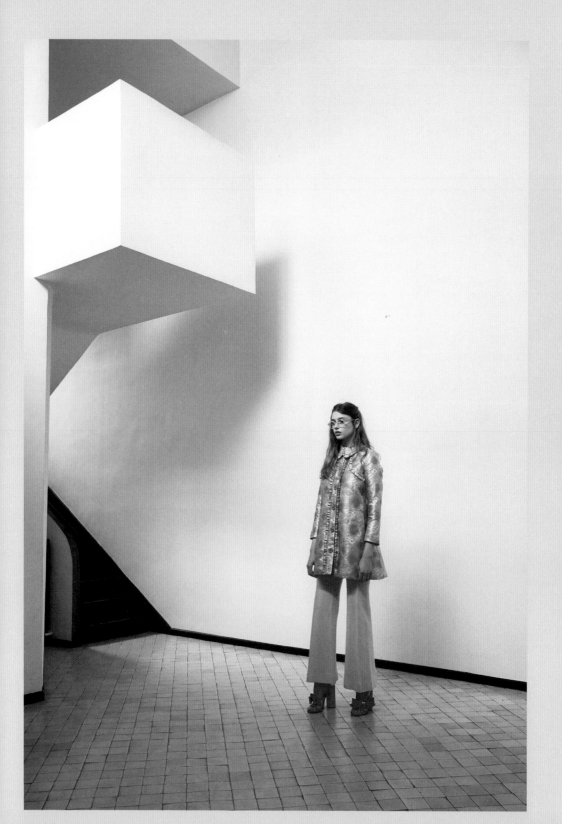

TONES OF FUCHSIA, POWDER PINK, AND SOFT BLUSH MAKE FOR A FEMININE STATEMENT. GLASSES BY ANDY WOLFF. PRINTED OVERCOAT BY MANOUSH. VINTAGE JUMPSUIT FROM CHEZ SARAH. STACKED PINK SANDALS BY MELLOW YELLOW.

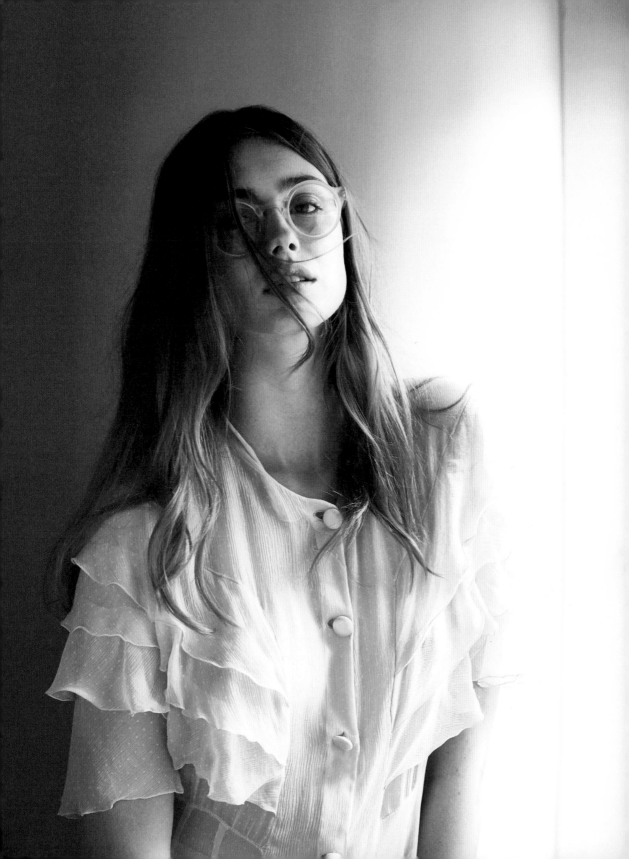

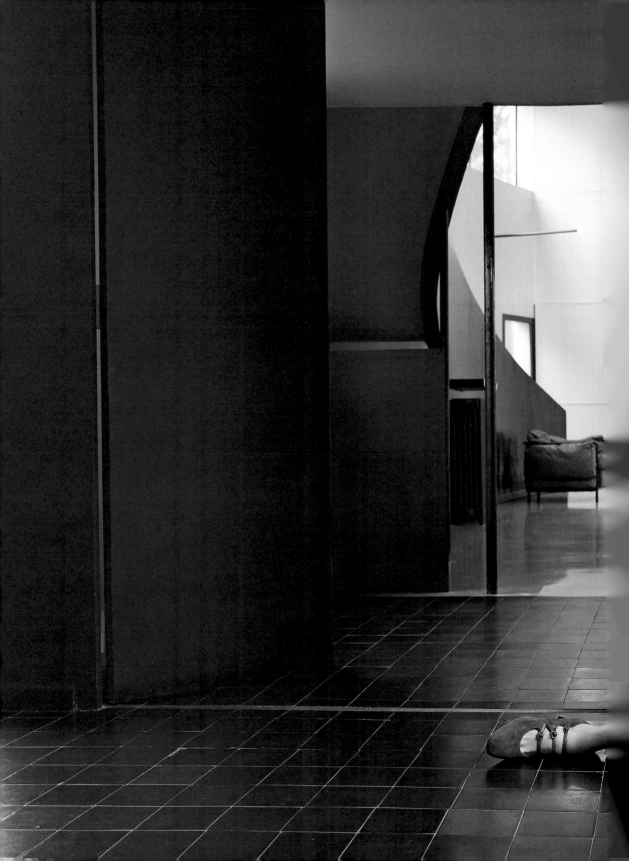

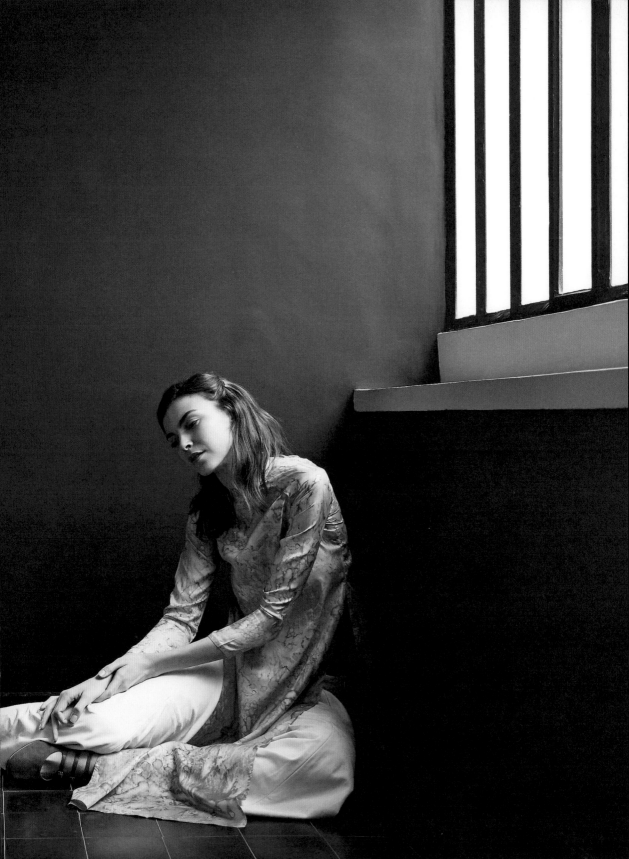

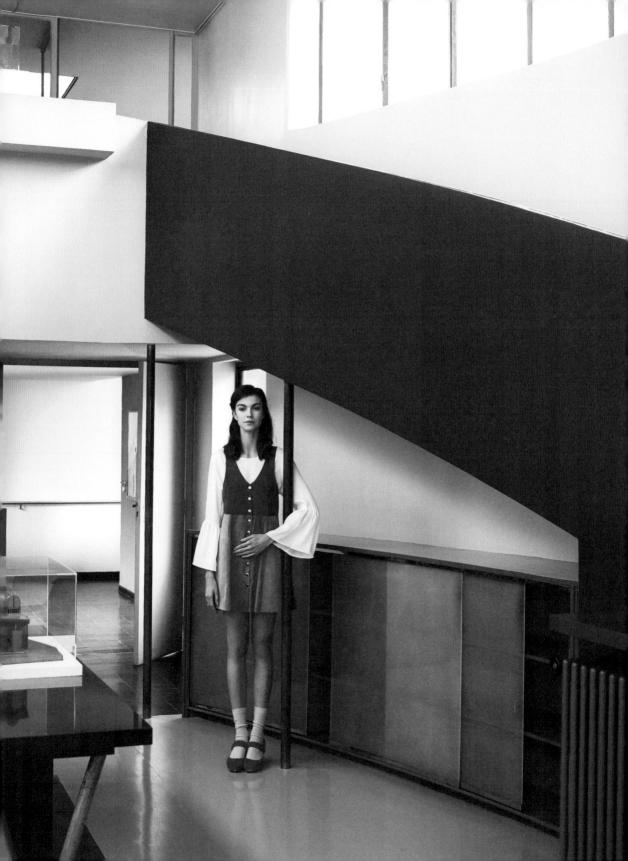

Maison La Roche

Designed by prolific Swiss-French architect and artist Le Corbusier in collaboration with his cousin Pierre Jeanneret between 1923 and 1925, Maison La Roche is a pioneering work of the International style. Located in Paris's 16th arrondissement, the cubist structure was originally designed for Swiss banker and avant-garde art collector Raoul La Roche as a villa-cum-gallery, and is now home to the Fondation Le Corbusier, which houses the world's largest collection of Le Corbusier drawings, studies, and plans. The groundbreaking design features a roof garden, an open-plan layout, horizontal windows, and an unprecedented use of concrete amid the more ornate art nouveau and Beaux arts structures of traditional Paris. It's the perfect off-the-beaten-path place to visit for design-loving travelers.

www.fondationlecorbusier.fr

HAIR BY LIV HOLST
MAKEUP BY KANA NAGASHIMA
MODELING BY DAIANE MENEGHAL
AND PRISCILA FARDEL OF
MADEMOISELLE AGENCY
TEXT BY BRYN KENNEY

Styling by Alison Reid
Photography by Rachelle Simoneau

TEN YEARS AGO, ALISON REID CAME TO PARIS FROM LONDON ON A WHIM. SHE THOUGHT SHE'D END UP BACK IN LONDON AND FIND WORK AGAIN AT A NINE-TO-FIVE JOB. INSTEAD, SHE FELL IN LOVE WITH THE ARCHITECTURE, ART, AND MORE-EASYGOING LIFESTYLE OF THE FRENCH CAPITAL AND DECIDED TO STAY. AWAY FROM THE PRESSURES OF HOME, SHE EVENTUALLY FOUND HER DREAM JOB AS A FREELANCE STYLIST, WORKING WITH FASHION BRANDS BOTH BIG AND SMALL.

COUP DE FOUDRE

English fashion stylist Alison Reid is playing for keeps in the City of Light

<u>Were you interested in fashion as a child?</u>

Yes, I can remember crawling up and down the driveway in front of my parents' house scraping my shoes along the ground and making holes in them because I wanted new ones. My mum was not pleased, to say the least.

<u>After growing up in England, how did you end up in Paris?</u>

I studied in London and worked there for a few years, then moved to Paris just for a change. I took my sister's apartment here while she went traveling for six months and ended up staying . . .

<u>You have what many would consider a dream job—working as a fashion stylist with clients</u> <u>ranging from smaller French brands to larger international brands. How did you get there? Did you always know this is what you would do, and if not, how did your plans change?</u>

I first imagined that I would work in a design studio. But that requires a lot of computer work, which I am not really keen on— I wanted to have the chance to create things myself and to work with my hands. Also, in a design studio you work on a new collection every season, but it still has a routine about it. Working freelance is definitely not predictable!

<u>Have you had any setbacks?</u>

It isn't an easy career. I have had to take unrelated jobs along the way just to be able to pay my rent. For example, I worked as a

pastry chef for a short period, which I actually really enjoyed. It's just a hobby now.

In addition to styling for fashion shoots, you also work as an art director and set designer. How do these disciplines relate to one another? Do you find one aspect of your work influencing another?

I work quite a lot with still life, which I really enjoy, and I often use props in shoots. It's partly because I have an interest in both areas, but also because both work with the same principles—color, texture, composition, etc.

What do you love best about your work?

I love that every project is different—I think that's what keeps it interesting and challenging. I like that I get the opportunity to work with my hands and make things sometimes, too.

How is your career different in Paris than if you had stayed in England and worked in London, for example?

While in London, I was working for a small fashion brand as design assistant—so, still in fashion but in a slightly different area. In Paris, I started working in styling and set design after organizing a cherry blossom–inspired party with a friend to fund-raise for the tsunami in Japan. We got really carried away with costumes and decorations and ended up working together on projects for almost four years afterward. We eventually went our separate ways, but I carried on working on similar projects independently. I think coming to Paris and being in a differ-

ent environment meant I tried new things without feeling too much pressure, whereas I would have been more worried about just getting on with things in London.

How does living in Paris compare with the idea of living in Paris?

For the first three years I lived here, I still felt like I was on holiday. It didn't feel like real life because I was still exploring and discovering new things and places and meeting new people. After that, it started to feel more like reality, but I think there is something about being in a foreign city and feeling like a foreigner that I quite like and that hasn't changed after ten years.

What neighborhood do you live in? Any favorite local spots you can recommend?

I recently moved to Saint-Ouen after living in Belleville for seven years. In Belleville, I'd recommend the **Parc des Buttes-Chaumont.** It's my favorite park in Paris; I used to run there several times a week, and I really miss it! I'm still getting to know Saint-Ouen, but the most obvious spot would be the **Marché aux Puces** for inspiration. It is also great for finding props for projects and shoots.

What inspires you the most about Paris?

In comparison to London, I find the architecture of the city more of an inspiring environment to be in. And even though London has so much going on creatively, I don't find it as enjoyable—it's harder and bigger and takes so much longer to get around.

What would a perfect day in Paris look like to you?

A perfect day in Paris would be beautiful and sunny, so I would go running in **Buttes-Chaumont** and then cycle through the streets. I'd go see some exhibitions (at the moment I really want to see the Margiela exhibition at the **Palais Galliera** and I always love visiting **Atelier Brancusi**). The day would have to involve cake. I haven't yet been, but I would love to go for afternoon tea at **Le Meurice** to try pastry chef Cédric Grolet's sculpture-like cakes. I'd probably be too full of cake for dinner, so then I would go to the **Palais Garnier** to watch a ballet or dance performance. I went to see Tree of Codes by Wayne McGregor there last year—the music was by Jamie xx and the set by Olafur Eliasson. It was so inspiring!

ALISON'S FAVORITE PARISIAN FASHION DESIGNERS AND SHOPS

Amélie Pichard
Ami
Coralie Marabelle
Cornaërt (for socks)
Guerrisol (to rummage for second hand pieces and sometimes customize them, too)
Harmony
Holiday (not exactly a brand, though they do make clothing, and I love the magazine)
Jacquemus
Lemaire
Maison Margiela

alisonreid.fr
@_alison_reid

BÉATRICE DE CRÉCY OF
BONNE MAISON, SOCK BRAND

Happy Socks, Stance, Maria La Rosa, Darner, Hansel From Basel—
statement socks and the brands that make them are having quite a
moment all over the world. But none are more artful than the socks
from Paris-based Bonne Maison. Cofounder and creative director
Béatrice de Crécy imagines up collections in the most beautiful
colors and patterns.

Photography by Bonne Maison

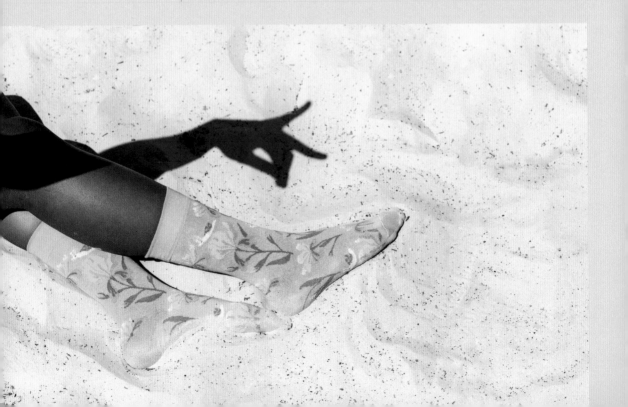

FIVE QUESTIONS

How did your sock brand, Bonne Maison, get its start?

Jean Gabriel, my partner, and I have worked together for more than thirty years on different projects and brands. Since our collaborations were often successful, we decided to build our own brand, and Bonne Maison was born.

What do you like about designing socks? What do you find challenging?

Socks—it's such a tiny space for expression. But that minimum of space provides maximum happiness in wearing it! That's the challenge that I love. Also, color is my motto. I create four or five special colors each season because it's so important to have the right ones. Colors have the power to make people happy. Even if it's only for a moment, little joys are very important.

Do you have any advice for aspiring accessories designers out there?

Follow your instincts and be very demanding with yourself.

What are your long-term dreams for Bonne Maison? And for your own career?

We plan to do stockings one day, and I dream of building a swimsuit line because I can't find any good ones on the market.

Where are you based? Do you feel it is a benefit or a handicap for a French designer to live/work in the capital city? Why?

I have lived in Paris since 2014, and it's just great to live here. There are so many things to see all the time—so many museums and good expositions! And there are good vibes, energy, and lightness in this town! Before moving here, I lived in Bastia, Corsica, and came often to Paris. It's an advantage to live in Paris, but if you only know Paris, that's not good, either. It's good to mix it up.

BÉATRICE'S FAVORITE SHOPS FOR SOCKS AND ACCESSORIES IN PARIS

Centre Commercial
Galeries Lafayettes
Le Bon Marché
L'Embellie Design
Marché aux Puces de la Porte de Vanves
Marché aux Puces de Saint-Ouen
Thanx God I'm a V.I.P

bonnemaison.fr/en
@bonnemaisonfr

INTERLUDE: ELISE TSIKIS, JEWELRY DESIGNER

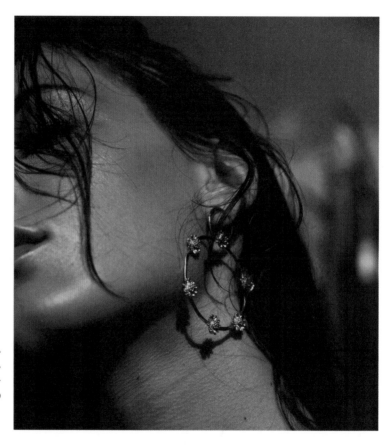

Photography by Elise Tsikis

Elise Tsikis rose through the ranks of prestigious fashion houses like Christian Dior before deciding to go it alone with her self-named line of jewelry. She says jewelry was the natural choice because "it includes everything—color, nature, preciousness." Looking to her French and Greek heritage for inspiration, Elise combines raw stones with clean modern lines, natural elements with urban sophistication. Her customers don't want to only "buy jewels, but to buy a history," and as a result, she freely shares her story and processes via social media (@elisetsikis). The designer confides she has "the best job in the world, in the most beautiful city in the world . . . I would not leave Paris for anything!"

Elise's studio playlist

The melancholy of these lyrics and melodies help me to go into my creative bubble, into my process . . . Music is essential to the creation.

"Le goût du sel de tes larmes," Brigitte, *Nues*
"Beautiful People Beautiful Problems," Lana Del Rey, *Lust for Life*
"Main Girl," Charlotte Cardin, *Main Girl*
"Man-O-To," Nu, *Man-O-To*
"Gold," Kiiara, *Low kii savage*
"The Closest Ghost (feat. Djéla)," Jean du Voyage, *The Closest*
"Borders," St. Beauty, *Borders*
"Nuit 17 à 52," Christine and the Queens, *Chaleur Humaine*
"Hit the Roads," Joe Bel, *Hit the Roads*
"A World Alone," Lorde, *Pure Heroine*
"Oceans," Petit Biscuit, *Presence*

You can listen to Elise's playlist on Spotify at http://spoti.fi/2PGyqXN.

elisetsikis.com
@elisetsikisparis

ITINERARY:

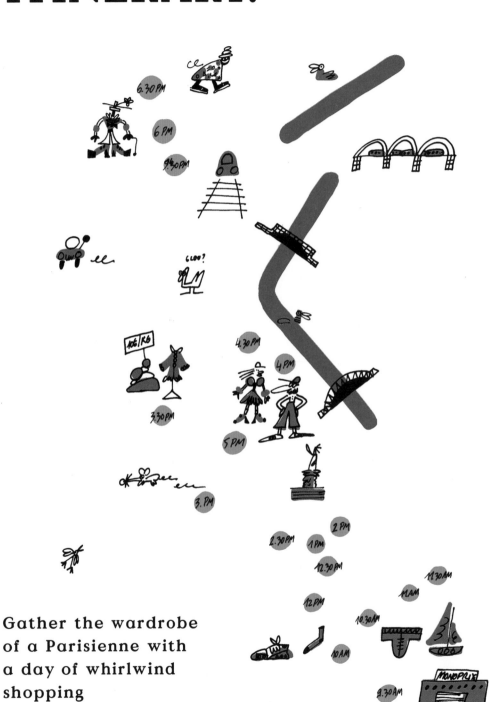

Gather the wardrobe of a Parisienne with a day of whirlwind shopping

Illustration by Paul Loubet

Paris's Right Bank has replaced the Left as the city's center of cool, contemporary art and design. You'll be covering a lot of ground in this whirlwind shopping tour—starting in the 11th arrondissement before heading to the 3rd, 10th, and 18th. But it's worth it if you want to dive deep into the city's style, so put on comfortable shoes and eat a good breakfast before you start out!

Tip: Follow this itinerary on any day except Sunday, when most boutiques are closed.

11TH ARRONDISSEMENT

9:30 A.M.

We'll start the day at **Monoprix** because 1) they open earlier than any of the other shops, and 2) as the so-called Target of France, you can often find treasures on sale for twenty euros or less.
99 rue du Faubourg Saint-Antoine, 75011
+33 1 43 07 59 40

10:00 A.M.

Head down the block to one of the city's branches of Japanese retailer **Muji**. This location has a beautiful Belle Epoque atrium. Then hit up **Petit Bateau** and **Aigle** for classic French striped tees and rain boots.
Muji: 91 rue du Faubourg Saint-Antoine, 75011
+33 1 53 33 48 48
Aigle: 67 rue du Faubourg Saint-Antoine, 75011
+33 1 43 38 73 01
Petit Bateau: 67 rue du Faubourg Saint-Antoine, 75011
+33 1 40 19 93 49

10:30 A.M.

No one captures the essence of French-girl style like **Isabel Marant**. This boutique on Rue de Charonne in the Bastille district was her first (opened in 1992).
16 rue de Charonne, 75011
+33 1 49 29 71 55

11:00 A.M.

With designs influenced by travel, music, and artistic collaboration, **Sessùn's** clothes are for the woman who appreciates casual chic with subtle yet unexpected details. This outpost also has a lifestyle assortment on one side, where you can pick up candles, art, and other objects curated by founder Emma François.
34 rue de Charonne, 75011
+33 1 48 06 55 66

11:30 A.M.

A cool French fashion label for men and women, **Frenchtrotters** also carries a well-edited selection of other apparel lines, along with candles and assorted gift items. Not sure what to take to the dressing room? Don't be afraid to ask the helpful and knowledgeable staff.
30 rue de Charonne, 75011
+33 1 47 00 84 35

12:00 P.M.

The shop is may be small and cramped, but the large assortment of vintage clothing at **Adom** is well edited and reasonably priced.
56 rue de la Roquette, 75011
+33 1 48 07 15 94

3RD ARRONDISSEMENT

12:30 P.M.

Up-and-coming designer **Valentine Gauthier's** first boutique is a juxtaposition of rustic wooden beams and exposed stone walls mixed with of-the-moment clothing. French *Elle* predicted she'll be the next Isabel Marant.
88 boulevard Beaumarchais, 75011
+33 1 75 57 14 33

1:00 P.M.

Chances are, you've seen photos of a vintage red Fiat posing near the entrance of this design emporium. There's a lot of hype around **Merci**, but for good reason. Three floors are filled with impeccably curated home goods, clothing, gifts, jewelry, paper goods, and more. Have lunch in the café, which serves seasonal salads and homemade desserts.
111 boulevard Beaumarchais, 75003
+33 1 42 77 00 33

2:00 P.M.

Sisters Domitille and Angélique Brion founded **Soeur** (French for "sister") in 2008 with the idea of creating clothing that epitomizes tomboy chic. Across the street at **Roseanna**, you'll find colorful, eclectic, and supremely stylish designs that are a fixture in the European fashion magazines.

Soeur: 12 boulevard des Filles du Calvaire, 75003
+33 1 58 30 90 96
Roseanna: 5 rue Froissart, 75011
+33 1 40 41 06 10

2:30 P.M.

Lemaire is a favorite of Parisian stylist Alison Reid (see page 137) for its understated wearability and attention to detail. The boutique—with pale, layered colors and a textured gold ceiling—is worth a look in and of itself.
28 rue de Poitou, 75003
+33 1 44 78 00 09

3:00 P.M.

On the day I showed up, the shop attendant at **The Broken Arm** was wearing a shimmery purple pleated dress with voluminous sleeves by Balenciaga, which was also for sale. Boring is not on the menu at this avant-garde fashion boutique. (Unless boring is currently in style.) If you need a break, have a cup in the coffee shop next door under the same name.
12 rue Perrée, 75003
+33 1 44 61 53 60

10TH ARRONDISSEMENT

3:30 P.M.

Sylvie Chateigner's taste is flawless. For more than twenty years, she's channeled that taste into the curation of her playfully named vintage clothing shop, **Thanx God I'm a V.I.P.** Arranged by color and featuring many designer brands, her collection is the mother lode for style-minded shoppers.
12 rue de Lancry, 75010
+33 1 42 03 02 09

4:00 P.M.

Using colorful African wax prints, and inspired by streetwear, **Atelier Beaurepaire** creates unisex pants, bomber jackets, and overalls.
28 rue Beaurepaire, 75010
+33 1 42 08 17 03

4:30 P.M.

Beloved by French fashion icons like Garance Doré and Carine Roitfeld, **A.P.C.** prides itself on its deceivingly simple designs.
5 rue de Marseille, 75010
+33 1 42 39 84 46

5:00 P.M.

Exposed stone walls and a vaulted glass ceiling create a stunning backdrop for the fashion and gifts by indie designers (Roseanna, Humanoid, Kowtow) at **Centre Commercial.** The children's shop down the street is equally chic, with canvas shoes by Cienta, rubber toys by Oli & Carol, clothing by Hundred Pieces, and much more.
Centre Commercial: 2 rue de Marseille, 75010
+33 1 42 02 26 08
Centre Commercial Kids: 22 rue Yves Toudic, 75010
+33 1 42 06 23 81

Tip: After leaving Centre Commercial, duck into the boulangerie next door, **Du Pain et Des Idées** (34 rue Yves Toudic), for one of their famous pastries. My favorite is the flaky escargot filled with cream cheese and berries.

18TH ARRONDISSEMENT

5:30 P.M.

Hop in a cab and head up to **Maison Château Rouge** in the Barbès neighborhood. African tradition meets Parisian design in Youssouf Fofana's cheerful boutique, filled with clothing and gift items.
40 rue Myrha, 75018
shop@lesoiseauxmigrateurs.com

6:00 P.M.

African wax prints, the vibrant cotton fabrics popular in West Africa, have caught on with the rest of the world in recent years. They come in a myriad of patterns—each of which has a specific story or meaning. Shop for them at **Holland Textiles** and other establishments along the Rue de Doudeauville.
68 rue Doudeauville, 75018
+33 1 44 85 28 14

6:30 P.M.

Moving from Brazzaville in the Republic of Congo to Paris in 1977, the clothing designer Le Bachelor's small atelier, **Sape & Co**, has become a landmark for his take on La Sape—an elegant movement in men's fashion (SAPE is an acronym for Société des Ambianceurs et des Personnes Elégantes, "Society of Ambiance-Makers and Elegant People"). Follow Parisian model Catherine Maigret's example and ask Le Bachelor to make you a bespoke menswear-inspired jacket.
12 rue de Panama, 75018
+33 1 42 64 40 15

Twenty Instagram Accounts to Follow for Parisian Style

BRANDS

@bonnemaisonfr
@elisetsikisparis
@isabelmarant
@maisonchateaurouge
@mara.paris
@roseannaofficiel
@sezane
@soeur_paris

INFLUENCERS

@jeannedamas
@janebirkindaily
@lamialand
@sarah_nait

SHOPS

@centre_commercial
@centre_commercial_kids
@frenchtrotters

STYLISTS

@_alison_reid
@charlottehuguet
@debsfez
@sagliogeraldine
@smala.paris

At Maison la Roche

Interiors + Exteriors

Whether your preference is gothic cathedrals, the **Eiffel Tower,** intimate pocket parks, or the soft-colored sophisticated boho look that's currently popular, you'll find no shortage of inspiring architecture, gardens, and interiors in Paris. Read this chapter to find out where to sleep in style, get ideas from stylist and interior designer Meta Coleman on how to incorporate souvenirs into your décor back home, and take a peek into the enchanting childhood home and garden of botanical designer Kali Vermes. You'll also hear the story and inspiration for Usha Bora's Franco-Indian line of textiles, grab a vintage-inspired playlist from homewares designer Louise Jourdan-Gassin, discover the charm of Paris's hidden passageways, and get my cheat sheet on Parisian interiors and architecture accounts to follow.

"The great city, so made for peace and art and all humanest graces, seemed to lie by her river-side like a princess

guarded by the
watchful giant of
the Eiffel Tower."

EDITH WHARTON

Beaux Rêves

By Kristy Mucci

Illustration by Lisa Laubreaux

SLEEP IN STYLE IN THE CITY OF LIGHT—OUR TOP RECOMMENDATIONS ON WHERE TO STAY

With so much to see and do (and eat!), it's easy to fill itineraries in Paris. We all have lists of must-visit museums, restaurants, and attractions, but do we ever give as much thought to where we'll rest our heads? Days spent exploring the city require a good night's rest, after all.

Paris is full of gorgeous architecture—a walk down practically any street will have some kind of charm to it—but the interiors can be equally stunning, and the hotel where you stay offers a chance to soak up some more unforgettable design. Just as it's saturated in beauty, Paris is also saturated with chic, meticulously designed places to stay. We've rounded up a few options worth considering.

THE RITZ

The Ritz is one of the grandest hotels in the city. A familiar setting for fashion editorials and classic movies, the famous hotel was recently renovated. It's hard to think of anything that could be improved upon here; every detail is exactly right. If a stay isn't in the cards, stop by for a cocktail at the legendary Bar Hemingway or afternoon tea at Salon Proust.

HÔTEL DU TEMPS

This small hotel has a friendly staff, smart design, and cheery, bright rooms. What more could one ask for? A good location and reasonable prices—they have those, too. There's a small bar downstairs, and plenty of restaurants and cafés to choose from on Rue du Faubourg Poissonnière, which is just around the corner.

HÔTEL PROVIDENCE

Hôtel Providence is having a moment, and for good reason. Impeccably designed rooms are filled with just the right amenities, including a smartphone with unlimited internet (goodbye, roaming fees) and a custom city guide; a computer (for those compelled to do a bit of work while on vacation); and a custom-made bar (for those who understand that vacation is for play). The downstairs bar and restaurant serve delicious food and drinks, and seem to always be bustling. The neighborhood is home to some of the best bakeries and cafés in the city, and Canal Saint-Martin is just a short walk away.

HÔTEL SAINT-MARC

Located in the 2nd arrondissement, with easy access to many notable shops, restaurants, and must-see monuments, Hôtel Saint-Marc is a small hotel with a lot to offer. The building dates to 1791, but has been renovated to include all the luxuries a modern traveler could want. Every corner of the art deco–inspired interior is picturesque, and the service is equally memorable. Start the day outdoors with breakfast in the courtyard. After wandering the city, treat yourself to an afternoon in the hotel's spa, which includes an indoor pool and steam room.

HÔTEL ESMERALDA

Hôtel Esmeralda has been in business for more than one hundred years. This Latin Quarter mainstay has always been popular among artists. Across the river from Notre-Dame (and, of course, named after the heroine in Victor Hugo's story) and right near Shakespeare and Co., it's the perfect stay for the literary traveler. The décor is quirky and charming, and the antique wooden staircase adds to the bohemian vibe.

APARTMENT RENTALS

Sometimes you want more space and a kitchen for cooking with produce from the local markets. For apartment rentals in Paris, we recommend Kid & Coe (for families) and One Fine Stay. Both websites have impeccably curated properties in the most desirable parts of town.

kidandcoe.com
onefinestay.com

HÔTEL DU TEMPS

HÔTEL PROVIDENCE

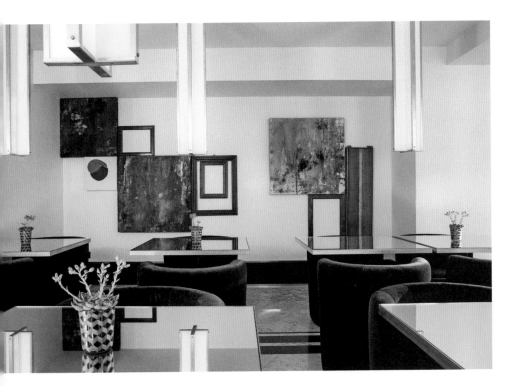

HÔTEL SAINT-MARC

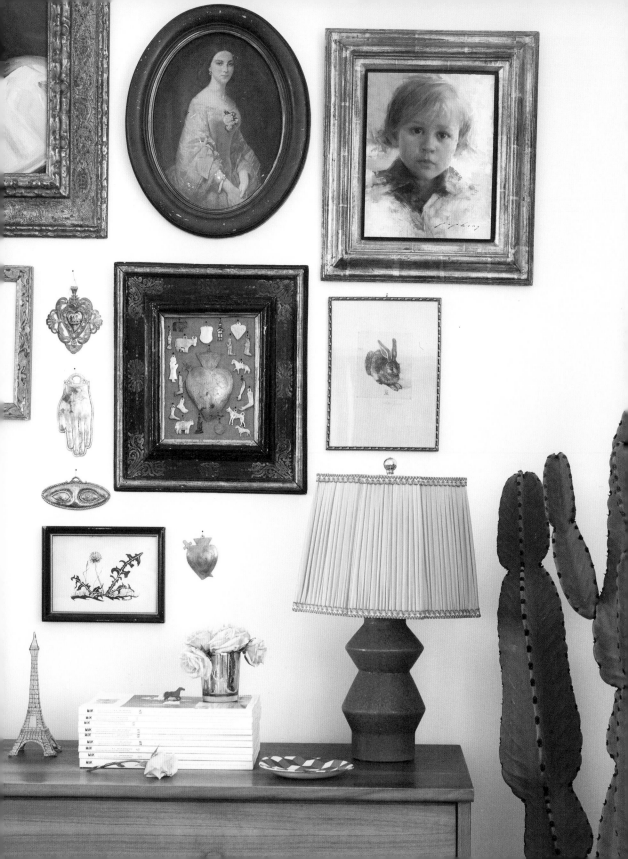

Chez Moi

TIPS FROM INTERIOR DESIGNER AND
STYLIST META COLEMAN ON HOW TO
INFUSE YOUR HOME WITH CHARACTER

STYLING AND TEXT BY META COLEMAN

Traveling never fails to inspire my design sensibilities, so I was excited to get some fresh ideas while visiting Paris last January. During my stay, I attended **Maison et Objet**, a trade fair dedicated to interior, textile, and furniture design. One of the shops, **Astier de Villatte**, was packed with exquisitely handcrafted eighteenth century–inspired ceramics glazed in a milky white. I admired them all but, true to form, I wound up buying one of the only pieces in the shop that incorporated color—the red and blue design on this plate (see opposite, on dresser) was really calling my name.

I love to bring home small mementos for my kids, so I was delighted to find this hand-painted paper **Eiffel Tower** from **Petit Pan** (see opposite, on dresser), which I found so unique compared with the many Eiffel Tower souvenirs available throughout the city.

One of my favorite destinations in Paris is the **Marché aux Puces de Saint-Ouen**, a gigantic flea market chock-full of vintage furniture, light fixtures, doorknobs, basically any home décor item you can imagine (also see pages 80–81). While I was there, freezing in the January air, I found myself gazing a little too long at this lovely pink lampshade (see opposite). The shop owner, wearing a beret and a big smile, took notice and offered me a deal that I couldn't pass up. I left the market dizzy with excitement and vaguely wondering how I was going to get my new treasure back home.

Of course, you don't have to buy a souvenir to take design ideas home with you. I make it a priority to visit museums when I travel and, on this trip, I went to the **Musée des Arts Décoratifs**. I'm endlessly fascinated with how people live, so being immersed in historic interiors and seeing decorative arts from different places and times was a highlight of my trip. While I was there, the museum featured a fantastic Bauhaus exhibit. I found the colors, shapes, and overall design of that movement so inspiring that after I came home, I made a simple Bauhaus-esque candle sconce to hang on my wall (see above).

After being away, I feel like the things I bring home with me, be they objects or ideas, not only give my home more character, more depth, and more dimension, but also provide physical reminders of the wonderful, happy memories I created while getting to know a new place.

For plant designer Kali Vermes,
home and family are essential
to her creative process

BY MEG CONLEY

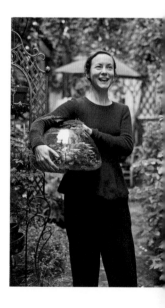

The
Glass
Gardens
of Kali

Kali Vermes was "born into a world of photography." Her father Philippe Vermes, a painter turned portrait photographer, involved her in his work from an early age. She grew up posing for him and helping develop his prints and Polaroids, a process she says was very manual and helped her to connect with his work.

Like her father, Kali became a photographer and is heavily influenced by her mother, Nancy Vermes, who is the "guiding angel" helping both Kali and Philippe to focus and move forward in their work. But unlike her father, Kali eventually moved on from photography to the more hands-on job of creating with plants. She designs terraces, floral arrangements, terrariums, and all kinds of plant-based projects for top hotels, publications, and private clients.

We caught up with Kali in her family's atmospheric home and garden not far from the Place de la Bastille.

How did you decide to change fields from photography to plant design?

I made my first terrarium because I wanted to make something with my hands. I was working on a book project with a series of photographs I had shot at the Watermill Center and was having trouble getting the project off the ground. During my residency at the Center, I had started to associate gardening with taking pictures, so I wanted to return to that. Combining a physical activity with a visual one was thrilling and greatly inspiring. It also stemmed from a need to watch plants grow, to care for them, and to protect them during the hard winter. I haven't stopped working with plants ever since!

Tell us about some of your projects.

I've been creating gardens and terraces in private homes and boutique hotels since 2010. Last spring, I designed the plant installations for the new **Hôtel National des Arts et Métiers** from head to toe. I wrote a book about terrariums called *Les Jardins de Verre de Kali (The Glass Gardens of Kali)*. And I did the terrace of the **Hôtel Amour**, among many other projects (including my own family's garden!).

How did you go about designing your family's garden? Was the process different than that of working with a client?

Actually, it was my father who started working on the garden when they first moved in. But I've taken over and am gradually adding things I recuperate here and there from different jobs and nurseries. It's like working on a patchwork quilt, little by little, which is different than the compressed timeline of working on a project for a client. For the

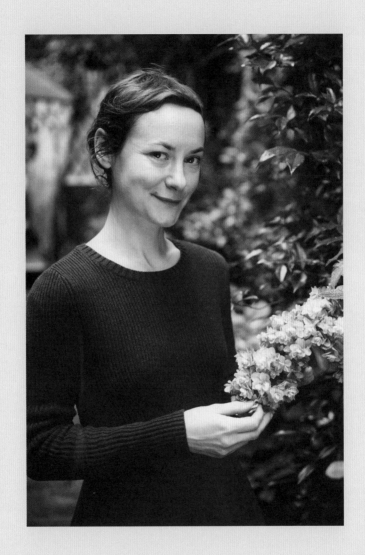

family garden, my process is intuitive—shaped by the different plants at hand and the available space and light.

I'd love to hear more about your family home. It's absolutely magical!

We moved into this flat in 1995. My father had a small photo studio in the same building as a feather duster factory when he heard that the factory was for sale. He jumped on the opportunity to buy it and converted it into his studio and the family home, separated by a small garden. He loves having his home and workspace right next to each other.

Over the years my parents filled the flat with furniture, books, objects, photos, and memorabilia. I think my father even worked at a

flea market for a while and brought a lot of things home. He also found a lot of objects in the neighborhood—when buildings were being destroyed he would save things that were going to be thrown away. Both my mother and father are inveterate collectors. One of the most special things in our flat is the half tail French piano. It has always been at the heart of our home—music had an important place in our upbringing.

Where did your parents grow up, and how did they meet?

My mother grew up in Laconia, New Hampshire. Her immigrant parents had a photography shop, and her father was a very active professional photographer.

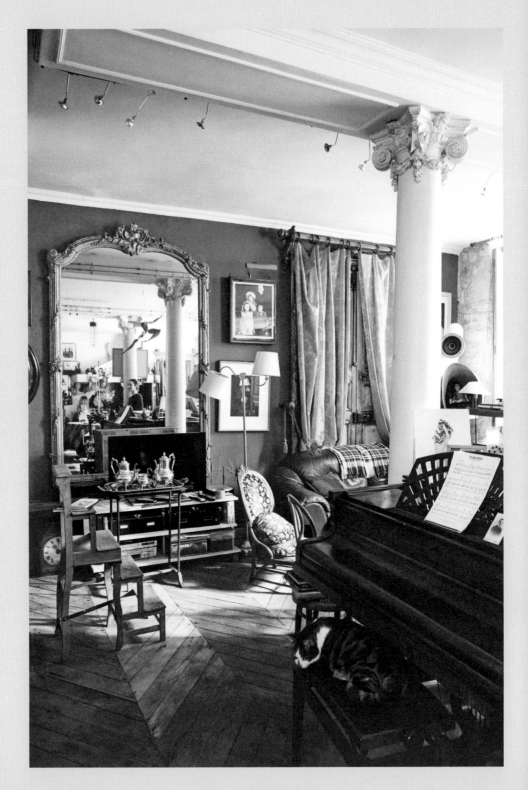

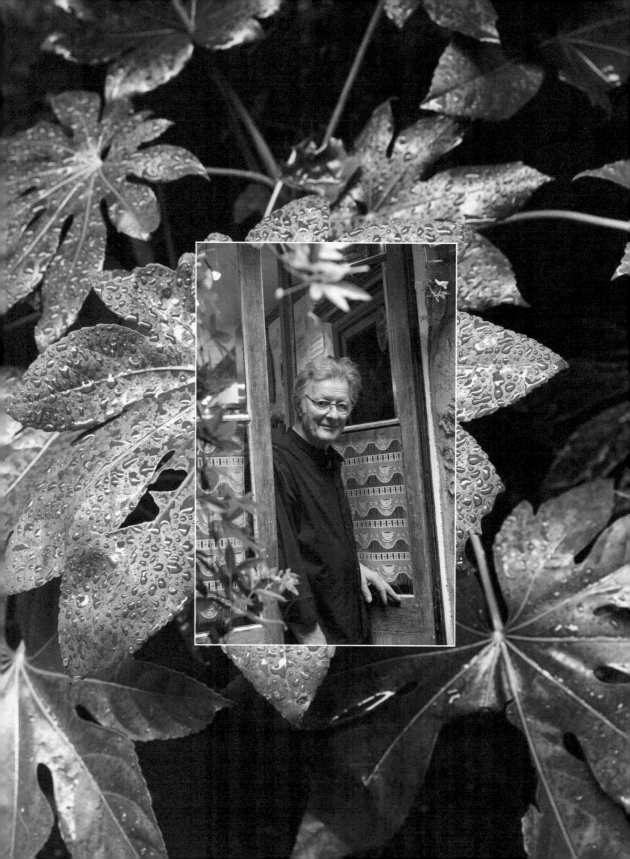

My father grew up in the countryside in Normandy. He comes from a family of farmers. He loved helping his mother in the garden but at age twenty moved to Paris to attend École nationale supérieure des Beaux-Arts [a prestigious art school]. He started out as a painter but later became a photographer when he met my mother.

They met in Paris through a Mexican painter friend they had in common. My father was making candles at the time and he left a set with my mother so she could sell them to her friends but instead she used them all at a party and when he returned she had to tell him the news and that's when they fell in love!

What was it like for you growing up in the Bastille neighborhood of Paris?

I like that it was quite *populaire*, which in French means "working class." It was low-key, with lots of artisan workshops, but then you have these beautiful seventeenth-century residences—these *hôtels particuliers* [mansions with private courtyards].

Do you have any childhood memories that influence your work? If so, what?

I remember going to the **Jardin des Plantes** (which is just across the river). We'd also go to **the market on the Île de la Cité** where my dad would buy plants and birds for the collection of birdcages and planters that he would meticulously refurbish every spring.

Can you tell us about any upcoming projects?

Right now, I'm finishing a big terrace for a client who has a mesmerizing view of the Parc de Saint-Cloud. And I recently was a floral artist on a photo shoot for *Vogue Ukraine*. I'm really enjoying branching out with plants into new territories.

kalivermes.com
philippevermes.com

KALI'S FAVORITE FLORAL AND PLANT SHOPS IN PARIS

Leaf
Mama Petula
Stanislas Draber
Succulent Cactus
Variation Végétale

A CREATIVE STATE OF MIND

An honest conversation
with interior designer Laure
Chouraqui on the inevitable
ups and downs of working
in the design industry

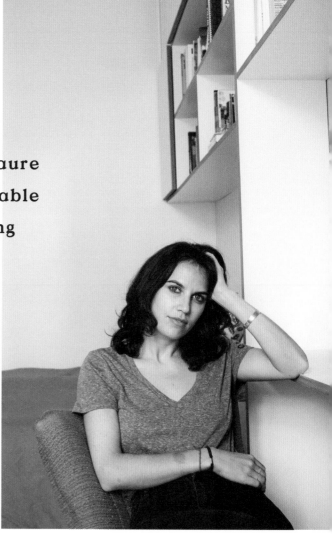

As Laure Chouraqui was growing up in Paris and abroad, she dreamed of going to architecture school. That dream came true, and soon she was working for prestigious players in the French design scene. Eventually she opened her own interior design firm with a couple of colleagues. Laure shares her story, tells us about the Parisian apartment she designed for herself, and explains why she moved on from her firm, despite its success.

What was it like growing up in Paris?

Actually, I was born in Paris but moved around a lot as a kid. I spent my first year in London. I don't remember living there, but I think it made an impression on me subconsciously because I still love that city so much. Then I spent two years in Hong Kong around the age of five, and a couple more in the Philippines around the age of eleven—both times for my father's work. In between those times abroad, we'd always come back to Paris.

When I was thirteen years old, I started to really get to know Paris—especially my neighborhood near the **Luxembourg Gardens**. All my friends lived in the neighborhood, and we'd hang out, go to the park, drink coffee in the Place Vavin at the **Lucernaire**, eat Chinese food on Sundays, go to the movies on the Boulevard Montparnasse . . . It was a nice time of life in a beautiful area of Paris.

How did you decide to become an interior designer and how did you get your start in that field?

I had always loved interiors—dollhouses, furniture, buildings, etc.—so I applied to architecture school. While in college, I realized I loved interior design more than anything, and I did an internship at *Marie Claire Maison*,

which is one of the biggest interiors magazines in France. Such a good experience!

After finishing my studies, I worked in a few places, including **Merci**, my favorite concept store in Paris. I was a stylist and assisted the art director, Daniel Rozensztroch. I then worked for Dorothée Meilichzon, who designs restaurants and hotels in Paris, London, and New York. Eventually, a couple of friends and I started Studio Sur Rue, an interior design company. We designed apartments and restaurants, from beginning to end.

Tell us more about Studio Sur Rue.

There were three of us friends, all unemployed and looking for new experiences. We decided to do something together. My friend David introduced me to our first client, and we started by designing his apartment in Neuilly (a very elegant suburb of Paris). Then new projects arrived—a restaurant, many other apartments, another restaurant . . . We were busy moving from project to project for almost four years.

I really enjoyed working on these projects, but I also felt I was caught up in the business and project management side of things and didn't have as much time to spend working with creative ideas, like I had at **Merci**. I missed

that. So I decided I needed to make a change and take a step back from Studio Sur Rue. Right now I am taking some time to figure out which direction I will go in next.

<u>Anything you can share?</u>

Haha, I'm not sure yet, but I will for sure do something with interiors, objects, or even food! But right now, as I'm writing this, I'm freaking out!

<u>What would be your dream project?</u>

I would love to own a beautiful shop selling objects, fabrics, food—just beautiful and good things, with good and interesting people. And we would do yoga all together. Too dreamy?

<u>That sounds amazing! In the meantime, I hear you rent out your apartment on Airbnb from time to time, is that right?</u>

Yes, I love hosting people, and I even made a little guide for them to use when they arrive, with my favorite addresses in it. Plus, renting the apartment out is a nice way to get a little money when I am not in Paris.

<u>And you designed your apartment, which is in the very cool Strasbourg–Saint-Denis neighborhood. Tell us about that process!</u>

That was such a great project. It's not a big apartment and I didn't have a big budget, so I concentrated on the bathroom and the bedroom. I designed a big built-in wardrobe for the room, which is the masterpiece of the place. I mixed old and new furniture. I bought a

Pierre Paulin chair (my favorite designer) and, well, I love being in this apartment—it feels really cozy!

Guests also appreciate the good vibes and refined design of my place. And they love the area, which is amazing with so many stores, cafés, and easy access to the Métro.

<u>What is it like being an Airbnb host in Paris? We've heard the city is cracking down on short-term apartment rentals, like New York City and many other places have. Does this affect you much?</u>

Right now, not at all. Honestly, I have too many Airbnb proposals, and I have to keep saying no. If I didn't, I wouldn't be able to live in my place anymore!

LAURE'S FAVORITE PLACES FOR INTERIORS AND INSPIRATION

Fondation Louis Vuitton
L'Institut Suédois
Le Bon Marché
Maison de Claude Monet in Giverny
 and the gardens
Marché des Enfants Rouges
Musée de la Chasse et de la Nature
Musée Rodin
Musée Zadkine
Théâtre des Bouffes du Nord

airbnb.fr/rooms/4853105?s=51
@laurechouraqui

USHA BORA OF JAMINI,
A TEXTILES BRAND

One of the factors that makes Paris's creative community so dynamic and exciting is the influence of so many different cultures from around the world. Usha Bora is the founder of and textile designer at Franco-Indian brand Jamini, which makes pillows, tablecloths, blankets, and more. She shares her story, her love for her city, and how her multicultural identity makes her designs so original.

By Erin Austen Abbott

FIVE QUESTIONS

How did you start working in textile design?

The birth of my first child made me realize I needed to create a meaningful bridge with India. I missed the colors, the food, and my friends and family, and I had to create a professional situation that would allow me to travel between India and France very frequently.

Once you decided textiles were your path, how did you go about making that dream a reality?

I had no experience in design—only a passion for textiles, an eye for detail, and a commitment to try and preserve traditional Indian crafts and savoir faire. At first, I worked as a freelance sourcing agent for some top French brands. Working with creative teams in these companies made me learn the basics of the textile industry and gave me an insight into French design and trends. I was really lucky to be able to adapt traditional Indian textile techniques for these discerning French brands. A few seasons later, I decided

to launch my own lifestyle brand, and that is how Jamini was born!

How do you think your connection to both French and Indian cultures benefits your work?

I am so lucky to belong to two fabulously creative and rich countries. Everywhere you look in India or in France is fodder for creativity. My Franco-Indian way of seeing the world allows me to interpret and adapt designs and techniques in different ways very quickly. So that's how I create things. I can see the potential in the simplest of details— on a stone carving in India or a French lace detail in a museum. My multicultural identity is unique, and this is what makes my designs and my brand so special and completely original!

How did you pick the locations for your two shops? What do you like about those neighborhoods?

My choice for the first shop was easy. I live in the Canal Saint-Martin neighborhood in Paris, and I watched the area evolve over the years from a slightly grungy neighborhood into a more gentrified, hipster-populated part of Paris. The city of Paris started an interesting project to move older, wholesale businesses out of the area and make those spaces available to rent to newer businesses targeting the younger, trendier population. I was lucky to be chosen as one of the first entrepreneurs to open a retail store on Rue du Château d'Eau.

As far as the second store is concerned, I studied the area around the Rue des Martyrs

neighborhood, which is one of Paris's top market streets. This street attracts a lot of high-income food connoisseurs and also has some hip hotels like the **Hôtel Amour** and **Hotel Panache**, which attract design-loving tourists. This area was missing home accessories stores for the growing *bobo* population, and it was a great choice for my second store.

What's your idea of a perfect day in Paris?

Lazy breakfast with fresh orange juice and croissants at my favorite neighborhood café—the newly opened **OHPE** café/store on Rue du Château d'Eau—followed by a walk to my stores. I often have lunch with friends in the 9th or 10th arrondissments. Many of my designer/journalist friends work in the area, and my favorite lunch spot is **Richer**, on Rue Richer. In the summer, Parisian bars spring up on streets and sidewalks, and this is really my favorite moment of the day—enjoying a glass of Burgundy in a small bar around Canal Saint-Martin! On weekends, I love walking in the city because every season is different and Paris is so stunningly beautiful at all times of the year! The ice cream at **Berthillon** is still my favorite, and I love the newly renovated **Monnaie de Paris** for their interesting and quirky exhibits.

USHA'S FAVORITE PARISIAN SPOTS FOR TEXTILE INSPIRATION

Musée des Arts Décoratifs
"Amazing exhibitions on design and fashion and an incredible bookstore."

Marchés aux Puces de la Porte de Vanves and Saint-Ouen
"I love hunting for vintage prints and weaves."

Pierre Frey
"A must-visit for textile lovers."

Musée Guimet
"Beautiful exhibits from China and Japan that showcase their magnificent textile traditions."

Merci
"The perfect shop for buying bed linens . . . the most beautiful shades."

jaminidesign.com
@jaminidesign

INTERLUDE:
LOUISE JOURDAIN-GASSIN
OF SÉRIE LIMITÉE LOUISE,
A HOME GOODS BRAND

By Erin Austen Abbott

When you have a passion for design, home goods, and vintage photography, starting your own business that could blend them all together seems like a dream. But that's exactly what Louise Jourdan-Gassin did when she started Série Limitée LOUISE, her brand of handmade napkins, aprons, and other items for the home. "I worked with a product designer for five years. I experienced all the diverse aspects of having a company, from accounting to dealing with the press. After a while, I wanted to do something for myself and to have my own brand." says Louise. Now spending hours at Paris flea markets and auction sales is part of her job. Creating and sourcing designs that will appear on a screen-printed stonewashed linen tea towel collection, for example, and making homes more beautiful.

serielimiteelouise.com
@serielimiteelouise

Louise's studio playlist

"I'll Be Seeing You," Billie Holiday, *Billie Holiday*

"And I Love Him," Esther Phillips, *And I Love Him*

"Into My Arms," Nick Cave & The Bad Seeds, *The Boatman's Call*

"Simply Beautiful," Al Green, *I'm Still in Love with You*

"After Hours," The Velvet Underground, *The Velvet Underground*

"L'anamour," Serge Gainsbourg, *Jane Birkin & Serge Gainsbourg*

"Hier encore," Charles Aznavour, *Que c'est triste Venise*

"Dis, quand reviendras tu?," Barbara, *Liberté*

"Il est cinq heures, Paris s'éveille," Jacques Dutronc, *Le Meilleur de Jacques DuTronc*

"Ann Wants to Dance," Papooz, *Green Juice*

"The Chain," Fleetwood Mac, *Rumours*

"How Can You Mend a Broken Heart," Al Green, *Let's Stay Together*

"My Baby Just Cares for Me," Nina Simone, *Little Girl Blue*

You can listen to Louise's playlist on Spotify at http://spoti.fi/2wtV24G

ITINERARY:

THE CHARM OF HIDDEN PASSAGEWAYS

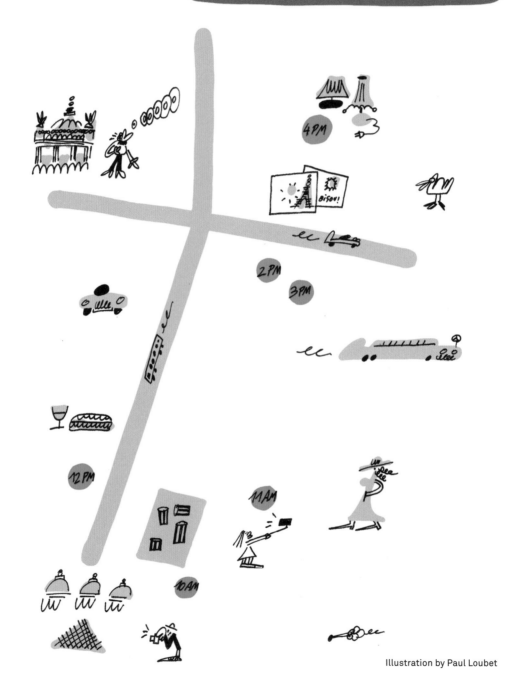

Illustration by Paul Loubet

Spend a day discovering these hidden remnants of nineteenth-century architecture

There's something magical about stepping into one of Paris's many covered passages. Pedestrian lanes protected by a glass roof and often lined with small shops and restaurants, they're fascinating survivors of nineteenth-century architecture. In the 1850s, there were 150 of these arcades scattered across the city. Today, only a couple dozen remain, but they're still perfect places to explore by foot on a drizzly day.

10:00 A.M.

Let's begin at the **Palais-Royal**. Over the course of its nearly four hundred years of existence, this example of seventeenth-century architecture has gone from regal residence to shopping mecca to house of ill repute to public treasure. Striped columns from Daniel Buren's 1986 art installation fill the inner courtyard and provide a striking postmodern contrast to the rococo flourishes of the original architecture. One of Paris's most popular covered passages, Galerie d'Orléans, was torn down in the 1930s, but you can still find highend shops like **Maison Fabre** (gloves), **Bacqueville** (royal and military medals), and **Didier Ludot** (vintage designer clothes) along the arcades surrounding the Palais-Royal garden.
8 rue de Montpensier, 75001
+33 1 47 03 92 16

11:00 A.M.

From the northern end of the Palais-Royal, walk through the Passage des Deux Pavillons and you'll see the entrance to the **Galerie Colbert** across the street. Take a quick look inside to see the magnificent marble pillars and glass rotunda. Next, step into the neighboring **Galerie Vivienne**. The tiled mosaic floor, soaring glass ceiling, and other ornate details make this one of the most iconic and well-known passageways in Paris. You'll find a variety of shops and restaurants—I like **Mad et Len** for candles; our food and drink editor, Rebekah Peppler, recommends **Legrand Filles et Fils** for wine (and candy!); and we both love browsing the antique books.
Galerie Colbert: 4 rue Vivienne, 75002
+33 1 47 03 89 00
Galerie Vivienne: 5 rue de la Banque, 75002

12:00 P.M.

With one of the best contemporary tasting menus in Paris (**Verjus**), a small, beautiful wine bar with a killer snack menu (**Verjus Bar à Vins**), and a casual, chic, brunch-with-the-best-of-them spot (**Ellsworth**), American expat team Braden Perkins and Laura Adrian have a trifecta of awesome options in the 1st, all within a few minutes' walk of Galerie Vivienne.
Verjus: 52 rue de Richelieu, 75001
+33 1 42 97 54 40
Reservations required.
Verjus Bar à Vins: 47 rue de Montpensier, 75001
+33 1 42 97 54 40
Ellsworth: 34 rue de Richelieu, 75001
+33 1 42 60 59 66

2:00 P.M.

After a leisurely lunch, head to **Passage des Panoramas**, which is considered the oldest passageway in Paris (built in 1799). In my opinion, it's also the most charming, with architecture remaining from original businesses like the Chocolatier Marquis and the Stern print shop. This arcade specializes in antique paper ephemera (so of course it would be my favorite)—a perfect spot to pick up some postcards for friends back home or pretty stamps for your collection. At the north end of Passage des Panoramas, you'll find the **Théâtre des Variétés**, which was founded by Marguerite Brunet under the guidance of Napoleon himself. You can still catch a performance today amid the Second Empire style of red velvet, gold filigree, and classic columns.

Passage des Panoramas: 11 boulevard Montmartre, 75002
contact@passagedespanoramas.fr
Théâtre des Variétés: 7 boulevard Montmartre, 75002
+33 1 42 33 09 92

Tip: You can buy tickets to performances at the Théâtre des Variétés online, by phone, or directly from the box of-fice, which is open from 11 A.M. to 6 P.M. Monday through Saturday and 12 P.M. to 4 P.M. on Sunday. If you're lucky, they might have something available day-of.

3:00 P.M.

Conveniently across the street, **Passage Jouffroy** feels like a continuation of the enchanting Passage des Panoramas. Inside you'll find the quaint toy shop **Pain d'Épices,** vintage and new comics and children's books at **Le Petit Roi,** and even a cozy and affordable place to stay, **Hôtel Chopin.** When lucky hotel guests return after hours, they get a kick out of strolling down the glass-covered passage with no one else in sight.

10-12 boulevard Montmartre, 75009
passagejouffroy@free.fr

4:00 P.M.

Passage Verdeau was named after its architect, who delightfully designed the iron ribs in the glass ceiling to look like the bones of a fish. Browse the antiques, books, and more among the shops of this beautiful arcade—one of our favorites is **Librairie Farfouille**. As you leave, turn left and walk down to the corner, where you'll find **À la Mère de Famille.** While there are several newer outlets around Paris, their flagship store, founded in 1761, is the oldest chocolate shop in Paris. Its tiled flooring, vintage lighting, and charming grandeur make the original the store to frequent. Pick up a few smart, orange-labeled boxes as gifts, and don't forget to get a treat for yourself.

Passage Verdeau: 6 rue de la Grange Batelière, 75003
infos@passagesetgaleries.fr
À la Mère de Famille: 35 rue du Faubourg Montmartre, 75009
+33 1 47 70 83 69

A FEW MORE PARISIAN PASSAGEWAYS AND COURTYARDS WE LOVE

Covered Passageways
Galerie Véro-Dodat
Passage Brady
Passage du Caire
Passage du Grand Cerf
Passage Molière

Courtyards
Cité Berryer
Cour Damoye
La Cour du Mûrier, l'École des Beaux Arts
Honor Café
Hôtel des Grands Écoles
Place Dauphine
Square Edouard VII

Tip: If you keep an eye out, you can often spy hidden courtyards and passageways as you tour the city. The ones we've listed here are open to the public, but if you're discreet, private courtyards with an open door can be fun to explore as well.

Sixteen Instagram Accounts to Follow for Interiors + Exteriors in Paris

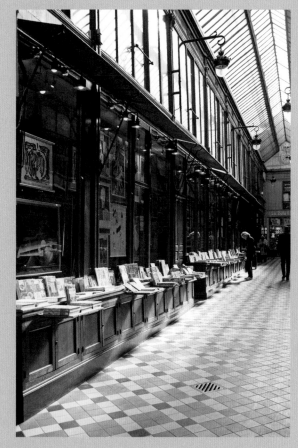

Passage Jouffroy

DESIGNERS

@hejustudio
@indiamahdavi
@jacques.grange
@vincent_darre

MAGAZINES

@ad_magazine
@milkdecoration_magazine
@thesocialitefamily

INFLUENCERS

@cecilemoli
@jasminetartine
@nathill
@raulcabrera
@ruerodier

SHOPS

@caravane_paris
@hartoedition
@jamini_design
@merciparis

Creative Food + Drink

You can't write about Paris without mentioning its incredible food and drink. Many of the chefs and pâtissiers in the city are artists in every sense of the word. Restaurateurs realize that the visuals of their establishments are as important as the menu. Even the produce at the markets is beautiful to behold and makes a wonderful subject for photography. With that in mind, keep reading to explore Paris's design-driven food scene. We'll discover a recipe starring an elegant bottle of French spirits and the story of how an American expat discovered French markets and her own creativity, along with recipes of classic French dishes. We'll also catch up with baker Frank Barron (aka Cakeboy Paris) in his refined Parisian apartment, discover the design philosophy of restaurant owner Mikael Attar, learn what music inspires Emma Sawko of Wild & The Moon, and tell you where to look for creative Paris-based food feeds on Instagram.

"At the closing hour we walked back through the dusk, lingering before the statues in the Tuileries gardens, and

when we had
dined off white
beans, salad,
and red wine, we
were about as
happy as anyone
could be."

ISADORA DUNCAN

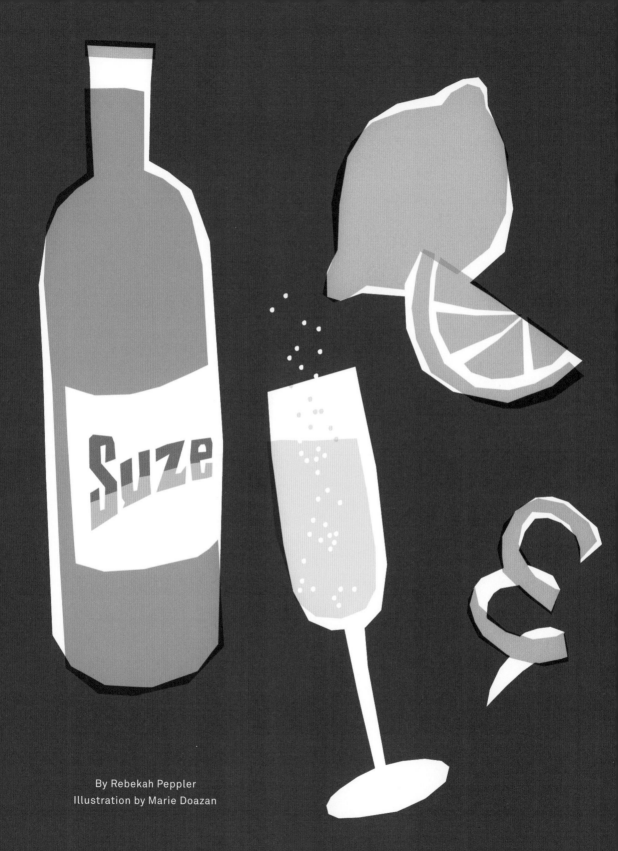

By Rebekah Peppler

Illustration by Marie Doazan

Hey, Suze

A recipe starring a striking and
historic French spirit

I've spent years perfecting the art of the liquid souvenir. Any and all amaro from Italy, rum (trust me) from India, some questionable cherry-flavored rakija from Croatia, and, until recently, Suze from France. After being wrapped carefully in the classic traveler's swaddle of dirty clothes and hope, each bottle joins the ranks of my home bar, destined to return us to these places, one sip at a time.

France's bittersweet, brilliantly yellow apéritif has become available stateside, leaving a con-veniently 750ml-size space in my suitcase for a new bottle to smuggle back to friends. (Cur-rently in rotation: Picon, Maison Denoix Fenouillette, and Noilly Prat's Ambré vermouth.) Invented in the 1880s by Fernand Moureaux, Suze gets its bitter notes from both wild and farmed gentian root. The root is native to the mountainous regions of France and Switzerland and used in plenty of other deliciously bitter spirits like as Campari, Salers, Avèze, and Angostura bitters. In Suze, gentian is macerated in grain alcohol before being pressed, distilled, and infused with a secret blend of aromatics. The result is bitter, yes, but also delicate, floral, and earthy.

Across France, Suze is served neat or on the rocks with a twist or—if you're feeling extra nouveau—with a splash of tonic. With increasing regularity, cocktail bars both in Europe and stateside sub it in for the Campari in a Negroni and rebrand the drink a "White Negroni." While I'm more than happy to pair my Suze with gin, I prefer it up, with bubbles, like in this take on a French 75. Serve it in a champagne glass or coupe, if you must, but I prefer the simplicity of a standard wineglass.

Suze 75

Makes 1 drink

½ ounce Suze
1 ounce gin
1 ounce fresh lemon juice
½ ounce simple syrup
Ice
Champagne or sparkling wine
Lemon twist, for garnish

In a cocktail shaker, combine the Suze, gin, lemon juice, simple syrup, and ice. Shake vigorously, then strain through a fine-mesh sieve into a chilled wine-glass. Top with champagne and serve with the lemon twist.

By Laurel Miller

Recipes by Emily Dilling

Prop styling by Astrid Chastka

Food styling by Pearl Jones

American expat and cookbook author Emily Dilling
discovers there's freedom in cooking sans shopping list

To Market,
to Market

France has inspired generations of food writers, from Marcel Proust to Julia Child and now newcomer Emily Dilling, whose first book, *My Paris Market Cookbook: A Culinary Tour of French Flavors and Seasonal Recipes*, was conceived while she was living in the 18th arrondissement off Boulevard Barbès, a diverse neighborhood populated by North African, Lebanese, and Greek eateries, cozy bistros, and the lively **Marché Ornano**. Dilling, a freelance writer and founder of the *Paris*

Paysanne blog and podcast, found herself captivated by her adopted city's food markets. That passion for produce and craft foods has sent her on a unique culinary trajectory.

Raised in the San Francisco Bay Area, Dilling comes from a family enamored of eating. "My mom always made home-cooked meals, and dinner was always shared at the table with family. I was lucky to be exposed to food that was both nourishing and made for sharing."

Back in 2010, Dilling had an epiphany while traveling throughout the West Coast of the United States. "That was when I started looking at where food comes from more closely," she says. "The excitement about food I experienced along the way—from farmers' markets in San Francisco and Portland to food activism in Seattle—got me thinking about what we eat in a different way."

After Dilling returned to France later that year, she began seeing the similarities between the food movement she'd observed in the States and what was happening in Paris. "I started meeting farmers and food artisans at my local markets, and that's how I found my tribe," she says.

Dilling first visited France as part of an exchange student program at Washington State's Evergreen College. "The idea was to improve my French and learn how to be French," she says. While Paris wasn't what initially attracted her ("I just fell for the culture and the language"), she soon grew enamored of the city: "I never dreamed of macarons or falling in love by the light of the Eiffel Tower; to me, Paris isn't an idealized place, but it feels like home. It's given me so much, and I can never be separate from it. There's a rich and lively diversity and kindness of strangers that makes it like no other place in the world." Though she initially set out to write a guidebook to the city's markets, it quickly morphed into a cookbook shaped around original recipes that Dilling describes as "traditionally French, yet accessible for readers everywhere, like one-pot meals and simple desserts.

If people feel confident in the kitchen, they're more likely to sustain themselves and their families by making home-cooked meals."

Dilling also acknowledges Paris's "collaborative, evolving, and product-focused" food scene: "What we're seeing that's new here is an openness to embracing foreign influence. You can see that the coffee culture is heavily influenced by Australia, and craft brewing beer draws inspiration from America, yet all of this is done with a certain French touch, and without any intention of co-opting a movement. I think the younger generation is traveling more and returning home excited about what they've discovered. It's a really exciting time to be in the city."

The following recipes, excerpted from Dilling's book, are her delicious take on French classics, simplified for the home cook.

EMILY'S FAVORITE PARISIAN MARKETS FOR FINDING BEAUTIFUL FOOD

Marché Bastille
Marché bio des Batignolles
Marché d'Aligre
Marché des Enfants Rouges
Marché Président Wilson

parispaysanne.com
@parispaysanne

LEMON ZEST MADELEINES

Preparation

Chill madeleine molds in the refrigerator for at least 30 minutes. Brush the chilled madeleine molds with 1 tablespoon of the melted butter, coating them evenly. Dust the molds with flour and tap out any excess. Return the madeleine molds to the refrigerator.

Whisk together the flour, baking powder, and salt in a large bowl.

In a medium bowl using a hand mixer, combine the sugar, lemon zest, and lemon juice. Beat in the eggs one at a time and continue to mix for 2 to 3 minutes more, until the batter is pale yellow.

Fold the flour mixture into the egg-sugar mixture, add the lavender, if using, and stir in the remaining 6 tablespoons melted butter.

Transfer the batter to a piping bag, if desired; otherwise, cover the bowl. Chill the batter in the refrigerator for at least 1 hour. Pipe (or spoon) the batter into each individual madeleine mold, filling them only about halfway. Lightly tap the pan against the counter to evenly distribute the batter and remove air bubbles. Chill in the refrigerator for 30 to 60 minutes.

Preheat the oven to 400°F (210°C).

Bake the madeleines for 11 to 13 minutes, until golden brown. Immediately remove them from the molds by inverting the pan and gently tapping until they fall out. Let cool on a wire rack until warm or room temperature.

Ingredients

Makes about 12 madeleines

6 tablespoons (¾ stick / 75 g) plus
 1 tablespoon butter, melted and cooled
¾ cup (85 g) sifted flour, plus more for
 dusting
2¼ teaspoons double-acting
 baking powder
Pinch of salt
½ cup (100 g) sugar
Zest and juice of 1 lemon
2 medium eggs
1 teaspoon dried lavender (optional)

TANGY
TOMATO TART

This tart is great for a light lunch accompanied by a green salad. You can dress it up by adding basil or mozzarella, but I like to keep it simple, using just a touch of Parmesan and letting the flavor of vine-ripe tomatoes stand out. The tang of Dijon mustard creates a nice balance with the sweetness of the tomatoes and the light seasoning of herbes de Provence.

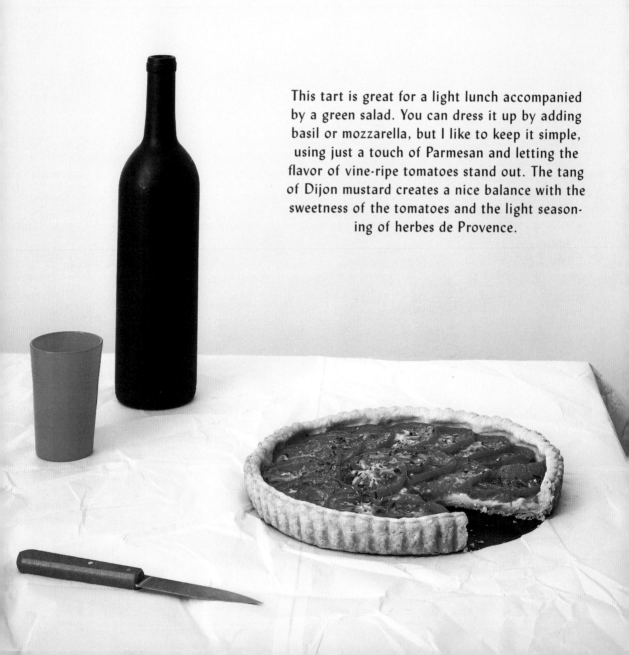

Ingredients

Makes one 10 inch (25 cm) tart

Butter, for greasing
Pâte Brisée (pie dough), recipe below
2 to 3 tablespoons Dijon mustard
4 or 5 large ripe tomatoes, cut into
 ¼-inch-(6mm) thick slices
1 tablespoon olive oil
2 teaspoons herbes de Provence
Pinch of sea salt
1 tablespoon grated Parmesan cheese

Preparation

Preheat the oven to 375°F (190°C).
Butter a 10 inch tart pan.
Roll out the pâte brisée and use it to line the bottom and sides of the prepared pan. Trim any excess dough. Prick the bottom with a fork. Spread a thin layer of Dijon mustard over the dough. Arrange the tomato slices in the pan in a circular pattern, overlapping them slightly. Drizzle the olive oil over the tomatoes, then sprinkle with the herbes de Provence, salt, and Parmesan. Bake for 25 to 30 minutes, until the tomatoes are golden brown.

Pâte Brisée

The trick with this recipe is not to overwork the dough, allowing for the water to be absorbed by the flour and butter mixture. The result is a flaky, versatile dough that works with both savory and sweet dishes. You can buy pre-made dough, of course, but there is little in life that rivals the feeling of satisfaction that comes with making your own.

2 cups (240 g) all-purpose flour
1 teaspoon fine sea salt
1 cup (225 g) chilled butter, cut into
 ½-inch (12 mm) cubes
½ cup (120 ml) ice water

Mix the flour and salt together in a bowl or food processor on low speed. Add the butter and mix until fully combined. If using a food processor, mix slowly and no longer than 15 seconds; if combining by hand, mix together for no longer than a minute, just enough to integrate the butter. It is okay if there are some lumps in the dough; these will disappear between the rolling out and baking. Slowly add ice water while combining or mixing by hand again. Do not work the dough longer than another 15 to 30 seconds with a food processor or 1 minute by hand. Gather the dough together with your hands—it can be a bit crumbly, but should stick when pressed together. Form a disc with the dough about ½ inch (12 mm) thick and 4 to 5 inches (12 cm) in diameter. Wrap in wax paper and refrigerate for at least one hour.

Once chilled, remove the dough from the refrigerator and allow it to come to room temperature. If the dough is too cold when rolling out it will tear, and if it is too warm it will stick to the rolling pin and countertop. When the dough is just lightly sticky, roll it out on a floured surface with a floured rolling pin. Roll to desired size, flipping over as necessary. Make sure the dough has a uniform thickness and that it corresponds to the size of the pie tin.

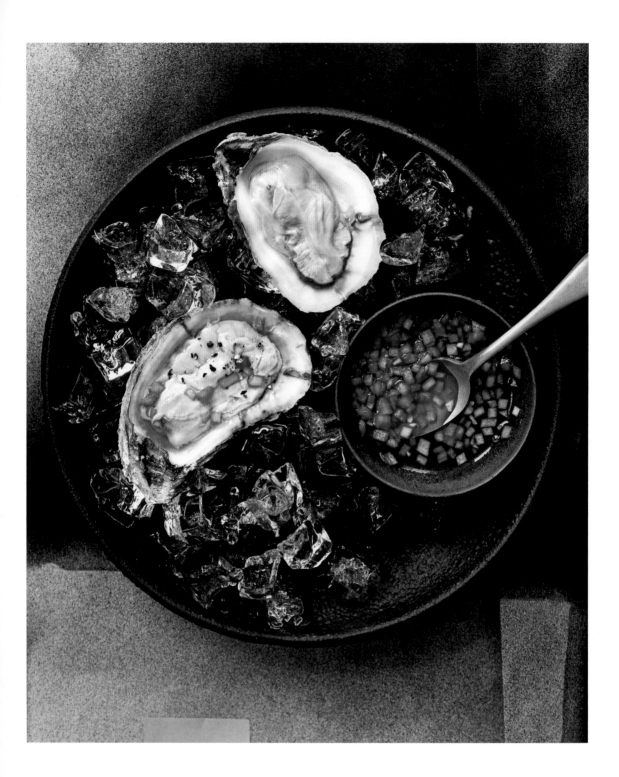

HUÎTRES À LA
SAUCE MIGNONETTE

Preparation

Make the mignonette in advance; it will be better the longer it is allowed to sit and infuse in the refrigerator.

In a small bowl, stir together the vinegar, shallots, 2 grinds of pepper, and a dash of salt. Cover and refrigerate for at least four hours before serving.

Hold a folded, clean dish towel in your oyster-holding hand to act as a shield between the oyster knife and your palm. You can also keep the back of your hand against a hard surface, such as a countertop, to give more resistance as you shuck the oysters. Insert the point of the oyster knife into the seam of the oyster; it can be hard to find a point of entry and you may have to try a few different spots. Once you've gotten into the oyster, push forward to disconnect the muscle from the shell; you will feel a click and release once you've done that, and you should be able to pry open the shell easily. Once open, pour out the liquid inside the oyster shell and then discard the top shell.

Arrange the oysters on a large plate for immediate consumption, or nestle them in ice if not serving immediately. Remove the mignonette sauce from the refrigerator at the last minute and serve with a small spoon so people can eat it with their fresh oysters.

Ingredients

For 24 oysters

1 cup (240 ml) red wine vinegar
¼ cup (35 g) finely chopped shallots
Freshly ground black pepper
Salt
24 fresh oysters

An American Baker in Paris

FRANK BARRON DISCOVERS HIS PASSION IN THE
WORLD OF FRENCH SWEETS

BY SARAH MOROZ

"Whenever a boy comes, you should always have something
baking," counsels Cher Horowitz, the sage teen played by
Alicia Silverstone in the 1995 movie classic *Clueless*. Cher
is "one of my lifestyle gurus," Frank Adrian Barron says, only
half-joking. He definitely believes one should always have
something baking.

California-born Frank landed in Paris seven years ago when his partner was relocated there for his job. An epicurean, he was elated by the move: "I went on this whole French pastry adventure and decided to have a different French pastry a day." He sampled various iterations of the Paris-Brest (choux pastry with a *mousseline pralinée*), favoring those by Jacques Genin and Philippe Conticini. His sweet tooth go-tos in Paris have expanded to include anything conceived by Pierre Hermé ("I will cross town to get a croissant Ispahan," he enthuses, citing the pâtissier's delicate trademark rose, lychee, and raspberry flavor) and *sablé* cookies from **Bontemps Pâtisseries** ("Just next-level sweet fillings . . . all hits").

He started photographing the delicacies he was eating around town, but "after a year, I basically wore myself out on French pastry by having it all the time." He started to miss "cozy, nostalgic cake—layer cake, banana bread, frosting, simple homemade stuff" that was hard to find in Paris, a city known for refined pastries and gâteaux, but not, well, cake. He turned to his own kitchen to satisfy his cravings and busily whipped up batter and buttercream, embellishing his creations with fresh berries or edible flowers. He often invited friends to indulge with him at teatime,

serving thick slices on vintage mint-hued Limoges plates tinged with gold. Like many, Frank grew up baking cakes with his mom and grandma. "Even, dare I say, cakes from a mix," he admits. His sweet tooth has remained, though he has come a long way from out-of-a-box baking.

Frank always photographs his lavish cakes, deploying a carefully orchestrated mise-en-scène featuring natural light and pretty tableware against his apartment's elegant hardwood floor and ornate molding. Posted thereafter on social media, his feed—so to speak—is a confectionery fever dream flecked with sugared cranberries, butterscotch drizzle, strawberry compote, cinnamon swirls, cream cheese frosting, and buttermilk bundt. His thousands of followers adulate over the modern-era Wayne Thiebaud installations and comment with hearts, hungry-faced emojis, and lots of exclamation points.

Photos are, indeed, a telling element of Frank's endeavor: aesthetics are as important as taste, and he is not shy about highlighting his curated life in the Marais. "The allure of Paris is far-reaching: people love this city and want to know more about it," he remarks, still clearly under the spell of the city's magnetism himself. "If you end a

sentence with 'in Paris'—like, 'I own a café . . . in Paris'—people go, WOW! Same thing: I baked a vanilla cake . . . in Paris. It does tend to elevate it," he says. "I know that—and I'm okay with that," he adds, laughing.

On Instagram, Frank christened himself Cake-boy—a reclaimed term used in his much-referenced movie *Clueless*. It always struck him as being funny, and fits the affectionate teasing he gets for the amount of sugar he consumes. "Cake is decadent and over-the-top," he says, cheekily acknowledging the parallel to himself.

Frank is a fixture of the rising craft coffee scene, often with his dog, Parker, in tow. Garrulous and charming, he knows every barista and fellow flâneur sipping a *café crème*. The opportunity to make a cake outside his home first popped up when a local café he frequented rang for a Cakeboy rescue after their habitual supplier couldn't deliver. The resulting treat was such a success that other cafés started to request his baking skills. "At first, I was like, 'It was a one-off,'" Frank says. "But then my partner and my friends asked, 'Why don't you? You should!'" From there, **Boot Café**, the tiny Marais hub where Frank is a near daily regular, filed an official order for their weekend crowd, and Parisian coffee spots **Loustic**, **Honor**, and **Café Oberkampf** have also since been supplied. Ultimately, Frank maintains an "among friends" policy and only bakes for places where he's a customer, plus the occasional custom birthday cake request.

Frank regularly sources ideas from the blog *Smitten Kitchen*, praising the site's accessible recipes and straightforward writing style. For more aspirational references, he turns to Linda Lomelino, a Swedish baker whose site

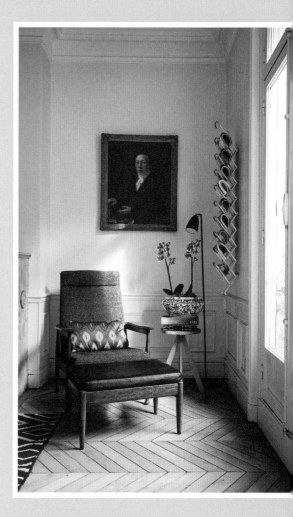

Call Me Cupcake he deems "dreamy." "They all look like Dutch seventeenth-century paintings," he says of her creations. Although Frank hopes to write original recipes in the future, for now he tweaks existing ones according to his mood, swapping chocolate for white chocolate or trying an alternate filling or garnish. He often reduces the amount of sugar, substitutes crème fraîche for sour cream, and revels in the exquisiteness of French butter ("you don't even need to buy high-end butter, and it's still amazing," he marvels). His skills as a home baker have progressed by leaps and bounds, thanks to his evolving mastery of the tools of the trade. "Two years ago, I would be like, 'You throw frosting on the cake—finished!'" he jokes. "Now I can use pastry bags and icing tips and know how to crumb coat." In this age of social media chronicling, the change is visible: "I can see the differences in my photos."

As for the future, he hopes to host baking workshops for small groups in his apartment: "I keep getting requests." Not surprisingly, he also hopes to one day pen a book on lifestyle: a kind of guide to baking and entertaining throughout the seasons.

Since his self-dubbed "buttercream shenanigans" seem almost too perfect to be real, I prodded him to reveal the one vice he can't resist. "Gummy candy," he says reflexively. (Specifically *schtroumpfs*—French for "Smurfs.") "I have thought about covering a cake in gummy candy, which I would never do . . . ever." He chuckles. "But I have fantasized!"

The following is an example of how Frank adapts recipes, giving classic American cakes a French twist.

@cakeboyparis
cakeboyparis.com

Frank Barron's Chocolate Cake with Caramel Beurre Salé

INSPIRED BY LINDA LOMELINO'S
DELUXE CHOCOLATE CAKE RECIPE

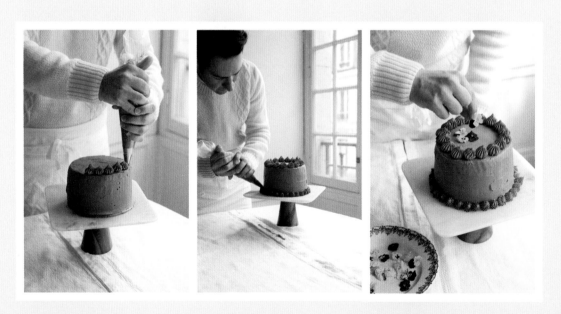

INGREDIENTS

FOR THE CAKE

Makes one 6-inch (15 cm) cake

1¾ cups (255 g) all-purpose flour
2 cups plus 2 tablespoons (425 g)
 granulated sugar
¼ cup (25 g) unsweetened cocoa powder
1 teaspoon baking powder
2 teaspoons baking soda
½ cup (120 ml) vegetable oil
1 cup (240 ml) strong-brewed coffee
1 cup (240 ml) buttermilk
1 tablespoon vanilla extract

FOR THE CARAMEL BEURRE SALÉ

1 cup (225 g) granulated sugar
6 tablespoons (85 g) salted butter at room tem-
perature,
 cut into small cubes
½ cup (120 ml) heavy cream
1 teaspoon kosher salt

FOR THE CHOCOLATE BUTTERCREAM

1½ cups (3 sticks/340 g) unsalted butter, at room
 temperature
4½ cups (565 g) confectioners' sugar
6 ounces (170 g) unsweetened chocolate, melted
 and cooled
1 tablespoon vanilla extract

TO FINISH

Maldon sea salt (optional)
Fresh flowers (optional)

PREPARATION

MAKE THE CAKE

Preheat the oven to 350°F (175ºC).

Butter and flour four 6-inch (15cm) round cake pans.

In a large bowl, sift together the flour, granulated sugar, cocoa powder, baking powder, and baking soda. Add the oil, coffee, and buttermilk and whisk until well incorporated. Add the eggs and vanilla and mix for a few minutes. Divide the batter among the prepared pans and bake for 30 to 35 minutes, until a cake tester inserted into the center of each cake comes out clean. Let the cakes cool in the pans for 15 minutes before inverting onto a wire rack.

MAKE THE CARAMEL BEURRE SALÉ

In a medium saucepan, heat the granulated sugar over medium heat, stirring continuously with a wooden spoon until the sugar turns to an amber-colored liquid. Once the sugar has completely dissolved, immediately add the butter. The mixture will bubble rapidly, so be mindful of splashback. Stir until the butter has completely melted, 2 to 3 minutes. While stirring continuously, slowly pour in the heavy cream. Allow the mixture to boil for 1 minute. Remove from the heat and stir in the salt. Allow to cool before using as your cake filling.

MAKE THE CHOCOLATE BUTTER-CREAM

In the bowl of a stand mixer fitted with the paddle attachment, beat the butter on medium-high for 2 minutes. Gradually add the confectioners' sugar and beat until well incorporated. Pour in the melted chocolate and vanilla. Mix until smooth.

ASSEMBLE THE CAKE

Level off the tops of the cake rounds with a serrated knife. Place the bottom of one cake, trimmed side up, onto a cake plate or cake round. Fill a piping bag fitted with a large plain tip with buttercream and pipe a line around the outside edge of the cake layer. Use the back of a spoon to spread one-third of the caramel over the cake layer to meet the buttercream border. Repeat with two additional cake layers, using the remaining caramel, then set the final layer trimmed side down over the filling.

Spread a very thin layer of buttercream over the whole cake. Chill the cake in the refrigerator for 15 minutes to seal in the crumbs.

Pile more buttercream on the top of the cake and work it down the sides with an offset palette knife. Once completely covered, you can switch to a larger palette knife and use it to smooth out the top and sides of the cake. For a rustic look, you can decorate the cake by sprinkling it with flakes of Maldon sea salt or, for a special occasion, with fresh flowers.

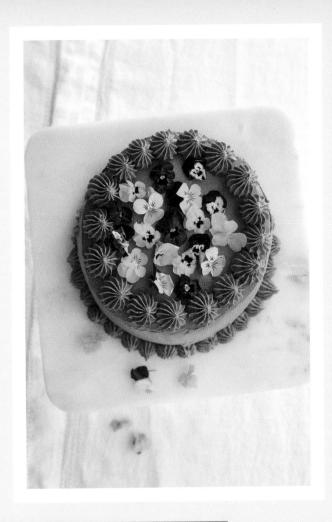

FRANK'S LIST OF THE MOST CREATIVE PASTRIES IN PARIS

Tarte au Citron (lemon tart) from Jacques Genin
Le Fraisier (strawberry cake) from François Perret at The Ritz
Paris-Brest Ispahan from Pierre Hermé
Le Mont Blanc from Mariage Frères
Fleur de Vacherin (vacherin flower) by Maxime Frédéric
at the Four Seasons George V
Saint-Honoré from Cédric Grolet
Pavlova from Bontemps Pâtisserie

MIKAEL ATTAR,
OWNER OF IMA RESTAURANT

Paris is home to many historic cafés, luxurious hotel dining rooms, and Michelin-starred establishments with exquisite food. But often when traveling, something delicious with a well-designed yet casual atmosphere is a better fit. IMA, owned by Mikael Attar and his partners, Jeremy Attuil and James Whelan, is one such place. Using high-quality seasonal ingredients in their food, they put that same attention to detail into the visuals of their restaurant.

MIKAEL'S FAVORITE EXAMPLES OF RESTAURANT DESIGN

Bouillon Pigalle
Miznon (the new location at 39
 quai de Valmy)
Pink Mamma
Ristorante National (inside l'Hôtel
 National des Arts et Métiers)

FIVE QUESTIONS

Can you tell us a little bit about your restaurant?

IMA is close to the Canal Saint Martin in the 10th arrondissement of Paris. It's a vegetarian restaurant and we work hard to use fresh, seasonal ingredients. On the menu you'll find different salads every day, *shakshuka*, pancakes, a variety of pâtisseries, and coffee from all over the world to accompany them.

How did you pick the location for IMA?

We were looking for a location in the center of Paris that would work as well during the day as at night, and during the week as well as the weekend. We also wanted offices and a local clientele from the neighborhood. The Canal Saint-Martin fit all of our criteria.

It's obvious that the visuals of your restaurant are important to you, but it must be an extra investment. What made you realize it was worth it?

More than a restaurant, we wanted to create inviting spaces where people could have a good time. Design is an integral part of that concept and brings attention to the food as well. For me, it's impossible to think only about the food—the visuals are important as well and you can't have one without the other.

Who have you worked with on restaurant design and what was that process like?

I worked with architects. My partners and I had precise ideas of what we wanted and the architects made those ideas a reality. But that doesn't mean that we didn't run into some surprises during construction! For example, we found a brick wall and a stone wall and ended up changing our plans to incorporate them into the design.

If someone had only one day to visit Paris, what would you recommend they do?

I would advise them not to come if it's only for a day! They'll leave frustrated because it takes time to get under the skin of the city and fully discover it. But, to try and respond to the question, I would tell them to walk from l'Hôtel de Ville to l'Arc de Triomphe by way of the Place de la Concorde . . . after having eaten breakfast at IMA, of course. And if they could fit in the **Louvre**, **Musée d'Orsay**, the Champs Elysée, the Place de la Concorde with its obelisque, and la Madeleine . . . it would be hard to do better.

ima.paris
@ima_paris

INTERLUDE:
EMMA SAWKO OF WILD & THE MOON, JUICE BAR AND HEALTH FOOD CAFÉ

By Erin Austen Abbott

When we think of culinary Paris, macarons, baguettes, cheese, and red wine come to mind. But there's a new wave of eating in France that could be represented by **Wild & The Moon**'s motto: "Slow food set to an urban beat." Green juices, bowls of ancient grains and roasted vegetables, salads, and other clean foods make up the menu at this modern plant-filled eatery.

Founder Emma Sawko took an interesting path to get to Wild & The Moon. Though originally from Paris, for years she lived in New York City and Dubai. It was while living in Dubai and looking for the health-conscious lifestyle that she grew up with that she and cofounder Alexandra de Montaudouin opened Comptoir 102, a concept store that blends fashion and design with a healthy café. Their concept paved the way for Emma to move back to Paris and open Wild & The Moon. Emma recalls wanting "to find a concept that I could implement in both cities, Paris and Dubai." While sourcing the fresh, farm-to-table ingredients she needed was a challenge in Dubai, "it's been a piece of cake in Paris," says Emma. "I believe eating healthy is really a global trend, and I can see it in both Paris and Dubai. Even if some

people continue to find prices high, they are also more aware of the importance of eating healthy. What you spend in healthy food you will not spend in drugstores. At the end of the day, you save money! The only downfall I've found to running my own business is the lack of time. I dream of spending more time with my family on a beach in Tulum."

wildandthemoon.com
@wildandthemoon

MORE PARISIAN HEALTHY EATING SPOTS THAT WE LOVE

Bob's Juice Bar
Echo
La Maison Plisson
Miznon
Nanashi
Rose Bakery
Tavline
Yemma

Emma's playlist

"All My Tears (Be Washed Away)," Selah feat. Kim Hill,
 Bless the Broken Road / The Duets Album
"Another Brick in the Wall," Pink Floyd, *The Wall*
"For You," Angus & Julia Stone, *Down the Way*
"Lost," Frank Ocean, *channel ORANGE*
"Back to Black," Amy Winehouse, *Back to Black*
"Because the Night," Patti Smith Group, *Easter*
"Ulay, Oh" How I Became the Bomb, *Adonis*
"Ashes," Ben Harper, *The Will to Live*
"Take Me Away," Ron Gelinas, *Electro Pop & Chill Music*
"Romeo and Juliet," Dire Straits, *Making Movies*

You can listen to Emma's playlist on Spotify at
http://spoti.fi/2MOkgFp

"Music is so important to the atmosphere of a restaurant. I choose songs for their meaning to me . . . For example, 'Another Brick in the Wall' played as I walked into my apartment in New York City on my fortieth birthday. All my friends where there—it was crazy. 'Because the Night' because it does belong to lovers. And I love Patti Smith—her poetry, her punk ways, and her activism. 'Romeo and Juliet' is an an oldie but goodie. I'm forever in love with this song. It reminds me of my teenage years, and it has stayed with me my whole life. And 'How I Became the Bomb' is my chill-time song. After a long day of work, I crash on the sofa and mumble 'Ulay, ulay, oh . . .' "

ITINERARY:

EATING AND DRINKING IN STYLE
BELLEVILLE + CANAL ST-MARTIN

Have a celebratory night strolling from one delicious drink to the next

By Rebekah Peppler
Illustration by Paul Loubet

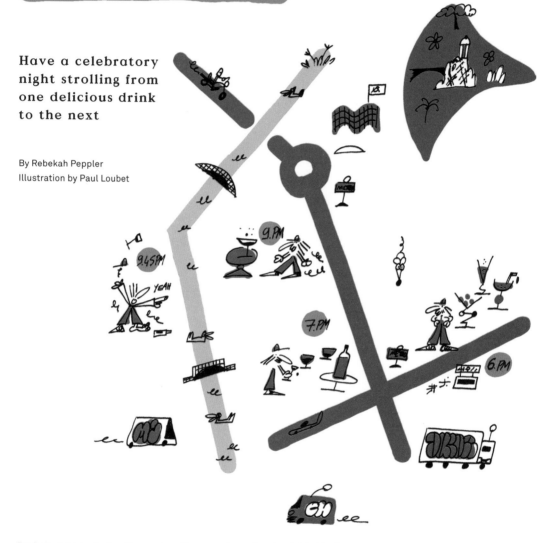

9.PM

9.45PM

YEAH

7.PM

6.PM

Paris has no end of options when it comes to eating (and drinking) in beautiful and beautifully hip places. We've taken the guesswork out of it (Put that extra time and energy toward another drink!) and compiled an itinerary in a fab neighborhood. Think of it as a bar crawl for the thirty-plus crowd . . . aka an emphasis on natural wine and elevated bar snacks. Follow along blindly from start to finish or pick a single spot to relax at, and then maybe one or two more for drinks before or after. Whatever you choose, grab a partner, sister, Instagram friend, Frenchwoman or -man you met in the market earlier . . . and make a night of it.

Belleville/Canal Saint-Martin

6:00 P.M.

Women and cocktails may in fact be our food and drink editor Rebekah Peppler's two very favorites things, so it's no surprise that the opening of **Combat** in the 20th arrondissement was a happy one. Owned and run by Elena Schmitt and Margot Lecarpentier (formerly of Experimental Cocktail Club), with cocktails by Elise Drouet (also formerly of Experimental Cocktail Club) and a partnership with Maxime Potfer (a man, but a very lovely one, who also happens to be the current bar manager for Experimental Cocktail Club), Combat takes its name from the former nickname of the section of Belleville in which it's located. The cocktails are as sharp as the women running the show, which is to say, very.
63 rue de Belleville, 75019
+33 9 80 84 78 60

7:00 P.M.

Post-cocktails, take a short stroll to **La Cave à Michel's** marble bar for a glass/bottle of natural wine and anything off the menu (it's all can't-miss, but definitely order eggs mayonnaise). If you're tired of standing, move next door to **Le Galopin** (owned and operated by the same brother duo) for a sit-down seven-course tasting menu.
La Cave à Michel: 36 rue Saint-Marthe, 75010
+33 01 42 45 94 47
Closed Monday and Tuesday.
Le Galopin: 34 rue Sainte-Marthe, 75010
+33 01 42 06 05 03
Reservations encouraged.
Closed Sunday and Monday.

9:00 P.M.

Craving another drink (or a coffee!) on your walk to the canal (see 9:45 P.M.) Five minutes from La Cave à Michel is **La Fontaine de Belleville**, a gorgeous corner café opened in 2016 by the founders of Belleville Brûlerie. The wine, cocktails, and small bites are all tops.
31-33 rue Juliette Dodu, 75010
+33 09 81 75 54 54

9:45 P.M.

Buy a bottle of wine off the shelves at Cyril Bordarier's pioneering *cave à manger*, **Le Verre Volé**, before they close at 10 P.M., and blend in as a Parisienne by drinking it on the banks of Canal Saint-Martin. (Or come earlier and eat/drink everything on the menu.)
67 rue de Lancry, 75010
+33 1 48 03 17 34

BONUS DRINK

Anytime before 11:00 P.M.: If there was one place Rebekah would end every evening (as it is, she's there often, so take a look around and please say hi) it would be **Septime la Cave**. It's a short cab ride away from wherever you are and closes at 11:00 P.M., so hurry up—the natural wine isn't going to drink itself.
3 rue Basfroi, 75011
+33 01 43 67 14 87

Twenty Instagram Accounts to Follow for Creative Food + Drink

CHEFS

@cedricgrolet
@desgateauxetdupain
@desserted_in_paris
@takdersou

INFLUENCERS

@cakeboyparis
@griottes
@healthymalo
@lostncheeseland
@myparisianlife
@rebekahpeppler
@sliceofpai
@sliceofparis
@sundaysinparis

CAFÉS AND RESTAURANTS

@cafemericourt
@fragmentsparis
@lafontainedebelleville
@le_dauphin_paris
@lepigalleparis
@seasonparis
@verjusparis

The
Guide
PARIS

All too often, travel guides are full of practical information but lack a curatorial eye. Ours is different.

I explored high and low to unearth the most delightful, design-oriented places in Paris. Some are well-known, others are well under the radar, some haven't changed for generations, others are brand-new, but all have that certain je ne sais quoi we crave in the City of Light. Food and drink editor Rebekah Peppler (a Paris local and cookbook author) searched out the most delicious and atmospheric restaurants, cafés, markets, and bars. We combined our findings with recommendations from the creative Parisians featured throughout the book. Cataloged by arrondissement for easy exploration, these recommendations of what to see and where to shop, eat, drink, and stay can be found on the following pages.

"When good
Americans die,
they go to Paris."

OSCAR WILDE

1st + 2nd
Arrondissements

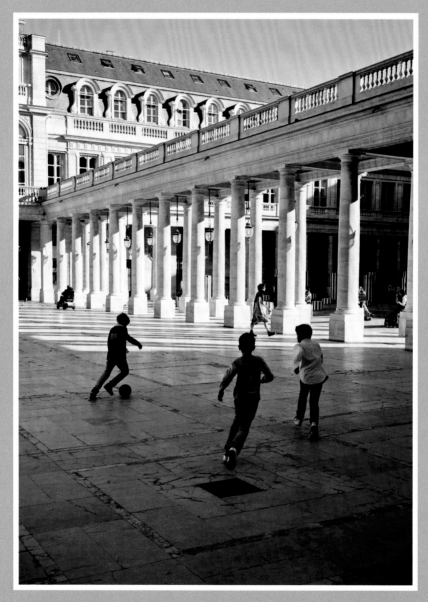

Square du Vert-Galant

BIBLIOTHÈQUE DU CINÉMA FRANÇOIS TRUFFAUT

Located within the subterranean, slightly depressing Forum des Halles shopping mall, this library devoted to cinema is a surprising and welcome find. Screen a classic film in the twenty-five-seat amphitheater or page through the archives of the seminal magazine *Cahiers du Cinéma* for incredible design and photography inspiration.

Forum des Halles
4 rue du Cinéma, 75001
+33 1 40 26 29 33

COMÉDIE-FRANÇAISE

Taking in a production at the oldest still-active theater in the world is worth it, even if you don't speak the language. Buy a ticket for a classic, well-known play (*Romeo and Juliet, Cyrano de Bergerac*, etc.); read a synopsis online; then sit back, relax, and enjoy the show in a venue that has held performances for more than three hundred years.

1 place Colette, 75001
+33 8 25 10 16 80

GALERIE COLBERT

See "Itinerary: The Charm of Hidden Passageways" (page 175).

4 rue Vivienne, 75002

GALERIE VÉRO-DODAT

Near the **Louvre** and the **Palais-Royal**, this elegant covered passageway (see page 176) has ceilings decorated with antique engravings, in addition to the more typical glass, and is home to high-end fashion accessory boutiques.

19 rue Jean-Jacques Rousseau, 75001

GALERIE VIVIENNE

See "Itinerary: The Charm of Hidden Passageways" (page 175).

5 rue de la Banque, 75002

JARDIN DES TUILERIES

Spanning from the **Louvre** on one end to the Place de la Concorde on the other, these gardens are immense. Designed in the traditional French formal style by André Le Nôtre, the famous landscape architect to Louis XIV, there are pathways for strolling and chairs near the fountains for relaxing. My kids loved the merry-go-round, playground, and trampolines.

Jardin des Tuileries, 75001

MUSÉE DE L'ORANGERIE

On the day after the armistice of November 11, 1918, Monet gave his monumental *Water Lilies* series to the state as a symbol of peace. Displayed according to his wishes in two large elliptical rooms with natural light from above, the paintings envelop visitors in a sea of willow branches, water lilies, and reflections of the sky. The museum has many more pieces in its permanent collection, as well as a rotating list of temporary exhibits, but Monet's chef d'oeuvre is the real draw.

Jardin des Tuileries, 75001
+33 1 44 50 43 00

MUSÉE DES ARTS DÉCORATIFS

See "Usha's Favorite Parisian Spots for Textile Inspiration" (page 171).

107 rue de Rivoli, 75001
+33 1 44 55 57 50

PALAIS-ROYAL

See "Itinerary: The Charm of Hidden Passageways" (page 175).

8 rue de Montpensier, 75001

PASSAGE DES PANORAMAS

See "Itinerary: The Charm of Hidden Passageways" (page 176).

11 boulevard Montmartre, 75002

PASSAGE DU CAIRE

The oldest covered passageway (see page 176) in Paris, it's also the longest and narrowest. Don't forget to look up as you're passing through—the facades of the upper floors still have their original beauty.

Passage du Caire, 75002

PASSAGE DU GRAND CERF

A vaulted glass-and-steel ceiling, wood-paneled shop facades, and a checkered-tile floor form the charming aesthetic of this covered passageway (see page 176) not far from the famous food shops of Rue Montorgueil.

145 rue Saint-Denis, 75002

PLACE DAUPHINE

It's easy to while away a warm afternoon on the terrace of one of the cafés lining this triangular shaped "square" on the Île de la Cité. Dating back to the early 1600s, Place Dauphine is just steps from the historic **Pont Neuf**.

Place Dauphine, 75001

PONT NEUF

Connecting the Right and Left Banks of the Seine and crossing the tip of the Île de la Cité, the Pont Neuf is the oldest standing bridge in Paris, dating to the sixteenth century. The bridge is decorated with 381 stone masks, or mascarons, representing figures from ancient mythology.

Pont Neuf, 75001

SAINTE-CHAPELLE

Sainte-Chapelle is a jewel box of a chapel, with soaring stained-glass windows in the gothic style depicting scenes from the Old and New Testaments. My friend Erynn Montgomery (of travel website Tropic of Candycorn) recommends purchasing tickets to a classical concert instead of elbowing your way through the hordes of tourists that descend on this iconic monument during its normal operating hours.

8 boulevard du Palais, 75001
+33 1 53 40 60 80

SQUARE DU VERT-GALANT

A splendid place for a picnic, this small park at the northern end of the Île de la Cité features lovely views from every side. Walk to the very tip and peek through the branches of the willow tree toward the Pont des Arts.

15 Place du Pont-Neuf, 75001

THE LOUVRE

This former palace of the French kings is the largest and most visited museum in the world, and now the location of an incredible Beyoncé/Jay-Z music video as well. From Egyptian antiquities to Renaissance paintings, from world-famous works (*Mona Lisa,*

Venus de Milo) to often overlooked masterpieces (*Une Odalisque, La Pietà de Villeneuve-lès-Avignon*), it would take you a lifetime to see it all. Avoid the lines and buy your ticket ahead of time online or in person at the *tabac* inside the Carrousel du Louvre.

Rue de Rivoli, 75001
+33 1 40 20 50 50

THÉÂTRE DES VARIÉTÉS

See "Itinerary: The Charm of Hidden Passageways" (page 176).

7 boulevard Montmartre, 75002
+33 1 42 33 09 92

SHOP

BACQUEVILLE

See "Itinerary: The Charm of Hidden Passageways" (page 175).

8 galerie de Montpensier, 75001
+33 1 42 96 26 90

DELFONICS

Who knew that in the mall underneath the Louvre, you'd be able to find such a great shop? I walked away with the perfect little coin purse from this Japanese stationery company.

99 rue de Rivoli, 75001
+33 1 47 03 14 24

DIDIER LUDOT

See "Itinerary: The Charm of Hidden Passageways" (page 175).

24 galerie de Montpensier, 75001
+33 1 42 96 06 56

E.B. MEYROWITZ

The fancy antique décor of this boutique is just about as fancy as the wares they sell. Although a range of designer eyeglasses are on offer, the real draws are the custom, made-to-measure designs.

5 rue de Castiglione, 75001
+33 1 42 60 63 64

FABIAN DE MONTJOYE

Lovers of antique jewelry, look no further.

177 rue Saint-Honoré, 75001
+33 1 42 60 14 12

LA DROGUERIE

If shelves upon shelves of colorful ribbon, buttons, rickrack, and other sewing notions sounds like your idea of heaven, this place is for you.

9-11 rue du Jour, 75001
+33 1 45 08 93 27

LA GALCANTE

Stacked floor to ceiling with vintage newspapers, magazines, photos, and posters, this shop helps many museums and libraries add unique pieces to their collection. It's a treasure trove for lovers of the printed page.

52 rue de l'Arbre Sec, 75001
+33 1 44 77 87 44

L'APPARTEMENT SÉZANE

What began as a collection of vintage clothing gathered by founder Morgane Sézalory in 2008 has quickly become a fashion line appreciated internationally for its French chic and reasonable prices. Visit L'Appartement to see the

Jardin des Tuileries

clothing displayed as if in a real (and beautifully styled) apartment.

1 rue Saint-Fiacre, 75002

MAISON FABRE

See "Itinerary: The Charm of Hidden Passageways" (page 175).

128-129 galerie de Valois, 75001
+33 1 42 60 75 88

MAISON VERTUMNE

A chartreuse exterior beckons you to this shop brimming with flowers in romantic arrangements.

12 rue de la Sourdière, 75001
+33 1 42 86 06 76

SOUS LE PARASOL

Behind the unassuming facade, you'll find a unique family business selling delightfully packaged perfume, soaps, candles, etc. that you can't find anywhere else. Perfect for gifts that don't break the bank.

75 boulevard de Sébastopol, 75002
+33 1 42 36 74 95

RUE HÉROLD

Inside this brightly lit fabric store, you'll find yards of natural fibers in muted colors. Curated by stylist and art director Charlotte de La Grandière, the selection is impeccable.

8 rue Hérold, 75001
+33 1 42 33 66 56

ULTRAMOD

This haberdashery is close to the passageways (see pages 174–176), if you feel like a detour for ribbons in velvet, silk, grosgrain, and more.

3-4 rue de Choiseul, 75002
+33 1 42 96 98 30

WHITE BIRD

With an elegant and contemporary curation of jewelry in stylish modern surroundings, you're bound to find something pretty for your finger in this boutique.

38 rue du Mont Thabor, 75001
+33 1 58 62 25 86

EAT + DRINK

BONESHAKER

Craving American-style doughnuts in Paris? Us, too. Not only are wife-husband duo Amanda Bankert and Louis Scott the kindest people ever, but they make the best doughnuts this side of the Atlantic.

77 rue d'Aboukir, 75002
+33 1 45 08 84 02
€

ECHO

Our food and drink editor, Rebekah Peppler, was a one-time LA resident, and the opening of Echo was like finding a spot of LA in a (nondesert) oasis. Think: Sqirl/Gjusta/Gjelina-esque (Surprise! The chef comes from the two latter spots), but with French-sourced ingredients. Prices are also quite LA-esque, so come prepared.

95 rue d'Aboukir, 75002
+33 1 40 26 53 21
€€

ELLSWORTH

See "Itinerary: The Charm of Hidden Passageways" (page 175).

34 rue de Richelieu, 75001
+33 1 42 60 59 66
€€

ÉPICES ROELLINGER

Breton chef Olivier Roellinger's library-esque shop carries twenty-eight types of pepper, eight different types of fleur de sel, and plenty more exotic spices from around the world. Choose from eighteen varieties of vanilla beans, ripened in the store's basement and housed in a gorgeous case that allows you to smell the individual flavor of each, and don't miss the chance to peruse their unique spice mixes.

51 rue Sainte-Anne, 75002
+33 1 42 60 46 88
€–€€

FRANÇOIS PERRET AT THE RITZ

Take tea at The Ritz and make sure to order a fraisier (strawberry cake). Recommended by Frank Barron (see page 203).

15 place Vendôme, 75001
+33 1 43 16 30 30
€€

"FRENCHIE STREET"

"Frenchie Street"—formally known as Rue du Nil—houses Gregory Marchand's three in-demand spots to eat and drink: **Frenchie** (prix fixe, reserve a table in advance), **Frenchie Bar à Vins** (a cozy two-room wine bar with modern takes on classic French dishes—get there around 6:40 to snag a place in the first seating at 7 P.M.), and **Frenchie to**

Go (Anglo-inspired sandwiches, plates, and sweets that are well-suited for a hearty brunch).

Frenchie: 5 rue du Nil, 75002
+33 1 40 39 96 19
Reservations needed.
€€€

Frenchie Bar à Vins: 6 rue du Nil, 75002
+33 1 40 39 96 19
€€

Frenchie to Go: 9 rue du Nil, 75002
+33 1 40 26 23 43
€

G. DETOU

Are you an accomplished baker, or do you know and love an accomplished baker who will make things for you? Head to G. Detou to marvel at the impressive (read: stacked-from-floor-to-ceiling) assortment of specialty baking supplies. Stock up on kilo boxes of chocolate, cake decorations, nut pastes, edible flowers, spices, Trablit coffee extract, and so. much. more.

58 rue Tiquetonne, 75002
+33 1 42 36 54 67
€

KUNITORAYA

There are many Japanese noodle shops on the nearby rue Sainte-Anne, but the tiny, always-busy Kunitoraya on the rue Villedo offers the best in the city, handmade on-site. Wait in line at the walk-ins-only noodle bar, or slip down the street to Masafumi Nomoto's second, more upscale location.

Udon Bistro Kunitoraya: 1 rue Villedo, 75001
+33 1 47 03 33 65
€

Restaurant Kunitoraya: 5 rue Villedo, 75001
+33 1 47 03 07 74
€

LA FERMETTE

This bustling, twenty-plus-year-old family-run fromagerie on Rue Montorgueil is tucked among equally quaint chocolate shops, bakeries, and cafés. They carry a wide range of cheeses and also offer trays of assorted slices, if you're looking to try a selection.

86 rue Montorgueil, 75002
+33 1 42 36 70 96
€

LA PÂTISSERIE DU MEURICE PAR CÉDRIC GROLET

Cédric Grolet's first Parisian pâtisserie, located in the hotel Le Meurice (where Grolet is also the pastry chef at Alain Ducasse's Le Dalì), is almost as stunning as his creations. In 2017, Grolet was named the Meilleur Chef Pâtissier Restaurant du Monde (World's Best Pastry Chef) and his work shows his nouveau talent. Think: pastries sculpted to look like perfect lemons, oranges, peaches, and apples filled with unexpectedly delicious fillings, a Rubik's Cube cake, and more. Recommended by Frank Barron (see page 201).

6 rue de Castiglione, 75001
+33 1 44 58 10 10
€€–€€€

L'ARBRE À CAFÉ

Stop into this tiny coffee shop and roaster directly across the street from Frenchie to Go for single-origin beans, coffee-brewing equipment, and chocolate.

10 rue du Nil, 75002
+33 1 84 17 24 17
€

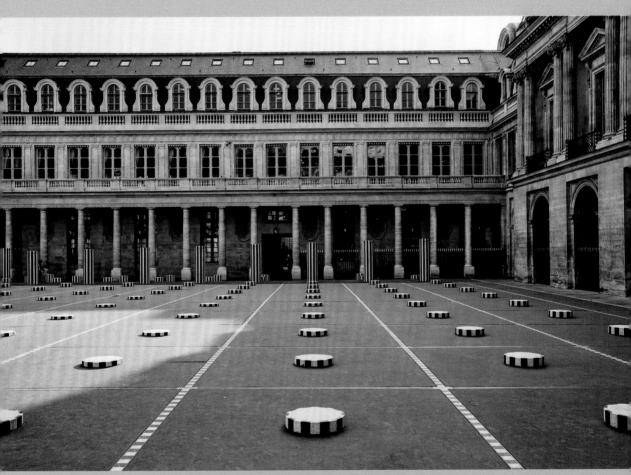

Palais Royal

LEGRAND FILLES ET FILS

This historic wine (and candy!) shop in the Galerie Vivienne specializes in traditional and special occasion bottles. Once there, you can order by the glass and enjoy the regal ambience or get a bottle to go.

1 rue de la Banque, 75002
+33 1 42 60 07 12
€–€€€

LE SOUFFLÉ

Forget attempting the perfect soufflé at home, Le Soufflé in the 1st arrondissement offers a full meal of the perfectly puffed, golden delicacies— without any of the stress. Recommended by the author's grandparents (see page 11).

36 rue du Mont Thabor, 75001
+33 1 42 60 27 19
€–€€

TÉLESCOPE

A well-established player in Paris's specialty coffee game, Télescope focuses squarely on what they've done best since 2012: first-rate coffee. Order a *noisette, café filtre,* or *café crème* at the small, stylish counter. If there are no free seats, take it to go and wander the nearby **Jardin du Palais-Royal.**

5 rue Villedo, 75001
€

RAVIOLIS CHINOIS NORD-EST

We crave these raviolis weekly. Raviolis Chinois Nord-Est is everything you want your local ravioli spot to be: cheap

(five euro for ten), tiny, and homemade. Get any of them that have celery— trust.

115 rue Saint-Denis, 75001
+33 9 81 17 19 08
€

LA BOURSE ET LA VIE

Daniel Rose's La Bourse et La Vie in the 2nd arrondissement serves flawlessly executed iconic French dishes.

12 rue Vivienne, 75002
+33 1 42 60 08 83
€€

TERROIRS D'AVENIR

In 2008, Alexandre Drouard and Samuel Nahon started providing seasonal French products from small producers to some of the best restaurants in Paris. In 2013, they opened four outstanding Terroirs d'Avenir shops on Rue du Nil: an *épicerie*, a fishmonger, a boulangerie, and a butcher. The prices may be slightly higher than the average grocer's, but the quality is bounds above.

3, 6, 7, 8 rue du Nil, 75002
+33 1 85 09 84 49
€

VERJUS

See "Itinerary: The Charm of Hidden Passageways" (page 175).

52 rue de Richelieu, 75001
+33 1 42 97 54 40
Reservations needed.
€€–€€€

VERJUS BAR À VINS

See "Itinerary: The Charm of Hidden Passageways" (page 175).

47 rue de Montpensier, 75001
+33 1 42 97 54 40
€€

YAM'TCHA

Adeline Grattard pairs seasonal French-Chinese dishes with an expansive tea program, making a meal that's unforgettable, if exceptionally difficult to book. Whether or not you snag a reservation at Yam'Tcha, be sure to pop by Boutique Yam'Tcha on Rue Sauval for a cup of tea or stop at the bao (steamed bun) window.

Yam'Tcha: 121 rue St. Honoré, 75001
+33 1 40 26 08 07
Reservations needed.
€€€

Boutique Yam'Tcha: 4 rue Sauval, 75001
+33 1 40 26 06 06
€

LOCKWOOD

Come for coffee (Belleville Brûlerie, weekend brunch only), stay for cocktails, and fall in love in Lockwood's warmly lit, convivial space.

73 rue d'Aboukir, 75002
+33 1 77 32 97 21
€

HOTEL DES GRANDS BOULEVARDS

I can't get enough of the vintage-inspired colors and canopy beds in this hotel, right around the corner from the hip restaurants on Rue du Faubourg Poissonnière in one direction and my favorite covered passageways (see pages 174–176) in the other.

17 boulevard Poissonnière, 75002
+33 1 85 73 33 33
€€

HÔTEL SAINT-MARC

See "Beaux Rêves" (page 154).

36 rue Saint-Marc, 75002
+33 1 42 86 72 72
€€

THE HOXTON

Classic architecture mixes with contemporary furnishings and a subdued color palette in this new addition to the Paris hotel scene. It's a part of the design-forward Hoxton hotel group, which started in London's Shoreditch in 2006 and is set to have around a dozen properties—including five in the United States—by 2020.

30-32 rue du Sentier, 75002
+33 1 85 65 75 00
€€

THE RITZ

See "Beaux Rêves" (page 153).

15 place Vendôme, 75001
+33 1 43 16 30 30
€€€€

Jardin des Tuileries

3rd + 4th
Arrondissements

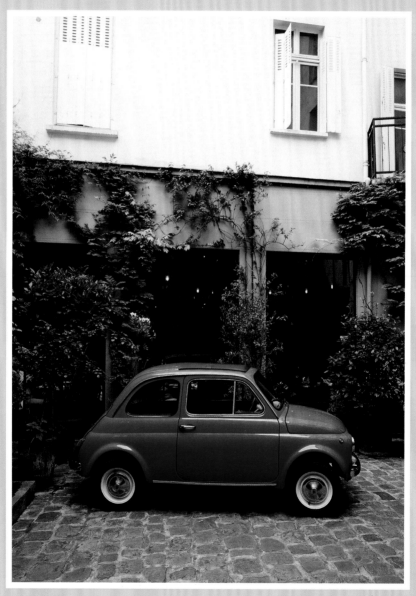

Merci

ALMINE RECH GALLERY

While Rech now owns spaces in London, Brussels, and New York, Paris is where she grew up and got her start as one of the few women art dealers in the French capital. Expect works by the likes of James Turrell, Julian Schnabel, and other big names in contemporary art.

64 rue de Turenne, 75003
+33 1 45 83 71 90

CENTRE GEORGES POMPIDOU

Famous for its colorful exoskeleton of escalators and walkways designed by Richard Rogers, Renzo Piano, and Gianfranco Franchini, the Pompidou hosts a vast collection of modern and contemporary art. Don't miss the Yves Klein pieces, the Brancusi studio, and the view from the roof.

Place Georges-Pompidou, 75004
+33 1 44 78 12 33

FLORENCE LOEWY

Since the 1960s, this gallery has dealt primarily in artist books, editions, and multiples.

9 rue de Thorigny, 75003
+33 1 44 78 98 45

GALERIE DEROUILLON

Discover upandcoming artists like Annabelle Arlie and Guy Yanai at this contemporary art gallery in the 3rd arrondissement.

38 rue Notre-Dame-de-Nazareth, 75003
+33 9 80 62 92 65

GALERIE ESCOUGNOU-CETRARO

An emphasis on contemporary installation art defines this gallery just a couple of blocks from the Picasso Museum.

7 Rue Saint-Claude, 75003
+33 9 83 02 52 93

GALERIE JÉRÔME PAUCHANT

Visit this gallery to see the work of very young emerging artists alongside (and in collaboration with) that of well-known artists.

61 Rue Notre Dame de Nazareth, 75003
+33 1 83 56 56 49

GALERIE KARSTEN GREVE

A beautiful courtyard entrance and grand exhibition rooms await at this contemporary gallery—one of the most prestigious in the city. Recommended by painter Bruno Albizatti (see page 53).

5 rue Debelleyme 75003
+33 1 42 77 19 37

GALERIE LES FILLES DU CALVAIRE

Playing against stereotype, the people working in this high-end contemporary art gallery are anything but snobbish. Take in the photography and paintings exhibited in their large skylit space, then relax on the couches while leafing through all the art books and catalogs on display.

17 rue des Filles du Calvaire, 75003
+33 1 42 74 47 05

GALERIE THADDAEUS ROPAC

From Anselm Kiefer to Jules de Balincourt, come to see the constant rotation of impressive works by emerging and established contemporary artists.

7 rue Debelleyme, 75003
+33 1 42 72 99 00

INSTITUT SUÉDOIS

The only cultural center of its kind outside of Sweden, Institut Suédois promotes Swedish art, film, literature, design, and culture via film screenings, children's workshops, a permanent collection of art (including a peaceful sculpture garden), and more. In summertime, spend a moment in the lovely courtyard while eating open-faced sandwiches from the adjoining café.

11 Rue Payenne, 75003
+33 1 44 78 80 20

LA GAÎTÉ LYRIQUE

With a constant rotation of concerts, exhibitions, screenings, classes, and festivals, this contemporary arts center always has something going on. Run by the city of Paris and housed in a historic theater, it's an energetic space that's under the radar for most tourists—all the more reason why you should visit.

3bis rue Papin, 75003
+33 1 53 01 52 00

MAISON DE VICTOR HUGO

Between the damask silk walls of Victor Hugo's former residence on the beautiful **Place des Vosges**, you'll find displays of his drawings, letters, and collections of art and objects. Recommended by photographer Cécile Molinié (see page 49).

6 place des Vosges, 75004
+33 1 42 72 10 16

MUSÉE DE LA CHASSE ET DE LA NATURE

If you're looking for a quirky and off-the-beaten-path place to visit, this museum dedicated to hunting and nature is an excellent choice. Taxidermied animals, tapestries, paintings, weapons, and more fill the rooms of two side-by-side historic mansions.

62 rue des Archives, 75003
+33 1 53 01 92 40

MUSÉE NATIONAL PICASSO-PARIS

After undergoing a massive five-year renovation, which more than doubled its size, the Picasso Museum reopened in 2014. Housed in Hôtel Salé, a seventeenth-century mansion, the collection holds thousands of works by the prolific artist.

5 rue de Thorigny, 75003
+33 1 85 56 00 36

PARIS DESIGN TOUR WITH ANNE DITMEYER

Meet up in the Marais for a personalized tour led by local graphic designer and writer Anne Ditmeyer. She knows all the best spots and makes you feel like you're hanging out with an old friend rather than on some generic tour. Highly recommended by my good friend and colleague, designer Brittany Jepsen (*Craft the Rainbow*, thehousethatlarsbuilt.com).

navigateparis.com
parisdesigntour

PASSAGE MOLIÈRE

A narrow cobblestone lane lined with shops, Passage Molière takes its name from the illustrious French playwright and theater named in his honor. You'll find a couple of quiet cafés, a shop making plaster molds of hands and feet, and a respite from weekend crowds.

157 rue Saint-Martin, 75003

PLACE DES VOSGES

This gorgeous example of symmetry in architecture was inaugurated in 1612 and is the oldest planned square in Paris. Once the place for the nobility to see and be seen, it's now a favorite with locals and tourists alike for taking a break from shopping in the surrounding Marais neighborhood.

Place des Vosges, 75004

SHOP

AU PETIT BONHEUR LA CHANCE

Brimming with vintage bric-a-brac, there's always something charming and affordable to take home from this place. Tea towels, toys, paper dolls, enamel signs, tote bags, bowls for *chocolat chaud*, salt cellars, christening gowns, plastic flutes, ribbon by the yard—the list is never-ending.

13 rue Saint-Paul, 75004
+33 1 42 74 36 38

BERNARD SERVICES

This shoe repair shop also has a vast selection of espadrilles, the traditional canvas and rope shoes of southern France, no matter the season.

23 rue du Temple, 75003
+33 1 42 77 34 99

BONTON

This mecca for hip children's design stocks clothing, toys, party supplies, and even furniture. Squeeze into the photo booth with your little ones or make them an appointment with the in-house hairdresser.

5 boulevard des Filles du Calvaire, 75003
+33 1 42 72 34 69

BROCANTE DE LA RUE DE BRETAGNE

It's rare to find a flea market in the heart of the city, so make sure to go if you're in Paris at the right time! Recommended by designer Marin Montagut (see page 81).

Rue de la Bretagne and neighboring streets, 75003
Twice a year in November and June.

CHANCE

It's easy to miss Chance's narrow storefront, but it's definitely worth a visit if you're interested in jewelry made by local artisans at affordable prices. Recommended by jewelry designer Elise Tsikis (page 141).

25 rue Charlot, 75003
+33 9 67 64 72 28

COMPTOIR DE L'IMAGE

Fantastic photo and fashion books are chaotically stacked to the ceiling in this bookshop.

44 rue de Sévigné, 75003
+33 1 42 72 09 17

Boot Café

Comptoir de l'Image

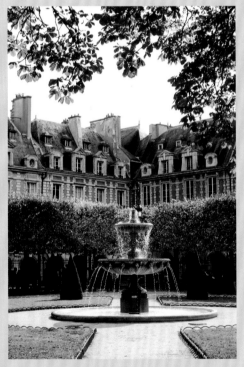

Place des Vosges

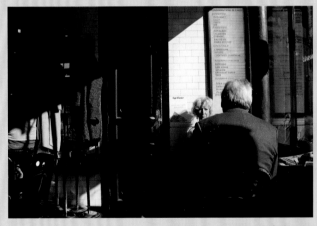

Café Charlot

FRENCHTROTTERS

See "Itinerary: Right Bank Women's Fashion" (page 143).

128 rue Vieille du Temple, 75003
+33 1 44 61 00 14

HARMONY

A temple to minimalist design, come to Harmony's flagship store on rue Commines for both men's and women's clothing—all made with the finest materials and produced by quality manufacturers across Europe.

1 rue Commines, 75003
+33 1 42 74 49 13

HARTÔ

Hip, modern furniture and décor from talented French and European designers are HARTÔ's specialties. Peruse their online shop or make an appointment to see everything in person at their showroom in the Upper Marais.

52 rue de Turbigo, 75003
+33 1 76 50 55 45
By appointment only.

ISAAC REINA

Clean, utilitarian shapes dominate the designs in Isaac Reina's leather goods shop. Isaac Reina studied architecture and worked at Hermès before starting his own line, and that unique pedigree shines through the clean utilitarian designs in his leather goods shop.

12 rue de Thorigny, 75003
+33 1 42 78 81 95

KERZON

Candles, soaps, and fragrances are the stars of this shop—all enrobed in softly colored modern packaging. My favorites are the candles named after iconic places in Paris—Jardin du Luxembourg, Île Saint-Louis, Place des Vosges, etc.

68 rue de Turenne, 75003
+33 1 57 40 83 45

LA MAISON DU PASTEL

If you play your cards right, you may be able to visit this charming family-run art supplier, which holds the title of the oldest pastel manufacturer in the world. (They're only open to the public on Thursdays from 2 to 6 P.M.) La Maison du Pastel still makes every pastel by hand according to a formula perfected under the direction of Edgar Degas in the late 1800s. Their range of colors is vast and absolutely luminous.

20 rue Rambuteau, 75003
+33 1 40 29 00 67

LEMAIRE

See "Itinerary: Right Bank Women's Fashion" (page 144).

28 rue de Poitou, 75003
+33 1 44 78 00 09

MAD ET LEN

See "Itinerary: The Charm of Hidden Passageways" (page 175).

27 galerie Vivienne, 75002
+33 1 81 70 97 24

MÉLODIES GRAPHIQUES

Right across the street from Papier Plus, Mélodies Graphiques has a completely different yet equally alluring feeling. Subdued color palettes and antique textures reign in this boutique filled with elegant papers and pens.

10 rue du Pont Louis-Philippe, 75004
+33 1 42 74 57 68

MERCI

See "Itinerary: Right Bank Women's Fashion" (page 144).

111 boulevard Beaumarchais, 75003
+33 1 42 77 00 33

OFR

Expect a sharp collection of contemporary books, magazines, and ephemera in both French and English at this bookshop in the Upper Marais.

20 rue Dupetit-Thouars, 75003

PAPIER PLUS

Walking into this store is like getting a shot of sunshine. Beautifully made journals and photo albums covered in brightly hued fabric line the walls. You'll also spot pencils, pens, and smaller notebooks in coordinating shades.

9 rue du Pont Louis-Philippe, 75004
+33 1 42 77 70 49

PAPIER TIGRE

See "Eye of the Tiger" (pages 68–71).

5 rue des Filles du Calvaire, 75003
+33 1 48 04 00 21

ROSEANNA

See "Itinerary: Right Bank Women's Fashion" (page 144).

5 rue Froissart, 75003
+33 9 86 62 58 32

SUCCULENT CACTUS

Walking through the doors of this boutique in the Marais will make you feel like you're stepping onto a terrace in Mexico, thanks to the terra-cotta walls and menagerie of cacti. Recommended by terrarium and garden designer Kali Vermes (see page 165).

111 rue de Turenne, 75003
+33 1 48 87 07 18

THE BROKEN ARM

See "Itinerary: Right Bank Women's Fashion" (page 144).

12 rue Perrée, 75003
+33 1 44 61 53 60

YVON LAMBERT BOOKSHOP

You'll easily get lost in the art books and indie magazines stacked on red tables at this chic boutique. If you can pull yourself away from the pages, peruse the art in the adjoining gallery space, too.

14 rue des Filles du Calvaire, 75003
+33 1 42 71 89 05

EAT + DRINK

BERTHILLON

This famous ice cream shop has sold scoops of black currant, pistachio, rose, and other fresh flavors since 1954. Recommended by textile designer Usha Bora (page 171).

29-31 Rue Saint-Louis en l'Île, 75004
+33 1 43 54 31 61
€

BONTEMPS PÂTISSERIES

This shop in the Upper Marais is a destination for delicately sweet *sablé* cookies sandwiched together with a variety of fillings. Also try the pavlova. Recommended by Frank Barron (see page 201).

57 rue de Bretagne, 75003
+33 1 42 74 10 68
€

BREIZH CAFÉ

Order a hard cider while you decide between a number of *galettes de blé noir,* Breton-style crepes. With a combination of savory Bretonese and Japanese flavors, you'll be hard-pressed to make the wrong choice. Finish with a salted caramel or butter-yuzu sweet crepe and on your way out, stop by the small *épicerie* next door for Bordier butter, sardines, and caramels. Pro tip: If the wait at the café is long, the *épicerie* has a few seats where you can sit and eat—just don't dawdle.

109 rue Vieille du Temple, 75003
+33 1 42 72 13 77
€–€€

CAFÉ CHARLOT

See "The Best People-Watching in Paris" (page 110).

38 rue de Bretagne, 75003
+33 1 44 54 03 30
€€

CARBÓN

Best to leave vegetarian tendencies at the door. The food at this new spot by Sabrina Goldin and Stéphane Abby, with David Kjellstenius (formerly of Au Passage) behind the grill, is filling in all the ways. The wine list has a slew of organic and natural bottles to choose from (and choose you should), but start with a cocktail. They're perfect.

14 rue Charlot, 75003
+33 1 42 72 49 12
€€–€€€

COFFEE IN THE MARAIS

Paris is finally a global player in the craft coffee scene, and the 3rd arrondissement houses its fair share of favorite spots to cozy up with a well-made *café crème.*

Ob-La-Di
54 rue de Saintonge, 75003
€

Broken Arm
12 rue Perrée, 75003
+33 1 44 61 53 60
€

Fragments
76 rue des Tournelles, 75003
€

Boot Café
19 rue du Pont aux Choux, 75003
+33 1 73 70 14 57
€

Fondation Café
16 rue Dupetit Thouars, 75003
€

Loustic
40 rue Chapon, 75003
+33 9 80 31 07 06
€

Neighbours
89 boulevard Beaumarchais, 75003
+33 7 67 99 99 91
€

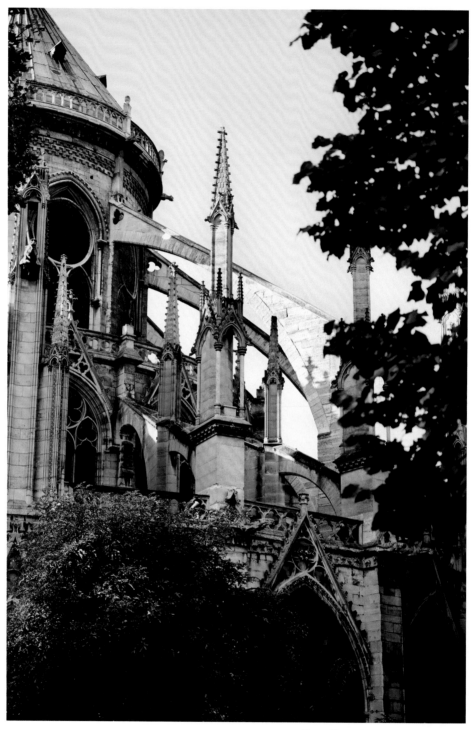

Above: Notre-Dame's flying buttresses
Opposite: Along the banks of the Seine

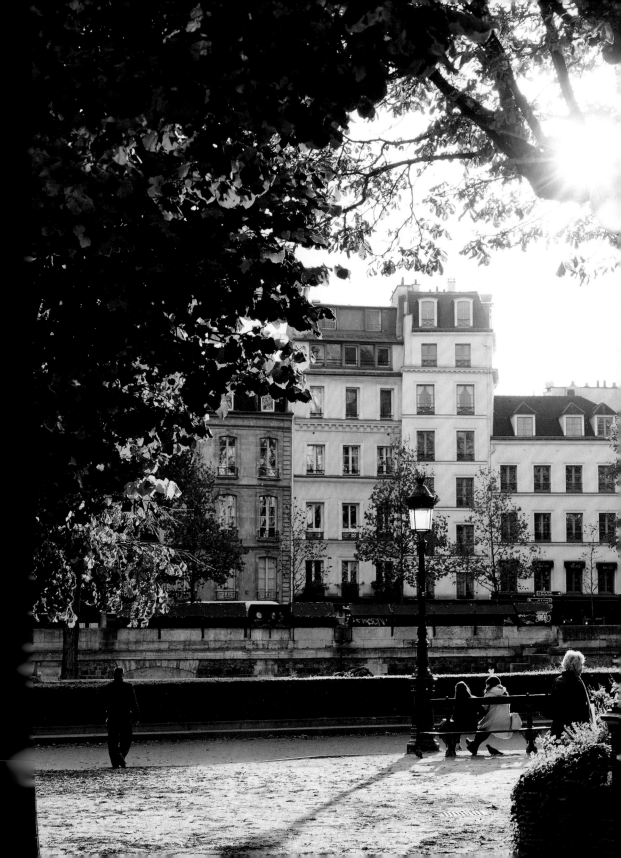

GRAND CŒUR

Grand Cœur has a neo-1970s design, one of the best terraces in town, and Rafael Gomes (formerly of Gramercy Tavern and Eleven Madison Park) behind the pass, offering up chef Mauro Colagreco's contemporary brasserie fare. All the wins in the Lower Marais.

41 rue du Temple, 75004
+33 1 58 28 18 90
€€€

IZRAËL

The moment you walk into this colorful spice shop, you'll be assailed by scents. The layers on layers of fragrances are as overwhelmingly pleasant as the selection of hard-to-find global groceries (favorite recent find: licorice sticks, amaretti cookies, and Colman's mustard powder).

30 rue François-Miron, 75004
+33 1 42 72 66 23
€

JACQUES GENIN

Jacques Genin's caramels (and chocolates) are reason enough to visit his salon in the Upper Marais, but once there, you should also take a seat in the small seating area and order a *tarte au citron* (lemon tart), Paris-Brest, or a made-to-order *millefeuille*. Recommended by Frank Barron (see page 201).

133 rue de Turenne, 75003
+33 1 45 77 29 01

JOUANNAULT

Practice your French at this family-run *fromagerie* and *affineur* situated just outside the Marché des Enfants Rouges (then head next door for crepes or couscous). Because they age their

cheeses on-site, you'll be guaranteed a fromage that is perfectly ripe.

39 rue de Bretagne, 75003
+33 1 42 78 52 61
€

LA MAISON PLISSON

This *alimentation generale*, or general food store, is split into two distinct spaces, with plenty of outdoor seating on either side. To the right, you'll find excellent fresh and dry goods, as well as cheese, wine, and prepared foods. The space to the left acts as a restaurant-café. Combine the two by shopping for gifts on the provisions side and capping your visit with a drink next door.

93 boulevard Beaumarchais, 75003
+33 1 71 18 19 09
€–€€

LE MARY CELESTE

With a solid cocktail program and natural wine list, Le Mary Celeste is the ideal stop for a post-meal/post–wine crawl nightcap. They make the most of the corner location by opening their floor-to-ceiling windows to the street (in nice weather, obviously). Also served up seasonally: wild oysters.

1 rue Commines, 75003
+33 1 42 77 98 37
€€

MARCHÉ DES ENFANTS ROUGES

The oldest food market in Paris, the Marché des Enfants Rouges originally sold only produce (and before that was a sixteenth-century orphanage). Now, with its hosts of food vendors, the market is best utilized as a dining destination (for produce, try one of the many other *marchés* across the city). Get crepes, galettes, and sandwiches at Chez Alain Miam Miam (closed

Mondays and Tuesdays); couscous, tagine, and mint tea at Le Traiteur Marocain; and bento boxes at Chez Taeko. Avoid the crowd and take your meal to the nearby Square du Temple.

39 rue de Bretagne, 75003
+33 1 40 11 20 40
€–€€

NANASHI

Healthy, bento-like meals and fresh juices make this bustling spot an essential for those times you need something to counteract all of that cheese, wine, and charcuterie.

57 rue Charlot, 75003
+33 9 60 00 25 59
€–€€

RISTORANTE NATIONAL

The restaurant inside the Hôtel National features a rooftop bar, patio, open kitchen, and retractable roof for seasonally appropriate days (and nights). Food and drink skew Italian trattoria, which, in our minds, means order a spritz. Recommended by the owner of IMA, Mikael Attar (see page 202).

243 rue Saint-Martin, 75003
+33 1 80 97 22 80
€€

ROBERT ET LOUISE

The open kitchen, open flame, and steaks to share—accompanied by salad or crispy potatoes—are the stars of this classic, cozy spot in the Marais. Start with rillettes, end with tarte tatin, plan to walk home.

64 rue Vieille du Temple, 75003
+33 1 42 78 55 89
€€

SEASON + SEASON TAKE AWAY

Bright and clean describes both the space and food at Season in the Upper Marais. There's fresh juice, açai bowls, kale salad, sprouted bread . . . basically everything healthy in a beautiful space. There's probably a line, so go around the corner to Season Take Away and bring your lunch to the Square du Temple Elie Wiesel Botanical Garden nearby. Mentioned in "Twenty Instagram Accounts to Follow for Creative Food+Drink" (see page 208).

Season: 1 rue Charles-François Dupuis, 75003
+33 9 67 17 52 97

Season Take Away: 8 rue Dupetit-Thouars, 75003
+33 9 86 26 21 00
€–€€

TROIS FOIS PLUS DE PIMENT + CINQ FOIS PLUS DE PIMENT

Take Trois Fois Plus de Piment ("three times more spice") at its name. The restaurant, dedicated to Sichuan noodles and ravioli by the chef-owner behind Cinq Fois Plus de Piment (also excellent, specializing in bao buns). Spice levels come scaled 1 to 5—for Parisian palates, a 2 is plenty intense.

Trois Fois Plus de Piment: 184 rue Saint-Martin, 75003
+33 6 52 66 75 31

Cinq Fois Plus de Piment: 170 rue Saint-Martin, 75003
+33 6 59 58 67 07
€

MIZNON

This rowdy Israeli-owned restaurant displays piles of cauliflower in its windows that are famously roasted whole and are so tender that they fall apart at the touch of a fork. A condiment bar with tahini, pickles, housemade hot sauce, extra pita, and heaps of gray salt are always on offer. The atmosphere at Miznon can feel a bit raucous, but it's all part of the charm.

22 rue des Ecouffes, 75004
+33 1 42 74 83 58
€

SHERRY BUTT

Serious, inventive cocktails, whiskey flights, good bar snacks, and a casual, surprisingly spacious vibe.

20 rue Beautreillis, 75004
+33 9 83 38 47 80
€–€€

UNE GLACE À PARIS

Emmanuel Ryon's ice creams and sorbets are creative, delicious, and made on-site daily from quality ingredients. Try a flight of three variations on vanilla, or be daring and try a scoop of bright orange (and actually delicious) carrot.

15 rue Sainte-Croix de la Bretonnerie, 75004
+33 1 49 96 98 33
€

STAY

HÔTEL CARON DE BEAUMARCHAIS

Named for Pierre Beaumarchais, who wrote the play *The Marriage of Figaro*, this boutique hotel is full of character. From the floral wallpaper to the classic furnishings, it's a far cry from the beige-on-beige of most travel accommodations. You may even be inspired to try playing the harp in the lobby.

12 rue Vieille du Temple, 75004
+33 1 42 72 34 12
€€

HÔTEL NATIONAL DES ARTS ET MÉTIERS

Textured yet monochromatic interiors by Raphael Navot and the bustling location are the main draws of this boutique hotel. But the spa, yoga classes, light-filled atrium restaurant, and summertime rooftop bar aren't bad, either.

243 rue Saint-Martin, 75003
+33 1 80 97 22 80
€€

MIJE HOSTELS

For traveling artists, students, and poets who would rather spend more on museums and good food than on a place to stay, I have a recommendation. With clean, simple rooms—some with rustic beamed ceilings—and a perfect location, this hostel chain in the Marais will fit the bill.

MIJE Fauconnier: 11 rue du Fauconnier, 75004
€

MIJE Fourcy: 6 rue de Fourcy, 75004
€

MIJE Maubuisson: 12 rue de Barres, 75004
+33 1 42 74 23 45
€

THE SAINT-SEBASTIAN RESIDENCE, KID & COE

For a large family, this bohemian apartment with five bedrooms and a lush terrace is a lucky find.

kidandcoe.com/destinations/le-marais/the-saint-sebastien-residence
€€

5th + 6th Arrondissements

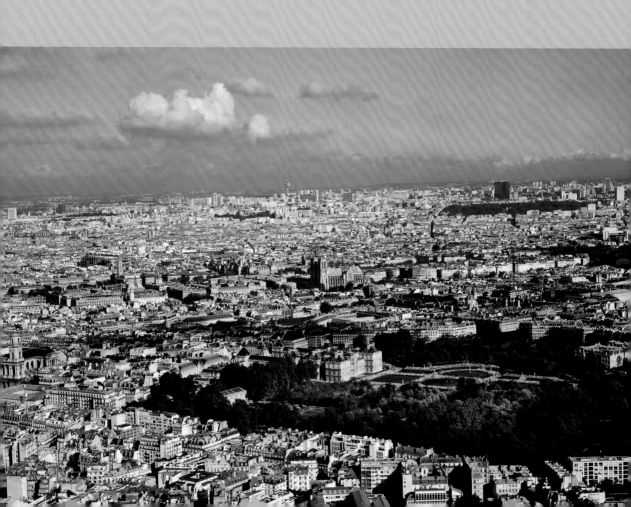

ACADÉMIE DE LA GRANDE CHAUMIÈRE

Almost any day of the week, you can drop in for a drawing session with live models.

14 rue de la Grande Chaumière, 75006
+33 1 43 26 13 72

BIBLIOTHEQUE MAZARINE

See "Itinerary: Classic Design in Saint-Germain" (page 97).

23 quai de Conti, 75006
+33 1 44 41 44 06

CHRISTINE 21

Hidden within the labyrinthine streets of the Latin Quarter, this small theater plays a mix of avant-garde and classic films—many of them in English—from *The Bad and the Beautiful* to *In the Mood for Love*. Cinephiles will appreciate the well-curated lineup. If you arrive early, relax in the cozy lobby of the Relais Christine across the street.

4 rue Christine, 75006
+33 1 43 25 85 78

COUR DU COMMERCE SAINT-ANDRE

See "Itinerary: Classic Design in Saint-Germain" (page 98).

Cour du Commerce Saint-Andre, 75006

DANSE SUR LES QUAIS DE SEINE

Every evening from June through August, hundreds of people gather to dance. Salsa, rock, tango, and traditional folk dancing from the Brittany region of France are all in the mix.

Square Tino Rossi, quai Saint-Bernard, 75005

GALERIE ERIC MOUCHET

With a roster of up-and-coming artists working in various mediums—Samir Mougas (see pages 40–44) among them—the mission of Eric Mouchet's gallery is to foster the growth of contemporary culture.

45 rue Jacob, 75006
+33 1 42 96 26 11

GALERIE FRÉDÉRIC CASTAING

See "Itinerary: Classic Design in Saint-Germain" (page 97).

30 rue Jacob, 75006
+33 1 43 54 91 71

GALERIE LA FOREST DIVONNE

Amid the traditional addresses in the Saint-Germain neighborhood lies this contemporary gallery, home to work by painter Bruno Albizzati (see pages 50–53), among other promising young artists.

12 rue des Beaux-Arts, 75006
+33 1 40 29 97 52

JARDIN DES PLANTES

The main botanical garden of France is home to greenhouses, libraries, archives, museums, and a zoo. Take a stroll through the Rose Garden in June when everything is in bloom, admire the glass and metal architecture of the Mexican Hothouse, or bring your sketchbook along to the Grande Galerie de l'Evolution.

57 rue Cuvier, 75005
+33 1 40 79 56 01

JARDIN DU LUXEMBOURG

See "Itinerary: Classic Design in Saint-Germain" (page 98).

Jardin du Luxembourg, 75006
+33 1 42 34 20 00

LA COUR DU MÛRIER, L'ÉCOLE DES BEAUX ARTS

Most Parisians don't even know about this courtyard hidden within the École des Beaux Arts. Along with the neighboring chapel, it's the only thing remaining from the Convent of the Petits-Augustins, which was founded by the scandalous Queen Margaret of France and Navarre in the early seventeenth century. Don't worry, it's open to the public.

14 rue Bonaparte, 75006
+33 1 47 03 50 00

LA PISCINE DE PONTOISE

See "How to Be Anne Berest Wherever You Are" (page 27).

19 rue de Pontoise, 75005
+33 1 55 42 77 88

LE DESPERADO

Lovers of classic cinema will want to know about this small theater in the Latin Quarter. Many of the films shown are American and play in the original language (*version originale*, or V.O.) rather than dubbed into French.

23 rue des Écoles, 75005
+33 1 43 25 72 07

LE GRAND ACTION

An art house theater with comfortable seating, you'll find quite a few English-language titles on the schedule.

5 rue des Écoles, 75005
+33 1 43 54 47 62

LUCERNAIRE

This unique art house venue in the Montaparnasse neighborhood is home to a theater, cinema, theater school, restaurant, and bar. Recommended by interior designer Laure Chouraqui (page 167).

53 Rue Notre Dame des Champs, 75006
+33 1 45 44 57 34

MUSÉE NATIONAL EUGÈNE-DELACROIX

See "Itinerary: Classic Design in Saint-Germain" (page 98).

6 rue de Furstenberg, 75006
+33 1 44 41 86 50

MUSÉE ZADKINE

A peaceful spot not far from Lux-embourg Gardens, this museum is dedicated to the works of modernist sculptor Ossip Zadkine and housed in his former home, studio, and garden.

100bis rue d'Assas, 75006
+33 1 55 42 77 20

MONNAIE DE PARIS

With a coin museum, two restaurants, a shop, and a rotating list of contempo-rary art exhibitions, there's something for everyone at this museum housed within the former Paris Mint. Recom-mended by textile designer Usha Bora (see page 171).

11 quai de Conti, 75006
+33 1 40 46 56 66

ODÉON-THÉÂTRE DE L'EUROPE

Designed by Charles de Wailly and Marie-Joseph Peyre in neoclassical style, this prominent theater was inaugurated by Marie Antoinette herself in 1782. Pierre Beaumarchais's play *The Marriage of Figaro* debuted there only two years later, in 1784.

Place de l'Odéon, 75006
+33 1 44 85 40 40

STANISLAS DRABER

Lush bouquets of roses and peonies await at this neighborhood florist. Recommended by terrarium and garden designer Kali Vermes (see page 165).

19 rue Racine, 75006
+33 1 43 29 07 88

YANNICK SUZNJEV

Feel like a true local by settling into a week-long course in flower arranging taught by this celebrated Parisian florist.

33 rue de Vaugirard, 75006
+33 1 42 84 49 28

SHOP

ASSOULINE

See "Itinerary: Classic Design in Saint-Germain" (page 97).

35 rue Bonaparte, 75006
+33 1 43 29 23 20

ASTIER DE VILLATTE

See "Itinerary: Classic Design in Saint-Germain" (page 98).

16 rue de Tournon, 75006
+33 1 42 03 43 90

BASS ET BASS

Packed to the gills with wooden toys, this store is a must-see for those with young children. Pick up one of the adorable hand puppets that are designed in-house and handmade in the Czech Republic.

229 rue Saint-Jacques, 75005
+33 1 43 25 52 52

BONPOINT

If you're looking for the epitome of elegant children's clothing, look no further. In an expansive boutique that wraps around an interior courtyard, tiny clothes and shoes line the walls. They're almost too beautiful to touch. Almost.

6 rue de Tournon, 75006
+33 1 40 51 98 20

BULY 1803

See "Itinerary: Classic Design in Saint-Germain" (page 97).

6 rue Bonaparte, 75006
+33 1 43 29 02 50

CHARBONNEL

In the 1860s, pharmacist François Charbonnel decided to try his hand at making printmaking inks and varnishes. His creations are still highly regarded today (I remember them well from my days studying printmaking in school) and you can purchase them along with paint brushes, pencils, paper, and all kinds of art supplies in their shop on the banks of the Seine.

13 quai de Montebello, 75005
+33 1 43 54 23 46

CHARVIN

Priding themselves on strict standards of quality and avoiding the "plastification" of the modern world, this historic paint manufacturer and art supply shop is a must-stop for an artist on a sunny afternoon. Step 1: Pick out one of their beautiful little watercolor sets, a couple of paintbrushes, and a pad of cold-press paper. Step 2: Take the three-minute walk to the **Square du Vert-Galant** at the tip of the Île de la Cité and find a quiet place to sit and paint.

57 quai des Grands Augustins, 75006
+33 1 43 54 98 97

CIRE TRUDON

See "Itinerary: Classic Design in Saint-Germain" (page 98).

78 rue de Seine, 75006
+33 1 43 26 46 50

FLORENCE LOPEZ

Florence Lopez's colorful atelier is not what you normally expect from an antiques dealer. Each year, she completely redecorates the space in her arresting and original style according to the pieces currently in her collection.

18 rue du Dragon, 75006
+33 1 40 49 08 12

LA CHAMBRE CLAIRE

An international photography bookshop with a cobalt blue facade, La Chambre Claire (The Lightroom) is a captivating place to while away a rainy afternoon.

3 rue d'Arras, 75005
+33 1 42 01 37 36

LIBRAIRIE ALAIN BRIEUX

See "Itinerary: Classic Design in Saint-Germain" (page 97).

48 rue Jacob, 75006
+33 1 42 60 21 98

LIBRAIRIE DU CAMÉE

Specializing in books on decorative arts and crafts, this store knows its niche well. A treasure trove of obscure inspiration, you'll find books on everything from Merovingian jewelry to art deco furniture to the history of tassels.

70 rue Saint-André des Arts, 75006
+33 1 43 26 21 70

LIBRAIRIE THIERRY CORCELLE

Just across the street from the **Odéon-Théâtre de l'Europe,** this shop is brimming with antique illustrated books, games, and toys.

29 rue de Condé, 75006
+33 1 46 33 16 16

PIERRE FREY

See "Usha's Favorite Parisian Spots for Textile Inspiration" (page 171).

2 rue de Furstenberg, 75006
+33 1 46 33 73 00

SHAKESPEARE AND COMPANY

Across from Notre-Dame stands a bookshop unlike any other. Opened in 1951 by George Whitman, who made it his life's work to create a magical sanctuary of books, and now run by his daughter Sylvia, the shop still welcomes writers and artists to sleep among the shelves, as it has since day one. Come to a reading and peruse the stacks—just as great writers like Zadie Smith and Richard Wright have done before.

37 rue de la Bûcherie, 75005
+33 1 43 25 40 93

SMALLABLE

From furniture to fashion, Smallable is an engaging emporium that carries more than six hundred designer brands for children and their parents.

81 rue du Cherche-Midi, 75006
+33 1 40 46 01 15

SOLQUES BRUNO BOULANGERIE

On the Latin quarter side of **Luxembourg Gardens,** this little bakery is a hidden gem. Expressive handmade ceramic platters, bowls, and sculptural animal heads fill the shop, as do Bruno's unusual breads and pastries.

243 rue Saint-Jacques, 75005

SOULEIADO

In the mid-1600s, colorful cotton fabrics known as *indiennes* traveled from the Great Indies to the shores of France. Before long, enterprising locals set up factories where workers hand-printed the textiles with carved wooden blocks. Souleiado carries on the tradition today. The classically styled men's shirts, scarves, and travel pouches feel surprisingly fresh.

78 rue de Seine, 75006
+33 1 43 54 62 25

VOTRE ENCADREUR

While in Paris, if you find yourself the owner of a new piece of art that needs a frame, take it to Michèle Bernard at Votre Encadreur, who is an artist in her own right.

24 rue Servandoni, 75006
+33 1 43 54 65 53

EAT + DRINK

CAFÉ DE FLORE

See "The Best People-watching in Paris" (page 113).

172 boulevard Saint-Germain, 75006
+33 1 45 48 55 26
€€

CAFÉ DE LA NOUVELLE MAIRIE

While it opens at 8 A.M. (with coffee sourced from **L'Arbre à Café**; see page 220) and serves simple bistro fare all day, the real reasons to stop in to Café de la Nouvelle Mairie are its wide *terrasse* overlooking the Place de l'Estrapade fountain and its first-rate selection of natural wines.

19 rue des Fossés Saint-Jacques, 75005
+33 1 44 07 04 41
€

CHEZ CASTEL

See "Anne's Favorite Places to Celebrate the Launch of a New Book in Paris" (page 31).

15 rue Princesse, 75006
+33 1 40 51 52 80
€€

COMPTOIR DU RELAIS + L'AVANT COMPTOIR

Lunch is your best bet at Yves Camdeborde's Le Comptoir. Sit outside in any weather, warmed by custom blankets and heat lamps in the winter and the brilliant south-facing sun in the summer. Dinner is a five-course prix fixe of Béarnaise-style plates, and a table may/should be booked six months in advance. If you feel flush, book a room at the adjoined Hôtel Relais Saint-Germain and you'll be guaranteed a table. Or head next door to their standing-room-only sister restaurant, L'Avant Comptoir.

Comptoir du Relais: 9 carrefour de l'Odéon, 75006
+33 1 44 27 07 97
€€

L'Avant Comptoir: 3 carrefour de l'Odéon, 75006
+33 1 42 38 47 55.
€€

FREDDY'S

See "Itinerary: Classic Design in Saint-Germain" (page 98).

54 rue de Seine, 75006
€€

FROMAGERIE LAURENT DUBOIS

In 2000, Laurent Dubois was awarded a Meilleur Ouvrier de France (Best Craftsman of France) and is known for housing a selection of only the very best cheeses, though that doesn't mean there is a scant selection (this is France!). In the caves below his shop, the cheeses are aged to stinky perfection before shop assistants dole them out to eager customers upstairs.

47 boulevard Saint-Germain, 75005
+33 1 43 54 50 93
€

Above: Buly 1803

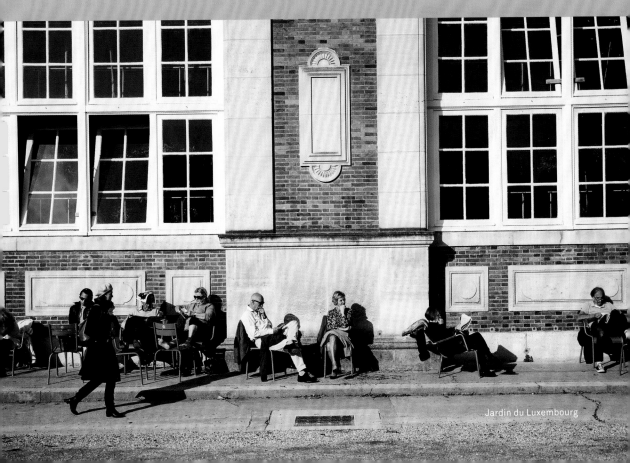

Jardin du Luxembourg

MAISON VEROT

Whether you choose pâtes, terrines, *saucisson, jambon*, headcheese, or Lyonnaise sausage, you can't go wrong. When in doubt, just close your eyes, point, and be happy with whatever charcuterie you get rung up for.

3 rue Notre-Dame-des-Champs, 75006
+33 1 45 48 83 32
€

HUÎTRERIE RÉGIS

See "The Best People-watching in Paris" (page 111).

3 rue de Montfaucon, 75006
+33 1 44 41 10 07
€€

LA COMPAGNIE DES VINS

The place to go for a good glass of wine in Saint-Germain-des-Prés, minus tourists. (*Shh!*)

7 rue Lobineau, 75006
+33 9 54 90 20 20
€–€€

L'ALCAZAR

See "Anne's Favorite Places to Celebrate the Launch of a New Book in Paris" (page 31).

62 rue Mazarine, 75006
+33 1 53 10 19 99
€€€

LA QUINCAVE

Frédéric Belcamp's tiny wine shop and wine bar in the 6th established itself as the destination for *vin nature* in 2003 and—in this current wave of natural wine bars remains as solid as ever. Ask the incredibly knowledgeable staff for a little direction and pair your bottle with a simple snack of rillettes or *saucisson*.

17 rue Bréa, 75006
+33 9 67 02 80 14
€–€€

LES DEUX MAGOTS

See "The Best People-watching in Paris" (page 113).

6 Place Saint-Germain des Prés, 75006
+33 1 45 48 55 25
€€–€€€

MARCHÉ RASPAIL

Hosting more than 150 vendors and open three days a week, Marché Raspail is one of the largest organic open-air markets in Europe and is perfect for picking up grocery staples like fresh organic vegetables, fruits, cheeses, eggs, and more and taking that perfect Instagram. (Be discreet about the last staple—vendors are there to sell, not act as free art subjects.)

Boulevard Raspail, between Rue du Cherche-Midi and Rue de Rennes, 75006
+33 1 43 24 74 39
€

MARIAGE FRÈRES

Come in for Le Mont Blanc at Mariage Frères's *salon du thé*, leave with a bag (or three) of quality tea from this renowned company. Recommended by Frank Barron (see page 201).

13 rue des Grands Augustins, 75006
+33 1 40 51 82 50
€–€€

POÎLANE

Be sure to make a visit to this third generation shop in Saint-Germain-des-Prés your top priority. Snack on thick slices of golden country *miche* (their signature four-pound loaf, which is considered by many to be the best sourdough in the world), flaky apple tarts, and butter *punitions*. Stop by again on your way out of town and buy another loaf to pack in your suitcase. The earthy flavor improves as it sits, and it will keep for over a week. Once you run out of your smuggled loaf, order more online with overnight international shipping.

8 rue du Cherche-Midi, 75006
+33 1 45 48 42 59
€

ROGER LA GRENOUILLE

See "Anne's Favorite Places to Celebrate the Launch of a New Book in Paris" (page 31).

28 rue des Grands Augustins, 75006
+33 1 56 24 24 34
€€

SEMILLA

See "Itinerary: Classic Design in Saint-Germain" (page 98).

54 rue de Seine, 75006
+33 1 43 54 34 50
Reservations suggested.
€€

Jardin du Luxembourg

SHAKESPEARE AND COMPANY CAFÉ

Situated directly next to the historic English-language bookshop, Shakespeare and Company Café serves locally roasted coffee from Café Lomi, teas from London-based Postcard Teas, snacks from Bob's Bake Shop, and plenty of literary puns. All of which is ideal for pre- or post-literary browsing.

37 rue de la Bûcherie, 75005
+33 1 43 25 95 95
€

STAY

HÔTEL DES GRANDS ÉCOLES

As you step off the street and through the door, you're greeted by a lush garden courtyard and a pretty pink facade. Rooms are clean, cozy, and papered in traditional toile. Great for families.

75 rue du Cardinal Lemoine, 75005
+33 1 43 26 79 23
€

HÔTEL ESMERALDA

See "Beaux Rêves" (page 154).

4 rue Saint-Julien le Pauvre, 75005
+33 1 43 54 19 20
€

HOTEL LE MONTANA

Literally next door to the famous and historic **Café de Flore,** this petite luxury hotel is decorated in a bold and graphic style and contains a swanky bar and rooftop terrace.

28 rue Saint-Benoît, 75006
+33 1 53 63 79 20
€€€–€€€€

L'HOTEL

If it's good enough for Oscar Wilde, it's good enough for me. The illustrious

writer spent his last days in this hotel, and you, too, can stay in his room if you like (or any of the other velvet-and-silk-bedecked rooms, if you'd rather). A restaurant, bar, pool, and hammam round out the opulent offerings.

13 rue des Beaux Arts, 75006
+33 1 44 41 99 00
€€€

THE SAINT SULPICE RESIDENCE, KID & COE

Contemporary art mixes impeccably with historic architecture in this family-friendly apartment near the Saint Sulpice church. Three bedrooms, a washer/dryer, and babysitters upon request guarantee the comfort of home away from home.

kidandcoe.com/destinations/
the-6th-arrondissement/the-saint-
sulpice-residence
€€€€

7th Arrondissement
+ Trocadéro

EIFFEL TOWER + TROCADÉRO

Step out of the Métro at the Trocadéro and then cross the street for a breathtaking view of the most recognized Parisian landmark. You may want to take a few photos and then leave it at that, since the mass of people beneath the monument itself can be overwhelming. If scaling the tower is on your must-do list, make online reservations in advance to avoid the ticket line.

Eiffel Tower: Champ de Mars, 5 avenue Anatole France, 75007
+33 892 70 12 39

Trocadéro: Place du Trocadéro et du 11 Novembre, 75016

MUSÉE D'ART MODERNE DE LA VILLE DE PARIS

For those who love modern and contemporary art, a perfect day could be spent among the collections of this museum and its next-door neighbor, the **Palais de Tokyo.** (I've done it—with kids in tow!)

11 avenue du Président Wilson, 75116
+33 1 53 67 40 00

MUSÉE D'ORSAY

On the left bank of the Seine, in a former railway station, sits the grand Musée d'Orsay. Having recently visited after twenty years, I can attest that it's still worth hazarding the crowds. The building itself is a spectacular specimen of Beaux arts architecture, and the collection of Impressionist art is unmatched.

1 rue de la Légion d'Honneur, 75007
+33 1 40 49 48 14

MUSÉE GUIMET

See "Usha's Favorite Parisian Spots for Textile Inspiration" (page 171).

6 place d'Iéna, 75116
+33 1 56 52 53 00

MUSÉE RODIN

Dedicated to the work of Auguste Rodin, this arresting museum is housed in an eighteenth-century mansion surrounded by a park. Visit the museum, the sculpture garden, or both to see famous works like *The Thinker,* along with hundreds of other works by Rodin, Camille Claudel, and more. If traveling with kids, the outdoor café is a nice place to stop for a drink while the little ones run around.

77 rue de Varenne, 75007
+33 1 44 18 61 10

PALAIS DE TOKYO

If you're looking for a change of scenery from all the antiques, this stunning contemporary art museum might be just the thing. You'll also find two restaurants, a bookshop, and a nightclub on the premises—all of which warrant a visit.

13 avenue du Président Wilson, 75116
+33 1 81 97 35 88

PALAIS GALLIERA

Housed in a Beaux Arts palace not far from the **Eiffel Tower,** the Palais Galliera is a museum showcasing fashion— both historic and of the moment. Recommended by fashion stylist Alison Reid (see page 137).

10 Avenue Pierre 1er de Serbie, 75016
+33 1 56 52 86 00

AMI

What started as a menswear line in 2011 by Alexandre Mattiussi now offers clothing in its signature relaxed style for women as well. Recommended by fashion stylist Alison Reid (see page 137).

22 rue de Grenelle, 75007
+33 9 82 30 96 77

DEYROLLES

More museum or cabinet of curiosities than store, a menagerie of taxidermies fill the rooms of this beautiful building with tall ceilings, wooden molding, and seafoam green walls.

46 rue du Bac, 75007
+33 1 42 22 30 07

ELISE TSIKIS

See "Interlude: Elise Tsikis, Jewelry Designer" (pages 140–141).

69 rue du Bac, 75007

INÈS DE LA FRESSANGE

Iconic French model, muse, aristo-crat, and fashion designer Inès de la Fressange puts her curatorial skills to good use in the stylish boutique that shares her name. The overall vibe is "Parisian prep." Clothing, candles, and other well-designed items fill the shelves. Peek through a window in the back to the atelier that creates her line of clothing.

24 rue de Grenelle, 75007
+33 1 45 48 19 06

LE BON MARCHÉ

The first department store in the world is arguably the most inspiring as well. You could easily spend an entire day browsing the racks of designer goods. Be sure to stop for lunch at the **Rose Bakery** or a stall in **La Grande Épicerie** (a gourmet food hall) across the street.

24 rue de Sèvres, 75007
+33 1 44 39 80 00

LOLA JAMES HARPER

This French lifestyle brand evokes the sunny feeling of California with its unique blend of palm tree photographs and casual yet luxurious candles and fragrances. Under the direction of founder Rami Mekdachi, Lola James Harper is branching out into hotels in Paris and beyond.

In Le Bon Marché, 1st floor: 24 rue de Sèvres, 75007
+33 1 44 39 80 00

MAISON MARGIELA

Begun in 1988 in Paris by Belgian designer Martin Margiela, this iconic French fashion house prides itself on its subtle yet unusual silhouettes. Recommended by fashion stylist Alison Reid (see page 137).

13 rue de Grenelle, 75007
+33 1 45 49 06 68

In Le Bon Marché: 24 rue de Sèvres, 75007
+33 1 42 22 54 58

PÉCHAUD ET COMPAGNIE

If you're in the area, stop by this tiny newsagent for a copy of *Marie Claire Maison* and to chat with the two lovely sisters who bought the place from another set of sisters back in 1979.

16 rue des Saints-Pères, 75007
+33 9 63 42 73 33

SAINT JAMES

Classic stripes bedeck the French sailor shirts invented by this brand in the nineteenth century. Recommended by designer Marin Montagut (see page 74).

44 rue Cler, 75007
+33 1 44 18 05 18

SENNELIER

You'll find wooden shelves stacked with paints, papers, pencils, and much more at this art supplier that has counted Paul Cézanne, Sonia Delaunay, and David Hockney among its collaborators.

3 quai Voltaire, 75007
+33 1 42 60 72 15

BARTHÉLÉMY

If the gorgeous storefront isn't enough incentive to visit renowned cheese monger Nicole Barthélémy's tiny shop, the walls packed from top to bottom with more than two hundred varieties of cheese will be. Rely on the expert staff to guide you—they know each cheese inside out and won't lead you astray.

51 rue de Grenelle, 75007
+33 1 42 22 82 24
€

CHEZ L'AMI JEAN

Risqué caricature–strewn Chez L'Ami Jean is the ideal spot for a long, lively, and very filling lunch. Seasoned pros know to go on a day they don't have dinner planned and/or have a post-meal nap penciled in. You'll be plenty full by the time you get to dessert, but don't miss Stéphane Jégo's rice pudding—you'll be bragging about its flavor and heft for years to come.

27 rue Malar, 75007
+33 1 47 05 86 89
€€

COUTUME CAFÉ

A bustling café just a few short blocks from Musée Rodin, Coutume Café is a lovely place to either drop by for a quick coffee or settle in for breakfast or lunch. Pick up a bag of their freshly roasted coffee beans on your way out.

47 rue Babylone, 75007
+33 1 45 51 50 47
€

DES GÂTEAUX ET DU PAIN

Before opening her own boulangerie-pâtisserie, Claire Damon spent time in top-tier kitchens, such as Ladurée and the Plaza Athénée. Her tarts and cakes are dazzling and just as delicious as they are gorgeous.

89 rue du Bac, 75007
+33 1 45 48 30 74
€

FROMAGERIE QUATREHOMME

Marie Quatrehomme was the first woman to win the prestigious Meilleur Ouvrier de France (Best Craftsman in France) title and is known for her Beaufort, Comté, and goat cheese. If it's a picnic you seek, the boutique is a ten-minute stroll to the **Luxembourg Gardens,** and we hear cheese pairs well with wine (grab a bottle in the cellar of the nearby **La Grand Épicerie**).

62 rue de Sèvres, 75007
+33 1 47 34 33 45
€

LA GRAND ÉPICERIE

The elegant and massive **Le Bon Marché** department store now has a food hall and it's just as elegant and massive as the store. There's an overwhelming array of specialty products — cheese, wine, meat, teas, chocolates, oils, spices, fresh and prepared foods, bread, more brands of water than you thought existed, even a generous stock of Reese's Peanut Butter Cups in the *Américain* aisle. Stop for edible souvenirs and gifts or just wander and take in the craziness of it all.

38 rue de Sèvres, 75007
+33 1 44 39 81 00
€–€€€

LA PÂTISSERIE DES RÊVES

Philippe Conticini's shop offers classic desserts with playful, modern twists. Don't miss the Paris-Brest and the *gâteau Saint-Honoré*. Eat it now, dream about it later.

93 rue du Bac, 75007
+33 9 72 60 93 19
€

111 rue de Longchamp, 75116
+33 1 47 04 00 24
€

MARCHÉ PRÉSIDENT WILSON

One of the loveliest and largest marchés in Paris, this one is known for attracting chefs from across Paris. Get there early and do a lap before deciding what to buy. Recommended by cookbook author Emily Dilling (page 185).

Avenue du Président Wilson, 75116
€

TAVLINE

Tavline ("spice" in Hebrew) is an aptly named and gorgeously executed restaurant. Israeli chef Kobi Villot Malka employs its namesake liberally across the Israeli-Moroccan menu, from mezzes to desserts to drinks in a small, casual space.

25 rue du Roi de Sicile, 75004
+33 9 86 55 65 65
€–€€

WILD & THE MOON

See "Interlude: Emma Sawko of Wild & The Moon" (pages 204–205).

19 rue de Chaillot, 75116
+33 1 84 25 61 20
€–€€

HOTEL THOUMIEUX

Mix-and-match patterns and velvet upholstery abound in this glamorous hotel not far from the **Eiffel Tower.**

79 rue Saint-Dominique, 75007
+33 1 47 05 79 00
€€€

RUE GASTON DE SAINT-PAUL II, ONE FINE STAY

I love the charmingly traditional décor of this one-bedroom apartment that's just a two-minute walk from the **Palais de Tokyo, Palais Galliera,** and **Musée d'Art Moderne.** It's also close to the most upscale food market in the city (**Marché Président Wilson**) and, of course, the **Eiffel Tower.** The clincher? An up-close-and-personal view of that same iron monument right through the living room windows.

onefinestay.com/home-listing/GAS334
€€€

SHANGRI-LA HOTEL

Dazzling views of the **Eiffel Tower** greet you from this hotel, which once belonged to Napoleon's nephew. Rooms are outfitted with discreet luxury. L'Abeille, a two-star Michelin restaurant situated next to the garden, is named after the emperor's favorite emblem, the bee.

10 avenue d'Iéna, 75116
+33 1 53 67 19 98
€€€€

SQUARE DE LA TOUR RESIDENCE, KID & CO.

This luminous apartment near *la Tour Eiffel* is filled with art, design objects, books, and toys for the little ones. You'll find all the convenient amenities that make travel with kids so much easier—laundry room, dishwasher, plenty of space (three bedrooms), crib, high chair, stroller, etc. Rue Cler—a pedestrian market street with bou-langeries, grocers, cheese shops, etc. is just around the corner.

www.kidandcoe.com/destinations/
champ-de-mars/the-square-de-la-
tour-residence
€€

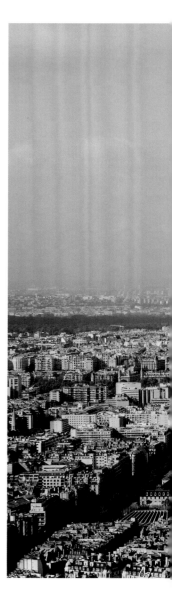

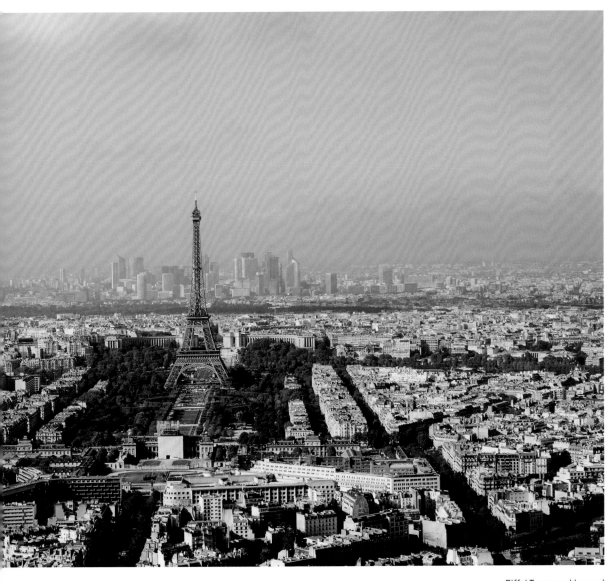

Eiffel Tower and beyond

8th + 9th
Arrondissements

Musée Nissim de Camondo
Photo: Meta Coleman

SEE

AMELIE MAISON D'ART

See "Itinerary: An Artful Day in Saint-Georges" (page 57).

8-10 rue Clauzel, 75009
+33 7 87 02 00 89

CITÉ BERRYER

A picturesque pedestrian lane, the "Village Royal" (as it is otherwise known) is lined with luxury boutiques and cafés.

Cité Berryer, 75008

GALLERIE NATIONAL DU JEU DE PAUME

Contemporary art exhibits heavy in photography and video installations await at this museum, tucked away within the **Tuileries**. Don't miss the killer selection of art books and magazines in the shop.

1 place de la Concorde, 75008
+33 1 47 03 12 50

GRAND PALAIS

Built in 1900 and containing the largest glass roof in Europe to this day, the architecture of this exhibition hall alone is worth a visit. Check their website for a complete list of exhibitions, expos, and events. Recommended by designer Marin Montagut (see page 74).

3 avenue du Général Eisenhower, 75008
+33 1 44 13 17 17

LA PHONOGALERIE

This quirky little museum/store/repair shop is dedicated to the love of antique gramophones. Recommended by Papier Tigre cofounder Maxime Brenon (see page 70).

10 rue Lallier, 75009
+33 1 45 26 45 80

MARCHÉ AUX TIMBRES ET AUX CARTES POSTALES

The Stamp and Postcard Market has something for everyone's budget. It's been held at the same place—the Carré Marigny—since the 1860s, when a wealthy stamp collector bequeathed the land to the city of Paris for that purpose.

Carré Marigny, 75008

MUSÉE DE LA VIE ROMANTIQUE

See "Itinerary: An Artful Day in Saint-Georges" (page 57).

16 rue Chaptal, 75009
+33 1 55 31 95 67

MUSÉE GUSTAVE MOREAU

See "Itinerary: An Artful Day in Saint-Georges" (page 57).

14 rue de la Rochefoucauld, 75009
+33 1 48 74 38 50

MUSÉE GRÉVIN

This family-friendly wax museum is a fun spot for kids to learn more about prominent people of France—both historic and current. Recommended by photographer Cécile Molinié (see page 49).

10 boulevard Montmartre, 75009
+33 1 47 70 85 05

MUSÉE JACQUEMART-ANDRÉ

The sumptuous mansion of Edouard André and Nélie Jacquemart was the talk of the town when it made its debut toward the end of the nineteenth century. Hydraulic lifts moved wall panels out of the way so that three large rooms could be combined into one, and the social couple could entertain up to one thousand guests at a time. The "winter garden"—an atrium decorated with exotic potted plants—provided a welcome respite from the crowded ballroom. Explore the rooms as they once were, along with the museum of Italian art upstairs. Afterward, stop by the café for tea.

158 boulevard Haussmann, 75008
+33 1 45 62 11 59

MUSÉE NISSIM DE CAMONDO

Built for successful banker Moïse de Camondo in 1911, the exquisite mansion was filled with Camondo's collections of French furniture and art objects. Intending his son, Nissim, to inherit the home, his plan was destroyed when Nissim died in World War I. Instead, he bequeathed it to the city of Paris, and it opened as a public museum in 1935, offering a fascinating look into how the aristocracy lived. The most interesting rooms are the kitchen and the bathrooms, which were state of the art for the period.

63 rue de Monceau, 75008
+33 1 53 89 06 50

PALAIS GARNIER

For a splurge-worthy night out, buy tickets to a performance at this theater, which inspired *The Phantom of the Opera*. The interiors alone merit a visit. Gilded flourishes and red velvet impress, while a mural by Chagall on the ceiling provides a welcome touch of playfulness.

8 rue Scribe, 75009
+33 1 71 25 24 23

PARC MONCEAU

A pleasant park with a playground, carousel, statues, and plenty of open space to run around in, Parc Monceau is popular with local families. Unlike most other Parisian parks, which follow the French tradition of formal symmetry, it features a meandering, informal layout inspired by traditional English gardens.

35 boulevard de Courcelles, 75008
+33 1 42 27 39 56

PASSAGE JOUFFROY

See "Itinerary: The Charm of Hidden Passageways" (page 176).

10-12 boulevard Montmartre, 75009

PASSAGE VERDEAU

See "Itinerary: The Charm of Hidden Passageways" (page 176).

6 rue de la Grange Batelière, 75003

SQUARE EDOUARD VII

A photo op waiting to happen, this pedestrian enclave is just a couple of blocks from the **Opéra Garnier**—you'll feel like you stumbled upon a secret.

Square Edouard VII, 75009

SHOP

CHRISTOFLE

For traditional silver and crystal, head to Christofle, which was founded in the 1800s by jeweler Charles Christofle. Still manufactured in France to this day, their luxurious goods have graced the tables of Napoleon and other French dignitaries. Recommended by Papier Tigre cofounder Maxime Brenon (see page 70).

9 rue Royale, 75008
+33 1 55 27 99 17

GALERIES LAFAYETTES

This grande dame of Parisian department stores has something for everyone. Even if you're not in the mood to shop, the stained-glass dome and view from the roof are worth a look.

Recommended by sock designer Béatrice de Crécy (see page 139).

40 boulevard Haussmann, 75009
+33 1 42 82 34 56

JAMINI

See "Usha Bora of Jamini, a Textiles Brand: Five Questions" (pages 169–171).

10 rue Notre-Dame de Lorette, 75009
+33 9 83 88 91 06

LE LABO

The antique-apothecary-meets-Brooklyn aesthetic of Le Labo is expressed differently in each of their boutiques around the world. Bottles of perfume are mixed by hand as you wait and there are often special formulations available exclusively at each location.

61 rue de Caumartin, 75009

LE PETIT ROI

See "Itinerary: The Charm of Hidden Passageways" (page 176).

39 passage Jouffroy, 75009
+33 1 40 22 94 60

LE SEPT CINQ

A curated selection of goods from Parisian independent designers make this shop the perfect place to gather souvenirs you will actually wear or use. Recommended by jewelry designer Elise Tsikis (see page 141).

54 rue Notre-Dame de Lorette, 75009
+33 9 83 55 05 95

LIBRAIRIE FARFOUILLE

See "Itinerary: The Charm of Hidden Passageways" (page 176).

27 passage Verdeau, 75009
+33 1 47 70 21 15

LIBRAIRIE LARDANCHET

Situated on the most luxurious lane in Paris amid designer boutiques, this bookshop focuses on art and antique books—no shortage of beautiful pages here.

100 rue du Faubourg Saint-Honoré, 75008
+33 1 42 66 68 32

PAIN D'ÉPICES

See "Itinerary: The Charm of Hidden Passageways" (page 176).

29 passage Jouffroy, 75009
+33 1 47 70 08 68

PLUS DE BRUIT

See "Itinerary: An Artful Day in Saint-Georges" (page 57).

35 rue de la Rochefoucauld, 75009
+33 1 49 70 08 7

EAT + DRINK

À LA MÈRE DE FAMILLE

See "Itinerary: The Charm of Hidden Passageways" (page 176).

35 rue du Faubourg Montmartre, 75009
+33 1 47 70 83 69
€

ARTISAN

Tucked into SoPi (South Pigalle), Artisan has a zinc bar, well-balanced drinks, and some solid late-night plates. Recommended by painter Bruno Albizzati (see page 50).

14 rue Bochart de Saron, 75009
+33 1 48 74 65 38
€–€€

CAILLEBOTTE

Opened a few streets from the team behind the well-loved bistro Le Pantruche, Caillebotte serves similar modern bistro fare in a bright space with an open kitchen. Recommended by painter Bruno Albizzati (see page 50).

8 rue Hippolyte Lebas, 75009
+33 1 53 20 88 70
€–€€

FOUR SEASONS GEORGE V

Stop into the Four Seasons for dessert, specifically the *fleur de vacherin* (vacherin flower) by Maxime Frédéric. Recommended by Frank Barron (see page 203).

31 avenue George V, 75008
+33 1 49 52 70 00
€€–€€€

HONOR

Paris's first outdoor specialty coffee shop (from English-Australian couple Daniel Warburton and Angelle Boucher) is designed to remain open year-round—despite Paris's tendency toward inclement weather—and also houses some of the city's best coffee. Take your brew to go or grab a seat at the stool-lined bar.

54 rue du Faubourg Saint-Honoré, 75008
+33 7 82 52 93 63
€

HÔTEL AMOUR

See "Anne's Favorite Places to Celebrate the Launch of a New Book in Paris" (page 31).

8 rue de Navarin, 75009
+33 1 48 78 31 80
€€

ITO IZAKAYA

Founded by Frenchmen Rafael Wallon and Vincent John Soimaud, Ito Izakaya brings the art of Japanese small plates to the 9th. Especially ideal for late-night dining. Recommended by painter Bruno Albizatti (see page 50).

4 rue Pierre Fontaine, 75009
+33 9 52 91 23 00
€–€€

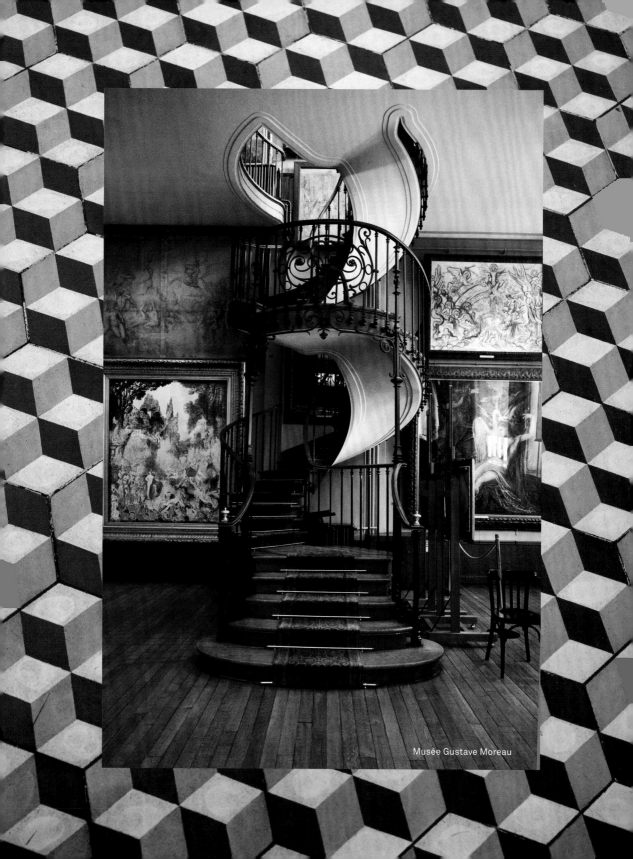

Musée Gustave Moreau

Garden of Musée de la Vie Romantique

Musée Nissim de Camondo,
Photo: Meta Coleman

Palais Garnier

LA FERME SAINT HUBERT

Paulette and Henry Voy's more than two hundred cheeses are always perfectly ripe, and if you ask nicely ("*s'il vous plaît,*" in whatever accent you can manage), they'll vacuum-pack them for you to take back home.

36 rue de Rochechouart, 75009
+33 1 45 53 15 77
€

LA MANO

See "Anne's Favorite Places to Celebrate the Launch of a New Book in Paris" (page 31).

10 rue Papillon, 75009
+33 9 67 50 50 37
€€

LE PIGALLE

See "Itinerary: An Artful Day in Saint-Georges" (page 57).

9 rue Frochot, 75009
+33 1 48 78 37 14
€–€€

LE VIN AU VERT

Etienne Lucan and Sébastien Obert's simple *cave à manger* (wine shop and deli) offers a first-rate natural wine selection at fantastic prices. Pair something off the wall with a cheese and charcuterie plate, or take a few bottles to go.

70 rue de Dunkerque, 75009
+33 1 83 56 46 93
€–€€

LULU WHITE

Small and elegant, this art deco speakeasy is tucked behind a discreet windowless facade, marked by a small brass engraving of the New Orleans brothel madam of the same name, and specializes in very delicious absinthe-laced cocktails and flights.

12 rue Frochot, 75009
res@luluwhite.bar
€–€€

PIERRE HERMÉ

Pop into one of the one and only Pierre Hermé shops for a Paris-Brest Ispahan, and leave with a carton of macarons. Recommended by Frank Barron (see page 201).

89 boulevard Malesherbes, 75008
+33 1 43 54 47 77
€€

PINK MAMMA

Pink Mamma, the sixth opening from the duo behind the Big Mamma Restaurant group, takes up four floors of a corner space in trendy south Pigalle. From the speakeasy basement to the foliage-heavy top floor, there's plenty to see—and eat. Don't miss the truffle pasta or the smoked stracciatella.

20bis rue de Douai 75009
+33 1 40 36 03 94
€€

RICHER

An all-day neobrasserie by Charles Compagnon (of 52 **Faubourg Saint-Denis,** and **L'Office**) that's just as lovely for coffee or lunch as it is cocktails and seasonal small plates. Recommended by Usha Bora (see page 171) and painter Bruno Albizatti (see page 50).

2 rue Richer, 75009
+33 9 67 29 18 43
€–€€

RUE DES MARTYRS

Lined with bakeries, cheese shops, and other edible treats, Rue des Martyrs makes for a lovely afternoon of wandering from bite to bite. Stop in Sébastien Gaudard (number 22) for croissants; Fromagerie Chataigner (number 3) for, well, *fromage*; Chez Plume (number 6) for roast chicken; Rose Bakery for whatever vegetables they've roasted (number 46); Fromagerie Beillevaire (number 48) for more *fromage* and the best butter in France.

Rue des Martyrs, 75009

STAY

HÔTEL AMOUR

Steps from the Rue des Martyr with its many restaurants, the Hôtel Amour offers fashionable rooms to a fashionable clientele. Don't miss the glamorous terrace with its red velvet chairs and jungle of greenery designed by Kali Vermes (pages 158–165).

8 rue de Navarin, 75009
+33 1 48 78 31 80
€€

HOTEL CHOPIN

See "Itinerary: The Charm of Hidden Passageways" (page 176).

46 passage Jouffroy, 75009
+33 1 47 70 58 10
€

HÔTEL DU TEMPS

See "Beaux Rêves" (page 153).

11 rue de Montholon, 75009
+33 1 47 70 37 16
€

HÔTEL LANCASTER

Marlene Dietrich, Grace Kelly, and Clark Gable all visited the Hôtel Lancaster in their day. And it's easy to see why. The intimate size, coupled with lavish details like crystal chandeliers, velvet upholstery, and raised paneling, make it feel as though you're staying in a private mansion.

7 rue de Berri, 75008
+33 1 40 76 40 76
€€

HOTEL PANACHE

Vogue, Condé Nast Traveler, and *Architectural Digest* have all featured this boutique hotel with art-nouveau-meets-contemporary design and a convenient location in the heart of the city.

1 rue Geoffroy-Marie, 75009
+33 1 47 70 85 87
€

HÔTEL PLAZA ATHÉNÉE

Iconic red awnings and an ivy-covered interior courtyard greet you at this luxury hotel featured in *Something's Got to Give, Sex and the City, The Devil Wears Prada,* and other films. Inside you'll find five restaurants run by renowned French chef Alain Ducasse and rooms decorated with bespoke linen and Italian marble. In the winter, you can even skate on their private ice rink.

25 avenue Montaigne, 75008
+33 1 53 67 66 65
€€€€

LE PIGALLE

Designed by buzzy Parisian interior design duo Festen, this neighborhood hotel provides a hand-picked selection of vinyl in each room, a legit restaurant (see page 57), delicious room service, and weekly music nights.

9 rue Frochot, 75009
+33 1 48 78 37 14
€

Musée de la Vie Romantique

10th
Arrondissement

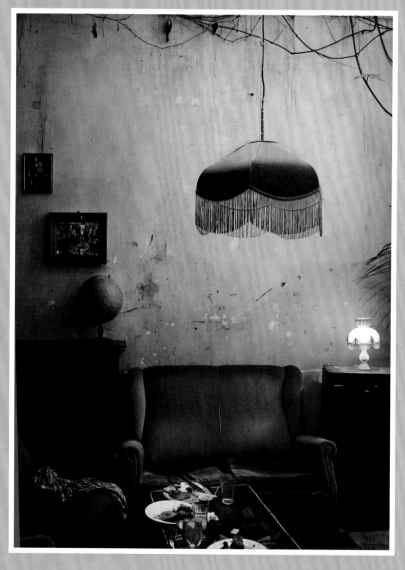

Le Comptoir Général

CANAL SAINT-MARTIN

Take a walk or have a picnic along the banks of the famous spot where Amélie Poulain skipped rocks.

Canal Saint-Martin, 75010

GALERIE UNTILTHEN

From an unlikely location in the **Saint-Ouen flea market** to their current spot in the 10th arrondissement on Boulevard Magenta, Olivier Belot and Mélanie Meffrer Rondeau are not the kind to follow the expected path. Neither are the contemporary artists they represent.

41 boulevard de Magenta, 75010
+33 1 53 20 16 84

LE COMPTOIR GÉNÉRAL

It's hard to pigeonhole this concert venue/café/hair salon/shop/museum, and that's the beauty of it. Le Comptoir Général is one of the most unique places I've seen in Paris—or anywhere for that matter. Visit the sprawling space filled with vintage furniture, towering plants, and frequented by an artistic clientele to see for yourself.

80 quai de Jemmapes, 75010
+33 1 44 88 24 48

LE LOUXOR

After decades of neglect, this hundred-year-old theater recently underwent a massive renovation that brought it back to its former glory and function. Designed by Henri Zipcy in the Egyptian style popular in the 1920s, striking blue and gold mosaics still draw the eyes of passersby. Films are shown in their original language (*version originale*, or V.O.), not dubbed in French.

170 boulevard de Magenta, 75010
+33 1 44 63 96 98

PASSAGE BRADY

Come to this covered passageway when you have a hankering for Indian, Bangladeshi, or Pakistani cuisine and to explore another example of a surviving nineteenth-century covered passageway.

46 rue du Faubourg Saint-Denis, 75010
+33 7 83 66 98 24

THÉÂTRE DES BOUFFES DU NORD

This beautiful nineteenth-century theater was rescued from disrepair in the 1970s by Peter Brook and is now home to forward-thinking productions, including some in English (with French subtitles). Recommended by interior designer Laure Chouraqui (page 168).

37 bis Boulevard de la Chapelle, 75010
+33 1 46 07 34 50

A.P.C.

See "Itinerary: Right Bank Women's Fashion" (page 145).

5 rue de Marseille, 75010
+33 1 42 39 84 46

ARTAZART

Overlooking the Canal Saint-Martin lies a bookshop packed to the gills with books, magazines, objects, and travel guides—all with an eye for design.

83 quai de Valmy, 75010
+33 1 40 40 24 00

ATELIER BEAUREPAIRE

See "Itinerary: Right Bank Women's Fashion" (page 145).

28 rue Beaurepaire, 75010
+33 1 42 08 17 03

BLEUET COQULICOT

Flowers spill out onto the street and vines climb up the facade of this charming little floral shop.

10 rue de la Grange aux Belles, 75010
+33 1 42 41 21 35

CENTRE COMMERCIAL

See "Itinerary: Right Bank Women's Fashion" (page 145).

2 rue de Marseille, 75010
+33 1 42 02 26 08

Bleuet Coquelicot

CENTRE COMMERCIAL KIDS

See "Itinerary: Right Bank Women's Fashion" (page 145).

22 rue Yves Toudic, 75010
+33 1 42 06 23 81

GROUND ZERO

In addition to records, this shop also sells well-designed furniture to store your vinyl collection and top-of-the-line equipment for listening to it. Recommended by Papier Tigre cofounder Maxime Brenon (page 70).

114 rue du Faubourg Poissonnière, 75010
+33 9 83 20 84 42

MADELEINE & GUSTAVE

Founded by a brother and sister and named after their grandparents, this airy boutique carries an array of home décor, plants, and gifts. Upstairs, you'll find a small café beside an enormous arched window.

19 rue Yves Toudic, 75010
+33 1 40 38 61 02

LA TRÉSORERIE

Textile designer William Morris once said, "Have nothing in your house that you do not know to be useful, or believe to be beautiful." This spacious Scandinavian-inspired boutique showcases objects that are both useful and beautiful. Cotton dish towels, stoneware, cutlery, and other items for the home are on display. And not all is from the northern countries, I walked away with a petite "Made in France" serrated knife—just the thing for slicing baguettes.

11 rue du Château d'Eau, 75010
+33 1 40 40 20 46

LEAF

Potted cacti, pilleas, and other green plants from this cute little shop make great gifts for any local hosts you may have. Recommended by plant designer Kali Vermes (see page 165).

46 rue Albert Thomas, 75010
+33 1 83 89 83 99

MACON & LESQUOY

Combining contemporary, witty designs with the traditional craftsmanship of intricate beading and embroidery, Macon & Lesquoy makes brooches and patches feel new again.

37 rue Yves Toudic, 75010
+33 9 53 92 89 70

OMY

See "Interlude: Elvire Laurent and Marie-Cerise Lichtlé of OMY" (pages 90–95).

2 rue Gabriel Laumain, 75010
+33 1 48 00 18 49

THANX GOD I'M A V.I.P

See "Itinerary: Right Bank Women's Fashion" (page 145).

12 rue de Lancry, 75010
+33 1 42 03 02 09

EAT + DRINK

BOB'S JUICE BAR

Sometimes you need a break from breakfast pastries. In these moments, New Yorker Marc Grossman's juice bar has you covered. Opt for a classic green smoothie, a cold press from the fridge, or one of many other housemade elixirs. They also carry Lomi coffee, bagels, and maki made with whole-grain rice.

15 rue Lucien Sampaix, 75010
+33 9 50 06 36 18
€

BRICKTOP PIZZA

Despite the relative ease in which you can get to Italy from France, good pizza in Paris is a tall order. Bricktop's Neapolitan-style pizza is affordable, fresh, and—wait for it—actually good. Plus, there's a to-go window for easy on-the-fly ordering and stumbling home after one too many *apéros*.

153 quai de Valmy, 75010
+33 9 67 44 60 71
€

CAFÉ CRAFT

Café Craft is the coworking approximation of a backward mullet: party in the front, business in the back. The front of the shop is a standard café for those civilized folk who prefer to socialize or read while caffeinating. The back is a clean, usable, pay-per-hour coworking space that serves—*gasp*—actually good coffee from Lomi. In a city that hasn't quite caught on to the coffee shop/desk culture, it's a true treat to bring your laptop and enjoy the shared desks, power outlets, high-speed Wi-Fi, and tasty drinks. Freelancers, rejoice!

24 rue des Vinaigriers, 75010
+33 1 40 35 90 77
€

DU PAIN ET DES IDÉES

The bakery that tops everyone's list is worth the hype. Buy, then immediately eat, Christophe Vasseur's house loaf, the *pain des amis*, but also try the snail-shaped escargot pastry (ask for these *bien cuit*—well done—to avoid a soggy, underbaked bottom), *sacristain* (twisted puff pastry stick), *chausson aux pommes* (apple turnover), or pain au chocolat.

34 rue Yves Toudic, 75010
+33 1 42 40 44 52
Closed Saturday and Sunday.
€

HOLYBELLY

If you're seeking pancakes, poached eggs, or anything brunch, head over to HolyBelly and get there early; there are no reservations and there is always a line. The space is sunny, the coffee (Belleville Brûlerie) excellent, and the service outrageously friendly.

59 rue Lucien Sampaix, 75010
+33 1 82 28 00 80
€

IMA

See "Mikael Attar of IMA Restaurant: Five Questions" (pages 202–203).

39 quai de Valmy, 75010
+33 1 40 36 41 37
€

LA CAVE À MICHEL

See "Itinerary: Eating + Drinking in Style" (page 207).

36 rue Saint-Marthe, 75010
+33 1 42 45 94 47
€–€€

LA CRÈMERIE

La Crèmerie might just be the friendliest *fromagerie* in town. Owner Dominique specializes in French cheeses and clearly knows her stuff. Round out your cheese plate with prepared foods, condiments, and charcuterie, as well as a modest selection of wines and craft beers.

41 rue de Lancry, 75010
+33 1 74 64 59 78
€

LA FONTAINE DE BELLEVILLE

See "Itinerary: Eating + Drinking in Style" (page 207).

31-33 rue Juliette Dodu, 75010
+33 9 81 75 54 54
€

LE GALOPIN

See "Itinerary: Eating + Drinking in Style" (page 207).

34 rue Sainte-Marthe, 75010
+33 1 42 06 05 03
Reservations encouraged.
€€

LE SYNDICAT

One of our favorite cocktail bars in the city, Le Syndicat celebrates historic French spirits and apéritifs (think: Bonal, Pineau des Charentes, Byrrh, Suze, Corsican eau-de-vie). Sit at the bar and put yourself in very capable hands.

51 rue du Faubourg Saint-Denis, 75010
lesyndicat@syndicatcocktailclub.com
€–€€

LE VERRE VOLÉ

See "Itinerary: Eating + Drinking in Style" (page 207).

67 rue de Lancry, 75010
+33 1 48 03 17 34
€€

LES ARLOTS

Thomas Brachet's *bistrot à vins* is always crowded and always delicious. The dishes are mostly comfort with a contemporary twist, and it's all reasonably priced.

136 rue du Faubourg Poissonnière, 75010
+33 1 42 82 92 01
Reservations encouraged.
€€

LIBERTÉ PÂTISSERIE BOULANGERIE

With a marble counter, concrete walls, and open kitchen, the aesthetic at Benoît Castel's Liberté is industrial, airy, and gorgeous. His pastries are just as pretty. Grab a lemon tart and don't miss the *pain du coin*, which is leavened with fermented quince.

39 rue des Vinaigriers, 75010
+33 1 42 05 51 76
€

PHILOU

Chef Philippe Damas's friendly, modern bistro just off the **Canal Saint-Martin** showcases the best local ingredients in season, including wild game. Save room for dessert.

12 avenue Richerand, 75010
+33 1 42 38 00 13
Reservations encouraged.
€€

TEN BELLES

A bright, beloved coffee shop and bakery just off the **Canal Saint-Martin.** In nice weather, snag a stool on the sidewalk outside or take your food and drink to go and cozy up to the canal; on more dismal days, settle into a colorful seat and linger over your Belleville Brûlerie roast in their cheerful two-story space. In the 11th, stop by Ten Belles Bread.

10 rue de la Grange-aux-Belles, 75010
+33 1 42 40 90 78
€

STAY

HÔTEL GRAND AMOUR

With a restaurant on-site and a stylish patio that's heated even in winter, this is a hotel you'll want to hang out in.

18 rue de la Fidélité, 75010
+33 1 44 16 03 30
€€

HÔTEL PROVIDENCE

See "Beaux Rêves" (page 154).

90 rue René Boulanger, 75010
+33 1 46 34 34 04
€€

RUE DES RÉCOLLETS III, ONE FINE STAY

Built by an eminent architect and now the home of an artist, a curator, and their daughter, this light, bright apartment near the Canal Saint-Martin is every bit as artistic as you'd hope.

onefinestay.com/home-listing/REC741
€€

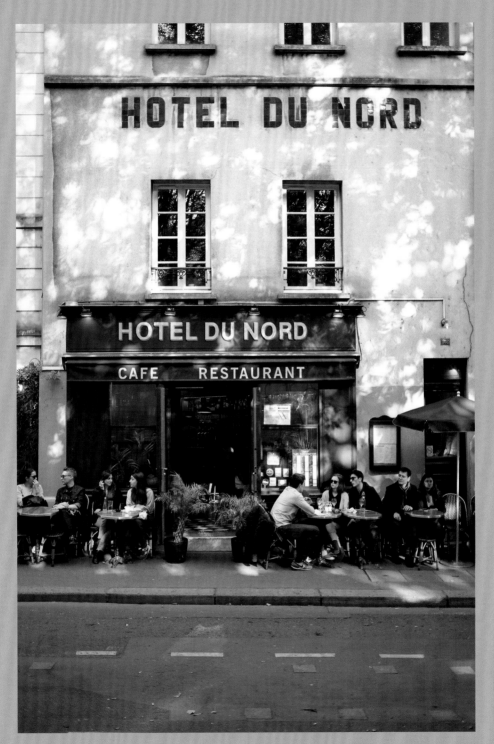

Hôtel du Nord

11th
Arrondissement

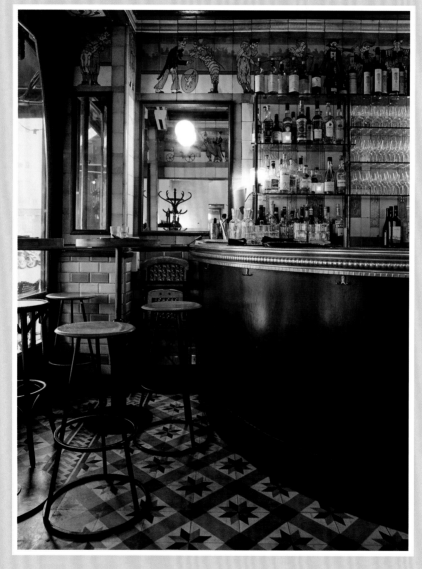

Clown Bar

SEE

ARTS FACTORY

Exploring the place where graphic arts, comics, and illustration connect, this gallery is handily situated amid the hip fashion boutiques of the Rue de Charonne in the 11th arrondissement. Recommended by Papier Tigre cofounder Maxime Brenon (see page 70).

27 rue de Charonne, 75011
+33 6 22 85 35 86

COUR DAMOYE

This hidden cobblestone lane is pretty in the summertime, with leaf-covered vines growing up the sides of the shops and cafés that line the way.

14 cour Damoye, 75011

ÉGLISE SAINT-AMBROISE

This nineteenth-century church, although grand and beautiful, is a quiet neighborhood spot perfect for experiencing a Parisian mass away from the crowds of Notre-Dame and the like.

71bis boulevard Voltaire, 75011
+33 1 43 55 56 18

MAJESTIC BASTILLE

With a charmingly vintage neon facade, this art house theater may not be the most deluxe place to watch a film in Paris, but it's a welcome find in a neighborhood lacking in cinema options. Films are shown in their original language (*version originale*, or V.O.).

2-4 boulevard Richard Lenoir, 75011
+33 1 47 00 02 48

MUSÉE DE POCHE

A gallery aimed at teaching children about art, Musée de Poche also hosts workshops for kids that tie art history in with the art-making process and a gift shop selling artist books, art kits, etc.

41 rue de la Fontaine au Roi, 75011
+33 1 48 06 73 24

MUSÉE EDITH PIAF

Created by a die-hard fan of the iconic French cabaret singer in two small rooms of his apartment for other die-hard fans, this quaint museum is stuffed with photos, dresses, letters, photo albums, and other memorabilia.

5 rue Crespin du Gast, 75011
+33 1 43 55 52 72

SHOP

ADOM

See "Itinerary: Right Bank Women's Fashion" (page 144).

56 rue de la Roquette, 75011

AIGLE

See "Itinerary: Right Bank Women's Fashion" (page 143).

67 rue du Faubourg Saint-Antoine, 75011
+33 1 43 38 73 01

AMÉLIE PICHARD

The glowing white-and-wood interior of Amélie Pichard's boutique provides the perfect backdrop for her attention-grabbing shoes, bags, and other accessories.

34 rue de Lappe, 75011
+33 1 71 20 94 08

ANNA KA BAZAAR

Thick wool for knitting, colorful fabrics, pattern books, and more are for sale at Anna Ka Bazaar in a hip and bustling section of the 11th.

16 rue Keller, 75011
+33 1 84 06 19 24

ANTOINETTE POISSON

Hand-printed papers and fabrics from Antoinette Poisson hearken back to the cozy charm of eighteenth-century interiors. Their atelier/boutique is tucked away in a quiet courtyard and feels worlds away from the nearby urban bustle.

12 rue Saint-Sabin, 75011
+33 1 77 17 13 11

259

BOESNER

Not far from the shopping hubs in the Upper Marais and Roquette neighborhoods, you'll find this unassuming art supply shop, ready and waiting should inspiration strike. Recommended by painter Bruno Albizatti (see page 53).

46 rue du Chemin Vert, 75011
+33 1 43 57 81 52

DEFRISE

It was a happy accident when I found this magical place. When I caught a glimpse of stacks of antique umbrellas and suitcases through the window, I didn't know what to make of it, but I knew I had to explore. Inside, surrounded by antique paraphernalia stuffed into every nook and cranny, a polite elderly lady explained that this was a prop house specializing in vintage and antique props of all kinds—from clothing to furniture to everything in between—and that their inventory filled multiple floors in more than one building plus a big outdoor courtyard. It's open to the trade only, but if you happen to be a stylist, photographer, set decorator, art director, etc., you'll feel like a kid in a candy shop at one of the only remaining prop houses of its kind in the city.

23 rue Basfroi, 75011
+33 1 43 79 78 29

ISABEL MARANT

See "Itinerary: Right Bank Women's Fashion" (page 143).

16 rue de Charonne, 75011
+33 1 49 29 71 55

KLIN D'OEIL

What's not to love about the sunny yellow exterior and vibrant collection of this lifestyle shop? In addition to offering paper goods, accessories, and home décor objects, they also host DIY workshops and events.

6 rue Deguerry, 75011
+33 1 77 15 22 30

LES FLEURS

The botanical-meets-vintage-apothecary vibe of this shop in the 11th is delightful. You're sure to find a gift for the gardener (or Anthropologie-loving) person in your life.

5 rue Trousseau, 75011

MAISON AIMABLE

Dishes, hanging plants, candles, and more fill the space of this friendly shop.

16-18 rue des Taillandiers, 75011
+33 9 82 53 16 18

MONOPRIX

See "Itinerary: Right Bank Women's Fashion" (page 143).

99 rue du Faubourg Saint-Antoine, 75011
+33 1 43 07 59 40

PETIT BATEAU

See "Itinerary: Right Bank Women's Fashion" (page 143).

67 rue du Faubourg Saint-Antoine, 75011
+33 1 40 19 93 49

SESSÙN

See "Itinerary: Right Bank Women's Fashion" (page 143).

34 rue de Charonne, 75011
+33 1 48 06 55 66

SOEUR

See "Itinerary: Right Bank Women's Fashion" (page 144).

12 boulevard des Filles du Calvaire, 75011
+33 1 40 41 06 10

26 rue de Charonne, 75011
+33 9 52 33 43 18

VALENTINE GAUTHIER

See "Itinerary: Right Bank Women's Fashion" (page 144).

88 boulevard Beaumarchais, 75011
+33 1 75 57 14 33

VARIATION VÉGÉTALE

A cheerful little neighborhood florist. Recommended by terrarium and garden designer Kali Vermes (see page 165).

18 rue du Général Guilhem, 75011
+33 1 43 55 22 45

52 FAUBOURG SAINT-DENIS

This no-frills, easygoing brasserie by Charles Compagnon boasts an affordable, rotating, seasonally driven menu and a killer wine list.

52 rue du Faubourg Saint-Denis, 75011
+33 1 48 00 95 88
€€

AU PASSAGE

Duck down a dark, empty passageway to get to this lively one-room wine bar. Once inside, order a mix of small plates from the chalkboard menu to pair with a slew of natural wines. If you can, opt for a seat at the bar to truly take in the animated bustle of dinner service.

1bis passage Saint-Sébastien, 75011
+33 1 43 55 07 52
€€

AUX DEUX AMIS

With a yellow Formica bar and very 1950s vibe, Aux Deux Amis is always packed and always lively. The natural wine list is fun, quirky, and on trend, while the concise food menu is refined but not predictable. Order a bit of cheese or the tortilla with your drinks. Go early, stay late, get rowdy.

45 rue Oberkampf, 75011
+33 1 58 30 38 13
€–€€

BISTROT PAUL BERT + LA CAVE DU PAUL BERT

Cult classic Bistrot Paul Bert opened in 2000 and remains a brilliant destination for contemporary bistro food. They have one of best *steaks au poivre (avec frites)* in town, but don't leave without ordering the Paris-Brest for dessert. If you can't get into the bistro's prix-fixe lunch or dinner service, walk down the street to La Cave du Paul Bert. With a wooden bar that seats ten, plus a few tables that spill out into the street, excellent country terrine, and a comprehensive natural wine selection, you'll be in good hands.

Le Bistrot Paul Bert: 18 rue Paul Bert, 75011
+33 1 43 72 24 01
€€

La Cave du Paul Bert: 16 rue Paul Bert, 75011
+33 1 58 53 50 92
€–€€

BOULANGERIE UTOPIE

Known for its natural sourdough breads and jet-black sesame éclairs, get one of each and wander by the nearby Canal Saint-Martin.

20 rue Jean-Pierre Timbaud 75011
+33 9 82 50 74 48
€

CAFÉ OBERKAMPF + CAFÉ MERICOURT

Owner Guy Griffin owns and operates two stylish cafés (within walking distance of each other), and they're both tops. Think of them as places to pop in for a quick perfect *café crème* or to call a friend and linger over lunch or brunch (get the shakshuka) or something sweet (don't miss the banana bread). While you're at it, take your first *apéro* of the evening at Café Mericourt—Guy makes a mean Saler's Spritz.

Café Oberkampf: 3 rue Neuve Popincourt, 75011
+33 1 43 55 60 10

Café Mericourt: 22 rue de la Folie Méricourt, 75011
+33 1 58 30 98 02
€

CHEZ ALINE

Delphine Zampetti's former horse butchery turned sandwich shop/delicatessen has one of the best lunchtime menus in Paris and stays open until they run out. Which they will, so get there early.

85 rue de la Roquette, 75011
+33 1 43 71 90 75
€

CLOWN BAR

Just next door to the Cirque d'Hiver ("Winter Circus"), Clown Bar is aptly named. The interior is beautiful, ornate, and tastefully decorated with clown memorabilia. The contemporary French small plates are delicious; the wine list exceptionally curated.

114 rue Amelot, 75011
+33 1 43 55 87 35
Reservations needed.
€€

COFFEE IN THE 11TH

Café Oberkampf
3 rue Neuve Popincourt, 75011
+33 1 43 55 60 10
€

Steel Cyclewear
58 rue de la Fontaine au Roi, 75011
+33 6 47 58 32 46
€

The Hood
80 rue Jean-Pierre Timbaud, 75011
+33 1 43 57 20 50
€

NaNa
10 rue Breguet, 75011
+33 1 43 38 27 19
€

Thank You, My Deer
112 rue Saint-Maur, 75011
+33 1 71 93 16 24
€

FULGURANCES

Check the website to see who's currently in the kitchen at Fulgurances; chances are, they're phenomenal cooks. The open-kitchen, young-chef incubator was opened by French food writer trio Rebecca Asthalter, Sophie Coribert, and Hugo Hivernat in 2015 with the explicit purpose to give chefs on the cusp of opening their own space a place to refine their skills, test out ideas, and get a handle on running a kitchen. So far, every chef who has come through the kitchen has delivered above and beyond.

10 rue Alexandre Dumas, 75011
+33 1 43 48 14 59
€€–€€€

LA BUVETTE

This gem of a *cave à manger* from Camille Fourmont offers an excellent selection of natural wines and small plates, and a laid-back space to relax and enjoy them. Go for a pre-dinner glass and bite, or stay and make a meal of the inventive small plates menu, charmingly handwritten on a displayed mirror. Whatever you do, don't miss the beans with citron or hesitate to buy a bottle or three of wine on your way out.

67 rue Saint-Maur, 75011
+33 9 83 56 94 11
€

LE CHATEAUBRIAND + LE DAUPHIN

More than a decade after Basque chef Iñaki Aizpitarte opened Le Chateaubriand in 2006, the trailblazing neobistro is still as playful, carefully sourced, and relevant as ever. Whether or not you get a seat at Aizparte's flagship, stop by Le Dauphin next door. The Carrara marble and mirrored Rem Koolhaas–designed tapas bar opened in 2010 and is a destination in its own right.

Le Chateaubriand: 129 Avenue Parmentier, 75011
+33 1 43 57 45 95
€€–€€€

Le Dauphin: 131 Avenue Parmentier, 75011
+33 1 55 28 78 88
€€–€€€

LE SERVAN

Tatiana and Katia Levha's light, beautiful neobistro offers a menu that is constantly changing with the seasons.

Tatiana (formerly of L'Arpège and L'Astrance) serves an à la carte menu that reflects her French-Russian-Filipino background.

32 rue Saint-Maur, 75011
+33 1 55 28 51 82
€€

LE ZINGAM

This tiny, perfect *épicerie* near the Voltaire Métro stop stocks a curated selection of local produce, beer, dairy, and flowers at greenmarket prices. A second location recently opened farther up in the 11th, and it's just as perfect.

75 rue du Chemin Vert, 75011
+33 7 87 55 65 56
€

51 rue de la Fontaine au Roi, 75011
+33 7 87 55 65 56
€

MARCHÉ BASTILLE

One of the biggest and best food markets in Paris (Thursdays and Sundays), our food and drink editor recommends coming to the Marché Bastille early, starting with a platter of freshly shucked oysters and a glass of white wine at one of the stalls scattered through the market, and doing your weekly shop with a sweet little buzz. On Sundays, grab a roast chicken and potatoes cooked in its drippings for the easiest Sunday supper there was.

Boulevard Richard Lenoir, 75011
€

MARTIN

The best nights start and end at **Martin**. Also, late afternoons—Martin opens at 4:00 p.m. and closes at 2:00 a.m. Whatever the time, grab a seat at one of the dark wooden tables inside or *en terrasse* and order from the affordable, constantly changing menu. The wine list is packed with natural gems and the small plates are just as inventive.

24 boulevard du Temple, 75011
+33 1 43 57 82 37
€–€€

MOKONUTS

Lately, whenever anyone asks our food and drink editor, Rebekah Peppler, where to eat in Paris, there's one answer the rises to the top (OK, two—see the next entry) and they're right down the street from each other. Ideally, go to Moko Hirayama and Omar Koreitem's Mokonuts for a late lunch, order all the dishes on the menu (it's short), linger over coffee and one of Moko's insane cookies, cakes, or whatever else she puts out on the counter that skews sweet, then, around 4 p.m., wander over for an early glass of wine at Septime la Cave.

5 rue Saint-Bernard, 75011
+33 9 80 81 82 85
Lunch only. Reservations suggested.
€–€€

SEPTIME LA CAVE + SEPTIME + CLAMATO

Septime la Cave isn't just the greatest/tiniest wine bar in Paris—it's the greatest/tiniest space anywhere. Stop for an *apéro* or nightcap, or spend the whole afternoon/evening—they open at 4 p.m. daily. If you want a coursed meal and have the foresight, reserve a table exactly three weeks in advance at Bertrand Grébaut's Michelin-starred Septime across the way on Rue de Charonne. Make the full rounds by popping by Clamato's bar for bubbles, oysters, and razor clams.
Septime la Cave: 3 rue Basfroi, 75011
+33 1 43 67 14 87
€–€€

Septime: 80 rue de Charonne, 75011
+33 1 43 67 38 29
€€–€€€

Clamato: 80 rue de Charonne, 75011
+33 1 43 72 74 53
€€

TANNAT

A well-designed, beautiful space featuring creative, seasonal dishes (and an excellent wine list). Come for lunch ($20 menu option: starter plus main of the day, or main plus dessert) or plan to celebrate something special at dinner.

119 avenue Parmentier, 75011
+33 9 53 86 38 61
€€

YEMMA

The counter at Yemma is piled high with *batbout* (a pita-esque bread made with semolina flour), *msemens* (flaky flatbread/crepes), and bowls of brightly colored, flavor-packed salads. Order one of TV chef Abdel Alaoui's couscous dishes or get a sandwich to stay or go (the merguez is especially tasty).

119 rue du Chemin Vert, 75011
+33 1 48 05 67 07
€

HOTEL PARIS BASTILLE BOUTET

Tasteful modern décor in a palette of white, wood, and caramel leather ensures that this property owned by the French hotel chain Sofitel has a warmer, more personable feel than your typical chain hotel. Although the 11th arrondissement is full of fantastic shops and restaurants, it's still hard to come by well-designed lodging, so this place is a welcome find.

22, 24 rue Faidherbe, 75011
+33 1 40 24 65 65
€€

RUE DU COMMANDANT RESIDENCE, KID & COE

Five-star reviews, a children's room full of adorable toys, and a convenient location in the trendy Bastille neighborhood are reason enough to book a stay in this two-bedroom, one-bathroom apartment.

www.kidandcoe.com/destinations/bastille/the-rue-du-commandant-residence
€€

RUE JEAN-PIERRE TIMBAUD, ONE FINE STAY

A tasteful combination of antiques, modern design, and rustic wooden beams characterize this spacious three-bedroom apartment convenient to the hippest areas of the city.

onefinestay.com/home-listing/TIM029
€€€

12th + 13th
Arrondissement

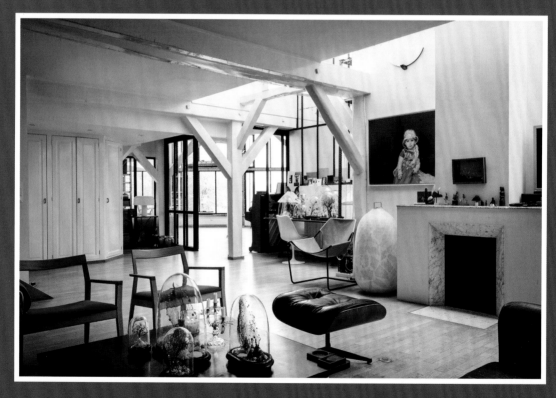

Jules César Loft, onefinestay
Photo: onefinestay

SEE

CINÉMATHÈQUE FRANÇAISE

Housed in a building designed by Frank Gehry, this institution holds the largest archives of film-related documents and objects in the world. Cinephiles could spend an entire day here—peruse posters in the library, have lunch at the on-site café, take a look at the bookstore, then catch a screening.

51 rue de Bercy, 75012
+33 1 71 19 33 33

CITÉ FLORALE

A delightful place to discover, Cité Florale is a pastel-colored neighborhood with streets named after flowers (Rue des Orchidées, Rue des Iris, etc.), vine-covered facades, and blossom-filled window boxes.

Cité Florale, 75013

FONDATION JÉRÔME SEYDOUX-PATHÉ

The Fondation Jérôme Seydoux-Pathé is a museum and archive dedicated to the historic French film company Pathé, whose catalog consists of more than ten thousand films, including critically acclaimed titles like *Slumdog Millionnaire, Lost in Translation*, and *Memento*. The on-site collections include iconographic posters, filmmaking cameras, books, periodicals, and more. There's also a screening room showing rotating themed film collections, educational programs for kids, and, for the extra enthusiastic, the opportunity to do research among the archives.

73 avenue des Gobelins, 75013
+33 1 83 79 18 96

GALERIE LAURENT GODIN

From small works on paper to enormous metallic sculptures to video installations—a spectrum of emerging artists show at this gallery in the 12th. Recommended by painter Bruno Albizatti (see page 53).

36bis rue Eugéne Oudiné, 75013
+33 1 42 71 10 66

LA BUTTE AUX CAILLES

Well known only to locals, this village-like neighborhood is a pleasant place to spend a quiet afternoon, with its street art, cobblestone streets, half-timber houses, and plethora of restaurants and bars.

La Butte aux Cailles, 75013

LA MAISON ROUGE

This intimate contemporary art museum hosts exhibits organized by independent curators. Themes range from broad overviews like *Counterculture 1969–1989: The French Spirit* to solo shows from artists such as Hélène Delprat and Shiharu Shiota.

10 boulevard de la Bastille, 75012
+33 1 40 01 08 81

LA PROMENADE PLANTÉE

The Promenade Plantée is a tree-lined walkway that covers almost three miles—from the Bastille in the west to Paris's city limits on the east. Built in 1994 on the remains of a nineteenth-century railway line, it was the world's first elevated park—predating New York's High Line by fifteen years.

1 Coulée verte René-Dumont, 75012

LE TRAIN BLEU

As immortalized in the writing of celebrated food writer M. F. K. Fisher, Le Train Bleu is an incredible example of Belle Époque architecture that happens to be in a train station (the Gare de Lyon). It was saved from destruction in the early 1970s, thanks to Fisher putting in a good word with the right people. Savor the atmosphere over a meal if you can, but the friendly staff don't seem to mind discreet looky-loos, either.

Gare de Lyon, place Louis-Armand, 75012
+33 1 43 43 09 06

LES DOCKS

The city of Paris took a series of industrial warehouses along the Seine and turned them into a recreation and event space for the public. During the day, visit an art exposition or eat at one of the restaurants. By night, the NUBA rooftop club—with its dreamy view—is the place to be.

34 quai d'Austerlitz, 75013
+33 1 76 77 25 30

SHOP

CARAVANE

If you're looking to emulate the European boho interior style so popular in Paris, layer on the pillows, sofa covers, tablecloths, and more from this French décor brand.

19 rue Saint Nicolas, 75012
+33 1 53 02 96 96

MARCHÉ D'ALIGRE

Catch this small but worth it flea market for affordable finds. Recommended by designer Marin Montagut (page 81).

Place d'Aligre, 75012

PARASOLERIE HEURTAULT

The legendary shop from Jacques Demy's classic French film *The Umbrellas of Cherbourg* may not exist in real life, but Parasolerie Heurtault is the next best thing. Pink walls surround exquisite umbrellas and parasols, which are all made by hand on-site. They also take bespoke orders.

Viaduc des Arts: 85 avenue Daumesnil, 75012
+33 1 44 73 45 71

PETIT PAN

An assortment of rainbow-hued fabrics, buttons, home décor, and gift items await at this cheerful shop. Recommended by interior designer Meta Coleman (see page 157).

7 rue de Prague, 75012
+33 9 54 18 50 39

EAT + DRINK

BATEAU EL ALAMEIN

A bar on a boat (music, too!). Recommended by Papier Tigre cofounder Maxime Brenon (see page 70).

Quai François Mauriac, 75013
+33 6 88 99 20 58
€

BLÉ SUCRÉ

Fabrice Le Bourdat makes one of the best croissants in Paris. Take it, along with a few madeleines and a kouign-amann to go and savor your treats in the leafy privacy of Square Trousseau across the street.

7 rue Antoine Vollon, 75012
+33 1 43 40 77 73
€

DERSOU

One of our all-around favorites, Dersou pairs chef Taku Sekine's (formerly of Clown Bar) dishes with Amaury Guyot's (formerly of Sherry

Butt) innovative cocktails in an airy, open space. Go on a weekend for brunch or make a reservation for the tasting menu, cocktails included. Whenever you're there, try to snag a seat at the bar to watch the action.

21 rue Saint-Nicolas, 75012
+33 9 81 01 12 73
Dinner reservations needed.
€€

LE BARON ROUGE

After a morning at the Marché d'Aligre, stop here for glasses of wine directly from the barrel and plates of cheese and charcuterie. Crowds—and platters of oysters—spill out into the street, which only adds to the ambience.

1 rue Théophile Roussel, 75012
+33 1 43 43 14 32
€

LE SIFFLEUR DE BALLONS

Light, bright, and low-key, this neighborhood wine bar has a dynamic range of well-priced natural wines and a mix of small and large plates for dining in.

34 rue de Citeaux, 75012
+33 1 58 51 14 04
€–€€

MARCHÉ D'ALIGRE

Open every day except Monday, Marché d'Aligre is one of the best open-air markets in the city. Not only is the market lively, it's affordable to boot. Go on a weekday to avoid denser crowds and inflated prices.

Place d'Aligre, 75012
€

COQ HOTEL PARIS

Picture moody dark walls, antique por-
traits, and brass fixtures. This jewel of
a hotel also offers a cheerful sunroom,
cozy bar, and convenient location just a
two-minute walk from the Place d'Italie
and its three Métro lines.

15 rue Edouard Manet, 75013
+33 1 45 86 35 99
€

HÔTEL HENRIETTE

Situated on a quiet street not far from
the Latin Quarter is this little hotel with
a big personality. The modern décor
comes in shades of teal, mustard, and
rose, and many of the rooms are lined
with on-trend wallpaper.

9 rue des Gobelins, 75013
+33 1 47 07 26 90
€

RUE JULES CESAR LOFT, ONE FINE STAY

Huge factory windows, original to the
former warehouse building, bathe this
entire apartment in light. Artistic décor
and a convenient location add to the
desirability of this two-bedroom loft.

onefinestay.com/homes/paris/rue-
jules-cesar-loft
€€€

A beautiful door in Paris

17th + 18th
Arrondissements

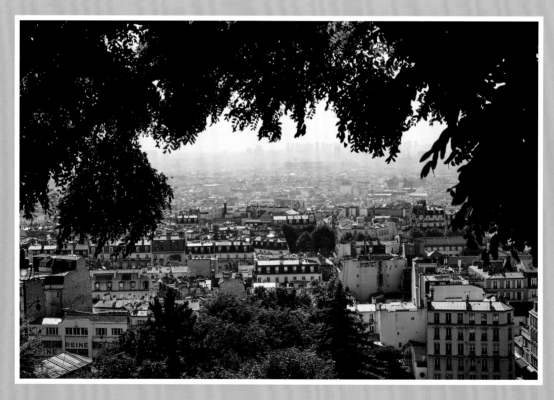

The view From Sacré-Coeur

SEE

BASILIQUE DU SACRÉ-COEUR

Touristy but never dull, sit on the steps in front of this iconic church in Montmartre for one of the best views in town. Climb to the top of the basilica for a closer look at the Roman-Byzantine architecture and to see not only Paris, but some 30 miles (50 km) into the countryside as well.

35 rue du Chevalier de La Barre, 75018
+33 1 53 41 89 00

HALLE SAINT-PIERRE

This center for outsider art functions as a museum, gallery, bookshop, café, and venue just down the hill from Sacré-Coeur.

2 rue Ronsard, 75018
+33 1 42 58 72 89

MUSÉE DE MONTMARTRE

Auguste Renoir completed several of his masterpieces, including *Bal du moulin de la Galette,* while living on this site in the late 1800s. The newly renovated gardens named in his honor, as well as the restored live/work space of Suzanne Valadon, Maurice Utrillo, and André Utter are highlights of a visit to this museum dedicated to the art and history of Montmartre. Recommended by photographer Cécile Molinié (see page 49).

12-14 rue Cortot, 75018
+33 1 49 25 89 39

MUSÉE NATIONAL JEAN-JACQUES HENNER

This house museum is dedicated to the work of painter Jean-Jacques Henner, a very famous artist in his day and contemporary of Sarah Bernhardt, Marcel Proust, Claude Debussy, and others.

43 avenue de Villiers, 75017
+33 1 47 63 42 73

PARIS PINBALL MUSEUM

Finding this funny little museum housed in a small space on the ground floor of an apartment building will make arcade lovers feel like they've struck gold. The entrance fee is 20 euro for unlimited play.

141 rue du Mont-Cenis, 75018
+33 1 42 59 95 38

SHOP

ADAM MONTMARTRE

A no-nonsense art shop on the north side of Montmartre, it carries a good selection of supplies for drawing and painting. Recommended by painter Bruno Albizzati (see page 50).

96 rue Damrémont, 75018
+33 1 46 06 60 38

GUERRISOL

If rummaging through the racks at thrift stores is your thing, you won't want to miss Guerrisol. Recommended

by fashion stylist Alison Reid (see page 137).

96 boulevard Barbès, 75018
+33 1 53 28 10 70

19 avenue de Clichy, 75017
+33 1 40 08 03 00

HOLLAND TEXTILES

See "Itinerary: Right Bank Women's Fashion" (page 145).

68 rue Doudeauville, 75018
+33 1 44 85 28 14

LA RÉGULIÈRE

A cute coffee/bookshop with free Wi-Fi and homemade cake, it makes for a welcome pit stop.

43 rue Myrha, 75018
+33 9 83 43 40 69

LE MARCHÉ SAINT PIERRE

Textile lovers will want to make a beeline for this chaotic seven-story emporium. They carry a vast selection: cotton toile, Chantilly lace, oilcloth, crepe satin, woven Basque toweling, and on and on. Designs by Christian Lacroix and Pierre Frey can be found on the top level.

2 rue Charles Nodier, 75018
+33 1 46 06 92 25

MAISON CHÂTEAU ROUGE

See "Roots" (pages 104–107).

40 rue Myrha, 75018

269

OH MY CREAM

We'll tell you a little secret. Walk into almost any pharmacy in Paris (their neon green cross signs are everywhere), and you'll find knowledgeable staff who can advise you not only on painkillers and bandages, but on face creams and serums as well. However, if you'd like a more high-end experience while purchasing your beauty products, we recommend Oh My Cream. This luminous store carries all the goods you need to achieve the naturally radiant look French women are known for.

4 rue des Abbesses, 75018
+33 9 86 24 36 51

SAPE & CO

See "Itinerary: Right Bank Women's Fashion" (page 145).

12 rue de Panama, 75018
+33 1 42 64 40 15

EAT + DRINK

ALLÉOSSE

A short walk from the Arc de Triomphe, Philippe Alléosse's shop is a destination for those seeking flawlessly aged, hard-to-find cheeses. Ask for the Bleu de Termignon.

13 rue Poncelet, 75017
+33 1 46 22 50 45
€

BAR À BULLES

Apéro on a quiet, leafy rooftop terrace sounds like a pipe dream in Paris. Lucky for us, Bar à Bulles makes it a reality. Recommended by Papier Tigre cofounder Maxime Brenon (see page 70).

4bis cité Véron, 75018
+33 9 73 23 79 72
€

BOUILLON PIGALLE

Parisian *bouillons*, which started in the eighteenth century as spots that served . . . bouillon (deeply fatty/restorative broths), transformed by the nineteenth century into places to grab a cheap, filling meal, before slowly going out of fashion over the twentieth century. Pierre and Guillaume Moussié (Chez Jeannette, Le Providence, and Le Mansart) opened their version in 2017 and kept the space large and the prices in the same vein as its nineteenth-century predecessors while adding a covered (and heated) terrace. Recommended by the owner of IMA restaurant, Mikael Attar (see page 202).

22 boulevard de Clichy, 75018
+33 1 42 59 69 31
€

CAFÉ LOMI

This large independent roaster does double duty as a café. Coffee offerings change based on what's being freshly roasted on-site, and there are plenty of tasty things to nibble.

3 ter rue Marcadet, 75018
+33 9 80 39 56 24
€

CUILLIER

A historic Parisian roaster, founded in 1844 and recently revived, focuses on strong, quality coffee in a smattering of locations across the city.

19 rue Yvonne le Tac, 75018
+33 1 42 74 95 37
€

GONTRAN CHERRIER

Coming from three generations of bakers, Gontran Cherrier has some of the most experimental breads in Paris. Selections include buns made bright red with paprika and stuffed with beef and coriander, a jet-black squid ink baguette with black sesame seeds, and a rye and red miso loaf.

8 rue Juliette Lamber, 75017
+33 1 40 54 72 60
€

22 rue Caulaincourt, 75018
+33 1 46 06 82 6
€

HARDWARE SOCIÉTÉ

A Parisian outpost of its Franco-Australian founders, Di and Will Keser's Melbourne location, Hardware Société is the perfect place to brunch—or sip chai—post–stair climbing at the nearby **Sacré-Coeur**.

10 rue Lamarck, 75018
+33 1 42 51 69 03
€

MARCHÉ BIO DES BATIGNOLLES

The first organic market in Paris, this open-air, Saturdays-only gem continues to deliver on high-quality, beautiful products. Bring extra bags.

34 boulevard des Batignolles, 75017
€

MARCHÉ ORNANO

Hit up Marché Ornano Tuesday, Friday, and Saturday mornings for a mix of produce from local farmers, cheeses, herbs, and more. Recommended by cookbook author Emily Dilling (see page 185).

18e boulevard Ornano, 75018
€

STAY

HÔTEL PARTICULIER MONT-MARTRE

Tucked down a cobblestone alley stands the Hôtel Particulier Montmartre and its verdant garden. The bar—furnished with red velvet chairs, palms, and a checkerboard floor—is frequented by locals as well as travelers who have an eye for design. Each of the five suites is handsomely appointed with a different look.

Pavillon D, 23 avenue Junot, 75018
+33 1 53 41 81 40
€€€

L'ERMITAGE SACRÉ-COEUR

Decorated with floral wallpaper and ornate wooden headboards, this traditional B&B has a private garden and is only steps away from the **Sacré-Coeur.**

24 rue Lamarck, 75018
+33 6 12 49 05 15
€

THE CLIGNANCOURT RESIDENCE, KID & COE

Modern Scandinavian and Italian design meets classic French architecture in this four-bedroom, two-bathroom apartment. Outfitted with toys, books, crib, and highchair, and across the street from a park, this spacious property is a dream when traveling with kids.

kidandcoe.com/destinations/montmartre/the-clignancourt-residence
€€

THE EPHREM HOTEL

For those interested in a spiritual retreat, this guesthouse of **Sacré-Coeur** welcomes pilgrims—upholding a tradition that goes back centuries.

35 rue du Chevalier de La Barre, 75018
+33 1 53 41 89 09
€

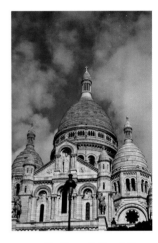

Basilique du Sacré-Coeur

Rooftops in the 18th

19th + 20th Arrondissements

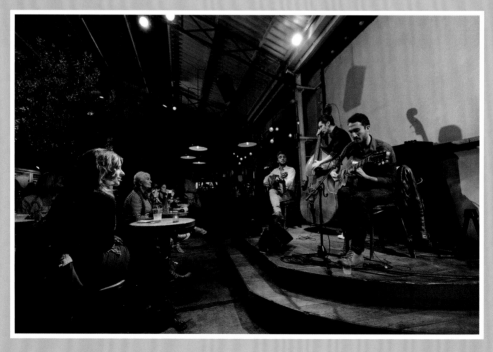

La Bellevilloise
Photo: La Bellevilloise

SEE

GALERIE JOCELYN WOLFF

As one of the early contemporary galleries to open in the now-bustling art scene of Belleville, Galerie Jocelyn Wolff continues to show foresight through their collaborations with artists—not only in the exhibitions on display, but in the gallery's architecture and design.

78 rue Julien Lacroix, 75020
+33 1 42 03 05 65

LA BELLEVILLOISE

Once home to the city's first workers' cooperative, you can now experience art exhibitions, concerts, festivals, and the bright café under a glass roof at La Bellevilloise. Drop in for Sunday brunch with live jazz.

19-21 rue Boyer, 75020
+33 1 46 36 07 07

LA MAËLLE GALERIE

Launched in 2012, this well-curated contemporary art gallery focuses on emerging artists from the West Indies.

3 rue Ramponeau, 75020
+33 6 14 80 42 00

LE CENTQUATRE

This hard-to-define space hosts art exhibitions, theater, music, and dance performances, a business accelerator for entrepreneurs, shops, and a thoughtfully designed play area for children.

104 rue d'Aubervilliers, 75019
+33 1 53 35 50 00

LE PLATEAU

This spacious, minimalist space is home to a rotation of contemporary art exhibitions and has an ambitious agenda to promote emerging artists and share their work with the public.

22 rue des Alouettes, 75019
+33 1 76 21 13 41

PARC DES BUTTES-CHAUMONT

Well-loved by locals, this city park contains a dramatic landscape of hills, grottos, bridges, and waterfalls. There's also a marionette theater and a few places to eat and drink, including the popular outdoor bar **Rosa Bonheur** (see page 274). On a warm day, join sun-seekers on the sloping lawns or climb to the top of the rocky island for sweeping views over the city.

1 rue Botzaris, 75019
+33 1 48 03 83 10

SULTANA

Although he also participates in the more commercially driven art fairs around the world (Frieze, Armory Show, etc.), Guillaume Sultana sees the role of the gallery space as a laboratory for artists to work on their projects, which translates into fascinating exhibitions for the visitor.

10 rue Ramponeau, 75020
+33 1 44 54 08 90

TRABENDO

Swiss architect Bernard Tschumi and Finnish interior designers Ahonen & Lamberg created a beautiful backdrop for the French and international musicians playing this 700-seat music venue.

211 avenue Jean Jaurès, 75019
+33 1 42 06 05 52

PARC DE BELLEVILLE

Climb to the top of this hilly park to see an incredible 180-degree view of the city. You'll also find a little lake and waterfall, plenty of grassy areas for picnics, an open-air theater, and a wooden playground for the kids.

Parc de Belleville, 75020

PÈRE LACHAISE CEMETERY

What do Jim Morrison, Chopin, Oscar Wilde, Gertrude Stein, and Edith Piaf all have in common? They were all laid to rest in Père Lachaise. Pay tribute to them and many more esteemed artists with a visit down the meandering lanes of this famous Parisian cemetery.

16 rue du Repos, 75020
+33 1 55 25 82 10

ATELIER BEAU TRAVAIL

Come to this artist- and designer-run space for unique handmade gifts for your friends back home.

67 rue de la Mare, 75020
contact@beautravail.fr
By appointment only.

L'EMBELLIE DESIGN

This little gift shop in the 19th arrondissement is filled with colorful fashion accessories, gifts, and items for the home. Recommended by sock designer Béatrice de Crécy (see page 139).

14 rue de la Villette, 75019
+33 1 42 01 42 89

VINTAGE 77

The colorful collection of vintage and new (vintage reproduction) clothing is skillfully curated and displayed at this popular little shop.

77 rue de Ménilmontant, 75020
+33 1 47 97 77 17

YOYAKU RECORD SHOP

A record label, distributor, and booking agency known primarily for electronic, house, and other underground dance music, Yoyaku also opened a record shop a few years ago on a quiet street in Belleville. They host occasional music nights and offer exclusive pressings that are available in-store only.

74 rue des Cascades, 75020
+33 1 83 06 75 78

BAROURCQ

Come summertime, the turquoise-painted BarOurcq throws open its doors to a busy terrace on the banks of the canal, full of picnickers and *pétanque* players. In the winter, locals tuck into cozy corners on well-worn sofas to play board games. Drinks and snacks are well-priced and there's a DJ nightly.

68 quai de la Loire, 75019
+33 1 42 40 12 26
€

COMBAT

See "Itinerary: Eating + Drinking in Style" (page 207).

63 rue de Belleville, 75019
+33 9 80 84 78 60
€

LA COMMUNE

Praise be, the team behind our favorite cocktail bar (Le Syndicat) opened another cocktail bar! This time, the focus is on shared punch bowls, and it's as dangerous as it sounds. The silver bowls (created specifically for the bar) are as beautiful as the space—which is to say, very.

80 boulevard de Belleville, 75020
+33 1 42 55 57 61
€

LE BARATIN

Raquel Carena's wine bar may be the perfect wine bar. It's pretty (zinc bar, check; mosaic tiles, check; chalkboard menu, check), the food is outrageously good, and the wine is (shocking) also quite nice and mostly organic. Also—and this isn't just us—Argentine-born Raquel is a treat in and of herself.

3 rue Jouye-Rouve, 75020
+33 1 43 49 39 70
€€

ROSA BONHEUR

Situated in the **Parc des Buttes Chaumont,** come to Rosa Bonheur for plenty of outdoor drink, dance, and gorgeous people (especially Sunday nights). The name is an ode to nineteenth-century French painter and sculptor Rosa Bonheur, who was famous for both her depictions of animals and her role in the early feminist movement. Our food and drink editor's rainbow heart is especially fond of this space.

Parc des Buttes Chaumont: 2 allée de la Cascade, 75019
+33 1 42 00 00 45
€

MAMA SHELTER

Rooms designed by Phillipe Starck, a pizzeria by Michelin-star chef Guy Savoy, a rooftop terrace *Vogue* named the best in Paris, and a location right next to the famous **Père Lachaise** cemetery define this hotel.

109 rue de Bagnolet, 75020
+33 1 43 48 48 48
€

RUE DE LA MARE, ONE FINE STAY

A welcoming terrace, double-height ceilings, and lots of light create a restful sanctuary after days spent exploring Paris. Not to mention the lovely furnishings, loads of space (three bed/three bath), and quiet location of this apartment at the end of a private lane.

onefinestay.com/homes/paris/rue-de-la-mare
€€€

A quiet street in Paris

And Beyond . . .

Water lilies at Giverny
Photo: Eva Jorgensen

CHÂTEAU DE LA ROCHE-GUYON

In a tranquil setting nestled between the banks of the Seine and a forest, this chateau is full of surprises. After touring the beautiful eighteenth-century manor with its extravagant decor, we were surprised to find a rock-carved staircase tunneling through the cliff behind the chateau. It led us to the hilltop dungeon where the view was well worth the steep (and slightly frightening!) climb. On our way back down, we took a peek at the loft where carrier pigeons used to roost in small alcoves carved from the rock.

Car required—rent one for a day and you could combine your visit with one to the nearby **Giverny.**

1 rue de l'Audience, 95780
La Roche-Guyon
+33 1 34 79 74 42

CHÂTEAU DE FONTAINEBLEAU

Napoleon knew how to make an entrance. And I can't think of a chateau with a grander entrance than that of his residence at Fontainebleau, with its curving symmetrical staircases and vast manicured garden. Before Napoleon, this chateau was home to many of France's kings and queens, dating back to the twelfth century. Beautiful gardens, lushly furnished interiors, four art museums, and noticeably fewer crowds than Versailles make this day trip a no-brainer.

It's a forty-minute train ride and fifteen-minute bus ride to Fontainebleau. If you're driving, consider stopping for a walk in the surrounding Fontainebleau forest, which is world-famous among rock-climbers.

77300 Fontainebleau
+33 1 60 71 50 70

CHÂTEAU DE VERSAILLES

This chateau, originally created by Louis XIV, needs no introduction, but I will tell you this. As beautiful as the main palace is with its hall of mirrors, the best part of Versailles is at the far end of the property, where Marie Antoinette would escape to the Petit Trianon (a small chateau) and Le Hameau de la Reine, a rustic working farm where she pretended to be a peasant (among royal comforts).

It's a relatively easy fifty-minute train ride and ten-minute walk to visit Versailles.

Place d'Armes, 78000 Versailles
+33 1 30 83 78 00

FONDATION CLAUDE MONET (GIVERNY)

One of my favorite places on the planet, Claude Monet's famous house and gardens are full of color and magic. The lily pond and Japanese bridge—made famous by his late-in-life paintings—are just as beautiful as you'd imagine, as are the rest of the gardens. And the interiors of his home, although less well-known than the gardens, are every bit as stunning. I came away so inspired by the way each room in his house was painted a different color

that I decided to do the same to my own home. Best decision ever.

It's easiest to get here by car, but you can also take the train to Vernon and then take a taxi, shuttle bus in the warmer months, rent a bike from one of the cafés across the street from the train station, or walk the three miles to Giverny.

84 rue Claude Monet, 27620 Giverny
+33 2 32 51 28 21

FONDATION LOUIS VUITTON

On the northern end of the Bois de Boulogne, not far from the **Jardin d'Acclimation,** you'll find this Frank Gehry-designed modern and contemporary art museum—a striking and unexpected shape among the trees. No matter where you are in the world, you can view every single artwork the museum has ever displayed on their website. Recommended by interior designer Laure Chouraqui (page 168).

8 avenue du Mahatma Gandhi, 75116
+33 1 40 69 96 00

JARDIN D'ACCLIMATION

My kids loved the rides and playgrounds at this old-fashioned amusement park in the Bois de Boulogne. I loved the vintage charm found in many of the rides and attractions.

Bois de Boulogne, rue du Bois de Boulogne, 75116
+33 1 40 67 90 85

MAISON ET OBJET

This semiannual trade show is an incredible resource for home décor, gift items, children's designs, and fashion accessories with a higher concentration of good design than at comparable stateside shows (NYNow, AmericasMart Atlanta, etc.). You could spend three entire days exploring the booths and still not see it all.

Paris Nord Villepinte: ZAC Paris Nord 2, 93420 Villepinte

MAISON LA ROCHE

See "House of Style" (page 133).

10 square du Docteur Blanche, 75016
+33 1 42 88 75 72

MONTPARNASSE TOWER

A stunning 360-degree view of Paris awaits on the roof terrace of the tallest building in Paris. Recommended by photographer Cécile Molinié (page 48).

33 Avenue du Maine, 75015
+33 1 45 38 52 56

MUSÉE BOURDELLE

Antoine Bourdelle has a museum, home, and garden dedicated to his sculpture just like his teacher and mentor, August Rodin. The moody atelier—with its wall of windows, worn herringbone floor, and smattering of sculptures both finished and in progress—is Instagram gold. Recommended by photographer Cécile Molinié (see page 49).

18 rue Antoine Bourdelle, 75015
+33 1 49 54 73 73

STUDIO MRG

Take a hip-hop, dance hall, house, Afro, or Kizomba dance class from this popular dance studio right outside the city limits. With options for all levels, no registration necessary, and at only 14 euro a class, it's an affordable adventure to add to your Paris itinerary.

10 rue Jules Vanzuppe, 94200
Ivry-sur-Seine
+33 1 46 70 46 45

VILLA SAVOYE

A visit to the Villa Savoye, which was designed by iconic French architect Le Corbusier, is not for everyone. Sadly, the walls are a bit dingy and the tiles are a bit cracked. Although it's surrounded by a ring of lawn and trees that frame it nicely in pictures, just beyond that are rows of run-down and nondescript apartment blocks. And yet . . . I still have to include it here because my family and I absolutely loved our visit. We had the entire place to ourselves. The kids slid down the wave-shaped bathtub and ran up and down the outdoor ramps while my husband and I couldn't get enough of the amazing modern architecture that still feels fresh today.

Arriving by car is ideal, but you can also take a twenty-minute ride to the Poissy train station and walk or take a cab from there.

82 Rue de Villiers, 78300 Poissy
+33 1 39 65 01 06

FOIRE DE CHATOU

Antique furniture, art, vintage records, *buvards* (see pages 82–87), and more line the aisles of this impressive flea market held on an island in the Seine not far from Paris.

It's a thirty-minute train ride and ten-minute walk to visit the Foire de Chatou.

Île des Impressionistes, Hameau Fournaise, 78400 Chatou

HOLIDAY

Tucked in an out-of-the-way storefront in the 16th arrondissement, *Holiday* magazine's shop stocks its chic sweatshirts, candles, tote bags, and magazines that draw a cult following.

11 rue Parent de Rosan, 75016
+33 9 67 25 56 40

MAMA PETULA

A green oasis, this shop has all that a plant hobbyist needs to get their fix. Recommended by plant designer Kali Vermes (see page 165).

74 avenue Denfert-Rochereau, 75014

MARCHÉ AUX PUCES DE LA PORTE DE VANVES

This flea market is the more affordable, friendlier version of the one in Saint-Ouen. Most objects for sale are small and easily tucked into a suitcase.

Avenue Marc Sangnier, 75014

MARCHÉ AUX PUCES DE SAINT-OUEN

See "Hunting for Treasure with Marin Montagut" (page 80).

To enter by the much more pleasant back entrance, take the Métro to the Garibaldi exit and then navigate to this address: Ma Cocotte: 106 rue des Rosiers, 93400 Saint-Ouen

MARCHÉ AUX VIEUX PAPIERS DE SAINT-MANDÉ

A market for antique books, stamps, postcards, and other paper ephemera held just outside the gate of Paris in quiet Saint-Mandé.

Avenue de Paris, near the Saint-Mandé Métro stop, 94160 Saint-Mandé

EAT

LE CAFÉ PAUL BERT

Ideal spot to lunch and drink *chocolat chaud à l'ancienne* (old-fashioned hot chocolate) while treasure-hunting at the Marché aux Puces de Saint-Ouen.

20 rue Paul Bert, 93400 Saint-Ouen
+33 1 40 11 90 28
€–€€

Jardin D'Acclimation
Photo: Eva Jorgensen

Giverny

Photos: Eva Jorgensen

ACKNOWLEDGMENTS

Working on this book took me back to my college days, when my friends and I would put our whole hearts into working on a creative project together—be it a band, an art exhibition, or the decoration of our apartment. The result would always be so much better than if I had tried to do it on my own, and that is true for *Paris by Design* as well.

Merci mille fois to everyone who helped create this book—it truly was a group effort: To Chaunté Vaughn, an incredible photographer and good friend who didn't hesitate for a second when I told her my idea, even when it included becoming roommates with me, my husband, and our two kids in a two-bedroom apartment while we worked on location in Paris; to my agent, Kate Woodrow, who mentored me even before we decided to do this project together and has been a constant source of encouragement and sage advice throughout the process; to my editor at Abrams, Laura Dozier, whose enthusiasm and expert direction took *Paris by Design* to the next level; to Rebekah Peppler, who brought all her Parisian insider knowledge and gift as a food writer to her role as food and drink editor; to Kari Jorgensen, who combed through the rough draft of the manuscript and whipped it into shape; to designer Linnea Paulsson Neppelberg who turned my vision for the book's aesthetics into a beautiful reality; to Cassandra Piket and Lars Stoten, who graciously shared all their favorite people and places in Paris; to Kasey Fleischer Hickey, who taught me that a book is a brand and shared valuable tips on how to work with a team of writers; to our interns at Sycamore Co., Alix Oike and Chloe Westenhaver, who assisted with research and fact-checking; and to the two-dozen-plus additional writers, illustrators, stylists, models, and other collaborators who believed in this project and added their own unique talents—and hard work—to shape *Paris by Design* into the magical book that it is.

I'd also like to thank everyone who supported me in the making of *Paris by Design* by giving feedback, cheering me on, watching my kids, and/or countless other kindnesses big and small: Zina Bennion, Paige Bischoff, Caroline and Paul Carruth, Meta Coleman, Julia Cosgrove, Meg Matteo Ilasco, Brittany Jepsen, Rubi Jones, Karl Jorgensen, Marc and Gayle Jorgensen, Merrilee Liddiard, Kris and Christine Pollock, Ben and Kate Pollock, Will and Rebecca Pollock, Hanna Dam-Stockholm, Chelsea Taylor, Alex Vaughn, and Sarah Wright.

I will be forever grateful to my mom, granny, and papa for sharing with me their love of France and all things French since before I can remember. This book wouldn't have happened without them.

Finally, to my little family—Kirk, Ingrid, and Lars—I love you bigger than the universe. Thank you for coming along on this amazing adventure. Here's to many, many more.

ABOUT US

AUTHOR

Eva Jorgensen grew up fascinated by her mother's bedtime stories about her Parisian adolescence, and as a result became a lifelong Francophile. After graduating with a BFA in fine art, a minor in French, and a subsequent MFA in fine art, she founded the award-winning stationery company Sycamore Street Press, selling her work in Anthropologie and hundreds of top independent boutiques in the United States and abroad. Eva is now the creative director at Sycamore Co., helping brands around the world tell their stories in a beautiful, natural way. She lives in the Utah mountains with her husband and two kids while listening to Françoise Hardy and traveling to France often.
sycamoreco.com
@sycamore_co

PHOTOGRAPHER

Chaunté Vaughn is a New York–based photographer who specializes in still life, interiors, and portrait photography. Originally from Las Vegas, she worked as a painter and graphic designer before graduating with a BFA in photography.
chauntevaughn.com
@chauntevaughn

FOOD AND DRINK EDITOR

Rebekah Peppler is an American writer and food stylist living in Paris. The author of *Apéritif: Cocktail Hour the French Way and Honey, a Short Stack Edition*, Rebekah's clients include the *New York Times*, *Real Simple*, and Food Network, and she has cowritten multiple cookbooks.
rebekahpeppler.com
@rebekahpeppler

DESIGNER

Linnea Paulsson Neppelberg is a Swedish graphic designer living in Stockholm. With a background in pattern design and architecture, she studied at the Royal Danish Academy of Fine Arts in Copenhagen, graduating in visual communication. Due to a love for the printed and tactile, her main focus is on designing books and magazines.
linneapaulsson.se
@linnea.paulsson.neppelberg

CONTRIBUTING EDITORS

Kari Jorgensen lives in Salt Lake City, Utah, where she produces electronic music under the name BOBO and works at the public library.
@actuallybobo

Lars Stoten is a fashion industry veteran and design luminary with an illustrious career spanning more than a decade. As a master tailor, draftsman, and designer, he has maintained posts at Carven, Mjölk Homme, Saint Laurent, and Givenchy. As a creative consultant, he has outsourced his design prowess to the likes of Colette Paris, Loveless Japan, United Arrows, Topman, Le Bon Marché, and Comme des Garçons. Lars is cofounder and creative director of KAFKA Paris.
@larsstoten

Cassandra Piket is a Dutch French interior designer who was born and raised in the Netherlands and now enjoys the great life in Paris. She works at the architectural firm Wilmotte & Associés, specializing in luxury private residential projects.

CONTRIBUTORS

Erin Austen Abbott grew up in Oxford, Mississippi, and lives there today. Her photography has exhibited throughout the United States and Europe. She is a freelance writer, art curator, owner of the online shop Amelia, and author of *How to Make It*.
ameliapresents.com

Steffie Brocoli is an illustrator who works from home—mostly on children's book projects. Since moving to Paris eight years ago, she has enjoyed painting murals on sunny Sundays and riding her bike around the city.
steffiebrocoli.com

Shannon Carlin lives in Brooklyn and has a master's degree in journalism. Her work has appeared on NPR, *Bustle*, and Refinery29. Like many Americans, her favorite French film is *Amélie*.
@new_girl_friday

Astrid Chastka is an artist and set designer based in New York City. She draws inspiration from her diverse background in jewelry design, architecture, and fine art to define a visual perspective that is bold and often unexpected, but always accessible.
astridchastka.com

Alexis Cheung is a journalist and nonfiction writer. Her work has appeared in the *New York Times, T Magazine, New York* magazine, and on ELLE.com, among others.

Originally from Hawaii, she currently lives in New York City.
@alexischeung

Meta Coleman is an interior designer and stylist based in Utah. Her work has been featured in *Anthology Magazine, Good Housekeeping, Sunset,* and *Flow Magazine.* She has also styled two books: *Playful* and *Old Home Love.*
metacoleman.com

Meg Conley is a writer who lives in Oakland, California, with her husband and three children.
megconley.com

Kira Cook writes, acts, makes films, and delights in being the arbiter of the best apple fritters in Los Angeles. Catch her hosting the PBS travel series *Islands Without Cars* or doing taste tests for Tastemade.
kiracook.com

Marie Doazan is a French illustrator. After working as an art director for several Parisian agencies, she is now devoted to illustration. Marie prefers to work with bold shapes and colors, stacking layers and playing with transparency.
@mariedoz

Sasha Gora is a writer and cultural historian with a focus on food history and contemporary art (often separately, but sometimes together). A Torontonian by birth, she lives in Munich.
lsashagora.com

Liv Holst is a hairstylist originally from Sweden. She moved to London in 2012 to pursue a career in fashion. Her work can be seen in *Vogue, l'Officiel, Offblack*, etc. Liv is now based in London and Paris. livholst.com

Pearl Jones is a food stylist and recipe tester based in Brooklyn. She enjoys traveling, snail mail, fabric marbling, and taking care of her more than twenty houseplants. @mpearljones

Bryn Kenny began her career as a writer and editor at *WWD* and *W* magazine, and served as a publicity director at Dior Beauty for seven years. Bryn's writing has appeared in *Gather Journal, Whalebone Magazine*, and Refinery29. @brynkenny

Lisa Laubreaux is a French illustrator who was born in Marseille and now lives in Paris. Lisa's work has appeared in many festivals (Maintenant, le Voyage à Nantes), the press (*Doo Little, Mint, Pli*), and on the products of renowned brands like Petit Bateau and Darty. lisalaubreaux.com

Nathalie Lété is a French artist living and working in Paris. Her paintings, ceramics, and textiles are inspired by flowers, birds, fairy tales, and vintage toys. She collaborates with worldwide brands in fashion and home décor. nathalie-lete.com

Paul Loubet is a French artist currently living in Spain. Primarily a painter, he also works as a muralist, illustrator, editor, tattooer, and graphic designer. @paulloubet

Laurel Miller is a food/travel writer based in Colorado and the editor of *Edible Aspen*. She grew up on a ranch, which inspired her to educate people about sustainable agriculture. sustainablekitchen.com

Nic Annette Miller is an artist with an enormous love for the natural world. She has a BFA in graphic design and printmaking from Utah State University, and currently resides in Brooklyn. nicanettemiller.com

Sarah Moroz is a Franco-American journalist and translator based in Paris. She writes about cultural topics for the *New York Times,* the *Guardian, New York* magazine, *Artforum,* and many other publications. sarahmoroz.tumblr.com

Kristy Mucci is a food and prop stylist, writer/editor, and recipe tester/developer based in New York. She currently works in the test kitchen at *Saveur* magazine. @kristymucci

Kana Nagashima was born in Japan, but her dream was to live in Paris. In 2011, Kana attended the Christian Chauveau makeup school, after which she was an assistant to Pat McGrath. She

currently freelances for magazines and musicians. @kanangsm

Alison Reid is a Paris-based British freelance stylist, set designer, amateur baker, papier maché-ist, aspiring ballet-goer, and bichon frisé admirer. alisonreid.fr

Anja Riebensahm is a freelance illustrator, writer, and pastry chef based in Brooklyn. She happily paints, eats, and writes about all things sweet. anjariebensahm.com

Cat Seto is an illustrator, author, and creative director of Ferme à Papier, a Paris-meets-Brooklyn stationery collection based in San Francisco. Her latest book, *Impressions of Paris*, is an illustrated journey through Paris, published by Harper Design. fermeapapier.com

Tania Strauss is a writer and editor based in Brooklyn. She likes books, film, and travel, books and films about travel, and wandering around with her camera. tlstrauss.com

Jaimie Stettin is a New Yorker who has been living and working in Paris since 2013. In the City of Light and elsewhere, she pursues good coffee and good conversation. @jaimiejen

"It's a great city, Paris, a beautiful city—

and—it was very good for me."

JAMES BALDWIN

Editor: Laura Dozier
Designer: Linnea Paulsson Neppelberg
Production Manager: Denise LaCongo

Library of Congress Control Number: 2018936277

ISBN: 978-1-4197-3470-0
eISBN: 978-1-68335-521-2

Text copyright © 2019 Eva Jorgensen
Photographs copyright © Chaunté Vaughn
Additional photography by Bonne Maison, Meta Coleman,
Hôtel du Temps, Hôtel Providence, Hôtel Saint-Marc,
Juan Jerez, Eva Jorgensen, La Bellevilloise, Mara Paris,
Samir Mougas, OMY, onefinestay, Christine Warren Pollock,
Rachelle Simoneau, Elise Tsikis, Carl Warren, Laura Warren

Illustrations by Steffie Brocoli, Marie Doazan, Lisa Laubreaux,
Nathalie Lété, Paul Loubet, OMY, Anja Riebensahm, Cat Seto
Cover © 2019 Abrams

Printed and bound in China
10 9 8 7 6 5 4 3 2 1

Abrams books are available at special discounts when purchased in quantity
for premiums and promotions as well as fundraising or educational use.
Special editions can also be created to specification.
For details, contact specialsales@abramsbooks.com or the address below.

Abrams® is a registered trademark of Harry N. Abrams, Inc.

ABRAMS The Art of Books
195 Broadway, New York, NY 10007
abramsbooks.com